READING THE VAMPIRE

V the
v y do
v

ti esta-
li es in
V *The*
S 3ram
A rary
A pire
cl such
as *ker's*
'*Dracula*'.

Reading the Vampire embeds vampires in their cultural contexts, showing how vampire narratives reproduce the anxieties and fascinations of their times – from nineteenth-century investments in travel and tourism, issues of colonialism and national identity and obsessions with sex, to the 'queer' identity of the vampire, the association of the vampire with the 'global exotic' and current concerns about wayward youth, the family and national security.

Ken Gelder is Principal Lecturer in English, Media and Cultural Studies at De Montfort University, Leicester (on leave of absence from the University of Melbourne, Australia).

POPULAR FICTIONS SERIES

Series editors:

Tony Bennett
Professor of Cultural Studies
School of Humanities
Griffith University

Graham Martin
Professor of English
Literature
Open University

READING THE VAMPIRE

Ken Gelder

London and New York

First published 1994
by Routledge
11 New Fetter Lane, London EC4P 4EE

Simultaneously published in the USA and Canada
by Routledge
29 West 35th Street, New York, NY 10001

© 1994 Ken Gelder

Typeset in 10 on 12 point Times by
Computerset, Harmondsworth, Middlesex
Printed in Great Britain by
T.J. Press (Padstow) Ltd, Cornwall

Printed on acid free paper

British Library Cataloguing in Publication Data
A catalogue record for this book is available from the British Library

Library of Congress Cataloging in Publication Data
Gelder, Ken.
Reading the vampire/Ken Gelder.
p. cm – (Popular fictions series)
Includes bibliographical references and index.
1. Vampires in literature. 2. Vampire films–History and criticism. I. Title.
II. Series: Popular fiction series.
PN56.V3G45 1994
809.3'9375–dc20 93–44485

ISBN 0–415–08012–6 (hbk) 0–415–08013–4 (pbk)

For Hannah and Christian

CONTENTS

PREFACE

This book attempts to analyse a particular subgenre of popular fiction, namely, vampire fiction. It wants to show, among other things, the tremendous reach of the vampire into the popular imagination; so much so that, these days, more vampire films and novels are being produced than ever before. We need also to appreciate the many forms vampire narratives can take, and the many different things they can say – although I wish to show that vampire narratives do share, or even 'reproduce', certain features. Of course, we probably most immediately associate vampires with *Dracula*; which particular *Dracula* we have in mind here, however (Bram Stoker's 1897 novel? The 1931 film with Bela Lugosi? The Hammer remakes of the 1960s and 1970s? Francis Ford Coppola's 1992 film – and the book of the film?), may not always be clear. But vampire fiction was a popular form long before *Dracula* – Stoker's novel – was published. The second chapter of this book reads the earlier vampire stories of Lord Byron and Dr Polidori – set in and around Greece – and Chapter 3 reads J. Sheridan Le Fanu's 'lesbian vampire' story, 'Carmilla' (1872). These are important examples of vampire fiction which, for good reasons, are accounted for before I come to *Dracula*, which also has a chapter devoted to it. Chapter 5 then looks at some vampire films, beginning with F.W. Murnau's *Nosferatu*, which allegedly 'plagiarised' Stoker's novel. Finally, the book examines a range of contemporary American vampire fiction: the 'vampire chronicles' of Anne Rice, and the 'vampire blockbusters' of Stephen King, Dan Simmons, Brian Aldiss and S.P. Somtow.

The opening chapter is less constrained by particular vampire narratives, although it has a lot to say about Stoker's *Dracula* by way of introduction. It begins by following the train journey Jonathan Harker takes at the beginning of this novel, into Transylvania – to trace the 'ethnography' of the Victorian vampire, and to comment on, among other things, the fortunes of this peculiarly nomadic creature as it spirals out of the nineteenth century and into one of its contemporary forms, the 'post-Ceausescu' vampire narrative. Along the way, it has things to say about nineteenth-century travelogues, national and 'polyphonic' identities, anti-Semitism, Karl Marx

and the circulation of capital – and another popular vampire novel, published during the year in which Bram Stoker was born, James Malcolm Rymer's massive *Varney the Vampire* (1847). One of the 'reproduced' features of vampire fiction might already be glimpsed in this account: the vampire's mobility. Much like capital for Marx, the vampire *circulates*; and this book attempts to understand what is at stake in this kind of designation.

In her book *American Vampires: Fans, Victims, Practitioners* (1990), the folklorist Norine Dresser reports on the way in which her topic immediately engaged people's 'curiosity' – where even those with no particular interest in vampires suddenly expressed their fascination about them to her (Dresser, 1990, 10–11). Speaking about my own book to academics and non-academics has led to similar expressions of fascination (as well as the occasional smile – what is an academic doing with such a 'low-brow' genre? – and the usual stock of vampirish puns, such as the one concerning stakes which I used a moment ago). To write about vampires in America, as Dresser does, is one thing; to write about them from Australia, as I have done, seems particularly perverse. And yet Australia, like any other nation, has had its share of 'real' vampires – as in the notorious 'lesbian vampire' murder in Brisbane in 1989, for example – as well as its share of vampire narratives, from 'Waif Wander's' peculiar story 'The White Maniac: A Doctor's Tale' (1867) to the trash-horror Melbourne film by Richard Wolstencroft and John Hewitt, *Bloodlust* (1991), banned in Britain – not to mention the parodically renamed *Trans-Sylvania Waters* (1992), a documentary about an Australian family overseen by a powerful and generally demonised matriarch.

My opening chapter notes another Australian connection, too. But the question remains: why vampires? The answer, for me, lies primarily in their unfailing ability to fascinate. That is, they evoke a response that is not entirely 'rational' – a response that may sit somewhere in between disbelief and, in fact, a *suspension* of disbelief. Vampires are both textual and extra-textual creatures; one can even 'know' about them (and 'irrationally' wish to know more about them) without actually reading vampire fiction or watching vampire films. In this sense, they are 'in' culture; and they may well have (or be mobilised to have) 'real' effects. As Norine Dresser notes, some people do actually imagine that they *are* vampires; they live (or labour) under this particular illusion. When I taught *Dracula* in a course on popular fiction at the University of Melbourne, there were always one or two students who claimed to have lived 'as' a vampire, or to know of others who had done so (Melbourne in fact has an extensive and spectacular 'Goth' youth subculture) – as if the illusion could, for a moment at least, be real enough. Others, however – such as Paul Barber in his book *Vampires, Burial and Death: Folklore and Reality* (1988) – seek to *disillusion*. The belief in vampires is, for him, simply an uneducated misunderstanding of the mechanics of a corpse's

decomposition – which then makes him wonder why it is that 'so many people have concluded – bafflingly – that if I am writing a book on vampires, then I must believe in them' (Barber, 1988, 4n). Vampire fiction, however, can play with these two positions and locate each one in particular ways. That is, to believe or not to believe in vampires *means* something in the cultural marketplace – something which is, essentially, ideological. For Professor Van Helsing in Bram Stoker's *Dracula*, it is necessary to believe in vampires because such belief indicates 'an open mind'; but the ideological project behind his belief is much *less* 'open'.

The pleasure of writing this book lay partly in wading through the dialectic of belief and disbelief, illusion and disillusion, in vampire narratives to try to express the ideological projects which drive them along. But I have not wished by any means to 'reduce' these narratives to ideology. The dialectic of belief and disbelief, illusion and disillusion, returns us time and time again to the realm of fictionality itself: the entertainment of this dialectic folds the reader into the narrative at the level of something much less reducible – which this book also seeks to articulate.

I would like to thank a number of people who have helped in the writing of this book – some of whom may well have initially responded to it in disbelief. First, the editors of the Popular Fictions series, Tony Bennett and Graham Martin, and Rebecca Barden at Routledge: their comments and suggestions have always been useful. I want to thank Tony Bennett in particular, as the editor and reader I worked most closely with – he has supported the book (peculiar as it first seemed) from beginning to end. Many people in the English Department at the University of Melbourne have also been helpful to me, and this has been much appreciated. I especially want to thank Ken Ruthven, who drew a number of articles and useful bits of vampire trivia to my attention; Peter Otto, who very kindly read and commented on Chapters 2 and 3 and talked at length about vampires with me; and Sarah Beaven, who helped me to sort out some ideas about vampires and psychoanalysis. In particular, I must thank my brother Alan, an *aficionado* of horror fantasy (and a good friend) who introduced me to the amazing novels of Dan Simmons and S.P. Somtow – novels which I, like most literature-based academics (whose interests in popular fiction are usually quite limited), would never otherwise have stumbled across. Finally, thanks to Hannah for all those conversations, for all kinds of clarifications, and for putting up with vampires in the house for so long.

1

ETHNIC VAMPIRES:
TRANSYLVANIA AND BEYOND

In August 1830, Thomas Scott published the first map of what was then
known as Van Diemen's Land – now called Tasmania. At this time, settlers,
with the help of the military, were ruthlessly clearing out Aborigines in an
organised movement which began in the south-east (Hobart and the nearby
islands) and swept across the island towards the west. When Scott drew his
map, over half of Van Diemen's Land was colonised. But although the
uncharted remainder – the dense forests and mountains south-west of the
infamous 'black line' – was left blank, it was nevertheless given a name:
Transylvania.[1]

These days, the name 'Transylvania' has been more or less completely
appropriated by vampire fiction and vampire films. One might be surprised,
in fact, to realise that it is an actual country – part of the Austrian-Hungarian
empire in 1830, later on a part of Hungary, and since the end of World War I
a part of Roumania. One of the peculiarities of vampire fiction is that it has –
with great success – turned a real place into a fantasy. It is impossible, now, to
hear the name *without* thinking of vampires; the very word invokes an image
of something unbelievable, something which inhabits an imaginary space
rather than a real one. But Scott's map complicates the picture. It precedes
the popularised association of Transylvania and vampires – which developed
in the later part of the nineteenth century and was consolidated in Bram
Stoker's novel *Dracula* (1897), the most influential of all vampire narratives.
But it also, perhaps, anticipates that later association. It shows that 'Trans-
ylvania' already operates as a transferable sign which carries its meaning to
other places – places which, as yet, can only be imagined. In this case, it
nominates a region which lies under the shadow of – but is still, for the
moment, outside – colonisation. For Scott and the colonisers of Tasmania,
the place-name 'Transylvania', with its evocative meaning, 'beyond (or, to
the other side of) the forest', must have seemed highly appropriate as a
designation for the last uncharted parts of the island. Transylvania itself no
doubt 'resembled' south-west Tasmania – mountainous, densely forested,
inaccessible and *inhabited*. Transylvania stands between Western Europe
and the Far East; Tasmania stands between mainland Australia and the far

1

South. The two place-names – on opposite sides of the globe – even sound like each other (Van *Demon's* Land, too, has a certain resonance here). It is, indeed, common in Australian literary studies to speak of the 'Tasmanian Gothic', a genre which expresses the sense of Tasmania's peculiar 'otherness' in relation to the mainland, as a remote, mysterious and self-enclosed place. In popular parlance, Tasmania is 'backward', out of step with civilisation: Transylvania is evoked in a similar way, from the point of view of mainland jurisdiction.[2]

TRAVELLING TO TRANSYLVANIA

These meanings have more to do with geopolitical arrangements in history than with literary effects – although it would be truer to say in the case of vampire fiction that the two fold into each other to become, ultimately, inextricable. Geoffrey Wall's somewhat melodramatic claim that 'Transylvania is Europe's unconscious' (Wall, 1984, 20) at least captures the aura that has surrounded the country for those who live elsewhere; and contemporary vampire fiction often draws heavily on this mythical representation. Nevertheless, Transylvania was not always an entirely unknown or imaginary place. As far as Britain was concerned, Transylvania became increasingly significant during the nineteenth century, not least because Britain had interests in this part of Europe which it wanted to consolidate. To reflect and accommodate these interests, Transylvania was accordingly documented in a variety of texts which grew in number as the nineteenth century went on. Vampire fiction as it intermittently appeared at this time was heavily indebted to perceptions of Transylvania made available in particular through travel narratives (some of which were no doubt motivated by political interests) and through the related disciplines of folklore studies and ethnography.

These latter associations will be elaborated upon shortly; but we can appreciate the intimate connection between vampire fiction and travelogue – where the protagonist undertakes and documents a long journey which brings him into contact with the vampire – simply by turning to the opening pages of Bram Stoker's *Dracula*. This novel was heavily dependent upon Victorian travelogues for its representation of Transylvania. But the protagonist, Jonathan Harker, is shown to know almost nothing about the country. Harker, a solicitor's clerk from London, keeps a diary, written in shorthand, as he travels towards Transylvania and Dracula's castle. The suspense of the novel depends here upon keeping Harker in ignorance of what he is about to encounter – like most vampire fiction, it works by systematically delaying the acquisition of knowledge. Harker does consult travelogues and ethnographies about Transylvania before his departure, but (for the purposes of maintaining his ignorance in these opening pages) they offer him no enlightenment:

I had visited the British Museum, and made search among the books and maps of the library regarding Transylvania; it had struck me that some foreknowledge of the country could hardly fail to have some importance in dealing with a noble of that country. I find that the district he named is in the extreme east of the country, just on the borders of three states, Transylvania, Moldovia, and Bukovina, in the midst of the Carpathian mountains; one of the wildest and least known portions of Europe.

(Stoker, 1988, 1)

The journey towards Transylvania is certainly not enlightening for Harker; indeed, he increasingly finds himself in the dark as he moves away from the familiar routines of 'civilised' life. Harker's first diary entry opens with his arrival in Buda-Pesth, the train running one hour late. This shift out of the orderliness of timetables – where, consequently, nothing can be anticipated – is a foretaste of what is to come: 'It seems to me that the further East you go the more unpunctual are the trains. What ought they to be in China?' (2). Yet although it is unreliable, the train nevertheless provides Harker with what Wolfgang Schivelbusch – in his study of railway travel and its con-sequences for how we see an expanding (or, shrinking) world – has called 'panoramic perception' (Schivelbusch, 1979). Harker only glimpses the scenery and the people he passes; they seem all the more spectacular for that. Railway travel thus enables certain conventions for travel writing to cohere: what one sees is panoramic, spectacular, distanced and soon left behind. Stephen D. Arata, in his article 'The Occidental Tourist: *Dracula* and the Anxiety of Reverse Colonisation' (1990), has drawn attention to the travelogue conventions at work in these opening pages: as well as complain-ing about the trains in Eastern Europe, Harker searches for a suitably 'old-fashioned' hotel, 'samples the native cuisine . . . ogles the indigenous folk . . . marvels at the breathtaking scenery . . . wonders at local customs . . . and, interspersed throughout, provides pertinent facts about the region's geography, history, and population' (Arata, 1990, 636). Harker uses the word 'picturesque' often enough to make Arata wonder if Stoker is parody-ing the conventions of the Victorian travelogue.

This may be true; it is also true that Stoker, never having visited Trans-ylvania, relied heavily on travelogue description. The key texts here, which are known to have formed part of Stoker's background reading for *Dracula*, are Charles Boner's *Transylvania* (1865), Major E.C. Johnson's *On the Track of the Crescent: Erratic Notes from the Piraeus to Pesth* (1885) and Emily de Laszowska Gerard's popular book, *The Land Beyond the Forest* (1888) – her essay on 'Transylvanian Superstitions' was published in *Nine-teenth Century*, 28 (July 1885), a journal edited by Stoker's friend Sir James Knowles.[3] Stoker's representation of Transylvania is grounded in the reports given in these and doubtless other texts, parts of which he had incorporated into *Dracula* almost word for word. Harker's disclaimer in the note at the

3

end of the novel – 'We were struck with the fact that, in all the mass of material of which the record is composed, there is hardly one authentic document!' (378) – is usually taken as a rhetorical gesture typical of Gothic fiction, a closing denial of the remarkable events which have just unfolded; but it might well refer to the novel's tendency to represent Transylvania (and Dracula himself) by drawing on what had already been represented elsewhere – in the travelogues and ethnographies. It is a way of saying, in other words, that nothing in *Dracula*'s account of Transylvania is original, everything has been copied or borrowed from other texts: this is, necessarily, a well-researched novel. Arata notes that when Harker reaches Dracula's castle, travelogue ends and the Gothic begins, and that this disclaimer is a final and somewhat desperate attempt to recuperate the former and repudiate the latter – in order to exorcise the horrors that have been described. I would rather say that – in accounts of Transylvania in particular – travelogue and the Gothic are already intertwined and inseparable. I should add, also, that the disclaimer is followed with a remark neither I nor Arata had quoted: 'nothing but a mass of type-writing.' This other, apparently banal reason why the documents in *Dracula* have become 'inauthentic' – another way of marking them as unoriginal, as copies – will be further discussed in Chapter 4.

The title of Arata's article – 'The Occidental Tourist' – applies principally to Dracula, an 'Occidentalist' who journeys to England; but Harker, too, functions as a tourist and the travelogues he and Stoker depend upon show just how traversed this otherwise 'unknown' part of Europe actually was. In turn, *Dracula* itself is traversed by subsequent vampire narratives: it is difficult to resist drawing on vampiric images to describe the way an ever-increasing amount of vampire fiction returns again and again to this particular 'source' for nourishment. Later chapters will elaborate on this point; but in the context of the discussion here one example might be sufficiently illustrative. S.P. Somtow's *Vampire Junction* (1984) has the New York analyst Carla dream that she takes 'a long train ride' to a place which she immediately recognises: 'She did not know the name of the country but somehow she thought it was Transylvania, because they all spoke in frightened whispers. There was a castle towering from the tallest crag' (Somtow, 1984, 250). This novel self-consciously reproduces Harker's experiences, as if the journey into Transylvania can now – after Stoker's novel – be expressed in no other way. Indeed, *Dracula* has enabled the production and intensification of an *actual* tourist industry in Transylvania (and Whitby, Yorkshire, for that matter – where Dracula lands in England – with its 'Dracula Trail' and 'Dracula Experience'), a rare feature for a novel. It is a feature that subsequent vampire narratives have occasionally parodied, such as the film comedy *Transylvania 6–5000* (1985), directed by Rudy de Luca, which shows newspaper reporters visiting Dracula's castle, negotiating with canny locals, relying on credit cards (American Express is highly visible on the castle

door) and wondering all the while about the 'authenticity' of what they are seeing. Transylvania, one of the journalists remarks, is 'cute', rather than (as for Harker) 'picturesque'. As the title suggests, the film folds American popular culture into a flamboyantly *inauthentic* 'Transylvanian' setting – as if this otherwise remote place has always belonged in Hollywood.

Can the 'real' Transylvania ever be represented? The editors of the socio-cultural study *Transylvania: The Roots of Ethnic Conflict* (1983) feel obliged to remind readers that it *is* a 'real' place, reclaiming it from 'storybook creation' but noting also that 'even the scholarly world has contributed to the fog that engulfs Transylvania' (Cadzow *et al.*, 1983, 1). Given the level of interest in the country during and after the fall of Nicolae Ceausescu and the coup in Roumania during the last days of 1989, one might have expected the 'fog' to be lifted at last. But Ceausescu was immediately represented in mass medias as, precisely, a new 'Dracula', a kind of reincarnation of the fifteenth-century tyrant Vlad the Impaler. The demonisation of a communist tyranny by western journalists was nowhere more relentlessly pursued than here – bolstered by the easy availability of 'on site' vampiric iconography. Signifi-cantly enough, the Ceausescus were executed on Christmas Day. The two biographies which followed the family's downfall – John Sweeney's *The Life and Evil Times of Nicolae Ceausescu* (1991) and Edward Behr's *'Kiss the Hand that Cannot Bite': The Rise and Fall of the Ceausescus* (1991) – indicate even in their titles an inevitable tendency to vampirise the communist dictator. For Sweeney, demystification and mystification go hand in hand: certain 'fables' about Ceausescu 'seem more eerie when one realises they are true – or at least, less of a lie than the "official truth"' (Sweeney, 1991b, 17). The 'real' in this account – where fables are true – lies elsewhere.[4]

For outsiders, journalists especially, who these days still venture into Roumania seeking the truth, the 'Dracula myth' would seem to be unavoid-able. A special number of the journal *Granta*, titled *What Went Wrong?* featured a report on Roumania by William McPherson, who had driven into the country during the revolution of early 1990. The Gothic slowly inter-venes to disturb the realism of McPherson's travelogue: 'All Roumania is dark, I was soon to discover, and Timisoara . . . seemed the darkest city I had ever seen'; 'the events I had myself witnessed, began to seem unreal' and so on. Later, he has strange dreams: 'was that a sound, or was I imagining it?' (McPherson, 1990, 11, 42, 44). Authenticity – whether certain events are in fact imagined or real – is a problem that remains unresolved in this country. Accordingly, McPherson, like Harker in Stoker's novel (and like the heroes of much contemporary vampire fiction), becomes increasingly paranoid: 'Who was who was difficult to sort out in Roumania'; '"How do you determine who is honest?"'; and – most alarming of all – '"What you see is not true . . . and what is true you cannot see"' (McPherson, 1990, 19, 21, 24). Harker's disclaimer at the end of *Dracula* – 'there is hardly one authentic

document!' – is precisely replicated here when a Roumanian student hands McPherson some papers with an incriminating list of names and dates:

> I didn't know if I were slipping into reality or out of it. In Roumania, I was beginning to learn, reality has a sliding floor. I looked at the document now in my hand. 'How do you know it's authentic?' I turned the pages. I turned the pages again. The names meant nothing to me. 'Petru, this is a copy. It is very easy to fake a copy.'
> 'Fake?'
> 'Falsify. Counterfeit.'
> 'No! It is veritable.'

<div style="text-align: right">(McPherson, 1990, 17)</div>

Transylvania, then, is not so much unknown or unknowable as a place that throws what *can* be known into crisis. To enter Transylvania is to encounter a representational problematic: what circulates there (and the knowledges one accordingly possesses) may be true or false, authentic or inauthentic, it is impossible to say.

POST-CEAUSESCU VAMPIRE NARRATIVES

It is worth noting that these recent events in Roumania actually gave rise to a number of vampire fictions and feature films – what I would call post-Ceausescu vampire narratives. Stuart Gordon's film *Bloodlines: An Evil Ancestry* (1989) shows Catherine, a young woman from Chicago, travelling to Ceausescu's Roumania to search for her lost father. Bucharest is rendered 'authentically' in an otherwise fantastic film – the airport is policed by the *Securitate*, the streets are full of people standing in queues. A news broadcast shows Elena Ceausescu receiving a standing ovation. Catherine declares to her friendly taxi-driver Max that she is not a 'sight-seer'; the film, in the meantime, gives a suitably panoramic view of the city under siege (by taxi, not by train) and systematically leads her to the most hidden (i.e. even *more* 'authentic') places. Vampires reside here, both connected to and somehow 'beyond' Ceausescu's *Securitate*; and like McPherson – in a country where identity is always illusory – Catherine can never tell who they are, 'who was who'. Even Max, it turns out, is 'one of them'. Ted Nicolaou's *Subspecies* (1991) is less interested in rendering a 'real' contemporary Roumania; but, with its largely Hungarian crew and actors, it figures the 'truth' of Ceausescu's regime through allegory and corrects misapprehensions about local folklore into the bargain. Three 'beautiful young [female] research assistants' arrive in Transylvania to accumulate local knowledge. They stumble into a battle between two vampire brothers, the good (younger) Stefan and the evil Radu (who has killed his father, King Vlad). The post-Ceausescu allegory is straightforward enough: 'to save the kingdom from the terrifying rule of Radu' and his 'primitive' army.

The American novelist Dan Simmons – whose vampire blockbuster *Carrion Comfort* (1989) will be looked at in Chapter 7 – has published a short story, 'All Dracula's Children' (1992) (later incorporated into his second vampire novel, *Children of the Night* (1992)). The story is centred on events immediately following the fall of the Ceausescus and captures most of the features of vampire fiction noted so far, modulating them in interesting ways. Like *Dracula*, it begins with a journey into Transylvania. The narrative opens with six United Nations 'semi-officials' (academics, a doctor, a minister, entrepreneurs) arriving in Roumania at an exact moment in history: 'We flew to Bucharest almost as soon as the shooting stopped, landing at Otopeni Airport just after midnight on December 29, 1989' (Simmons, 1992, 47). The narrator, Harold Winston Palmer, represents one of the largest corporations in the world, although what it produces is not specified. The guide, a mysterious figure named Radu Fortuna, takes the officials into those obscured zones – the 'real' Roumania – to which few others have access. A journey underground into a 'maze' of ammunition storehouses, however, seems 'dreamlike, almost hallucinatory' (53): the 'real' is already compromised by the Gothic imagination. The process of uncovering an 'authentic' Roumania is intensified when the officials visit Ceausescu's notorious orphanages and see 'the hidden children' (63). In an escalating pursuit of the 'real' Roumania, they demand to see what has so far been only an unconfirmed rumour: 'The AIDS ward was behind four sets of locked doors' (63). But the horrors revealed here occupy the centre of the story rather than the end. Until this point, vampires – Dracula, Vlad the Impaler, 'shades of Bela Lugosi' – have only entered events peripherally. Overcome by what he has seen, the doctor cynically observes, 'I wish it were Dracula we had to deal with here. . . . One monster biting a few dozen people, and the world would be galvanised with interest . . . but as it is, tens of thousands of men and women dead, hundreds of thousands of children warehoused and facing . . . *goddammit*' (69). Vampires here are less horrific than 'reality', but of more interest to tabloid newspapers – from which the story at this point would seem to distance itself. But as if fulfilling the doctor's wish, Simmons goes on to fold both of these horrors into each other by showing that vampires are (in both senses of the word) *behind* 'reality'. The narrator is taken by Radu to an industrial complex which – to indicate the 'backwardness' of the country – has been steadily polluting a nearby Transylvanian village. Radu explains,

Ceausescu gone now. Factory no longer have to turn out rubber things for East Germany, Poland, USSR . . . you want? Make things your company want? No . . . how do you say . . . no environmental impactment states, no regulations against making things the way you want, throwing away things where you want. So, you want?

(71)

Palmer does want the site for his corporation – his ethics are apparently at odds with the humanitarian sympathies of the United Nations team. But his view of the site is long-term: soon afterwards, the narrator – and Radu – are revealed as vampires. Like a kind of Roumanian Mafia, they belong to a 'family' which has, in fact, stage-managed the recent events, including Ceausescu's downfall. Indeed, good management is their creed: they speak of the need to 'contain' their earlier 'contagions', including industrial pollution and AIDS (they have, paradoxically enough for vampires, complete faith in science and modern technology). Their dying father is an example of this unrestrained contagion: 'Father was very careless. Remember, the HIV virus is a *retrovirus*. A contagion from millenia ago. The scientists do not know from whence it came, or how it was spread to humans' (76). The new vampires produce the conditions by which their earlier plagues can be controlled, moving now into the international, or rather, *multinational*, sphere, a new world order: 'The family has removed all barriers . . . national, ideological . . . so this can be true' (76).

Certainly Simmons's story relies on what I call in Chapter 7 the 'paranoid consciousness', the fabrication of a deeper 'reality' in Roumania, the sense that (in this case) events are ultimately manipulated by vampires – as if bearing out the sinister aphorism which defines Ceausescu's regime for McPherson, 'what you see is not true . . . and what is true you cannot see'. But this only perpetuates, rather than resolves, the question of authentic versus inauthentic representation discussed above. The new vampires, identified with business in the West, have both a subtextual and a supertextual function, operating invisibly for the most part to drive the 'real' events along – and gesturing, perhaps, to the role Western governments and business, which certainly helped to consolidate Ceausescu's regime, may indeed have had in his overthrow. In this sense, they may be 'real' or they may not. The story, unexpectedly for the reader (who might also want to know 'who was who' in Roumania), goes on to identify its vampires by showing that their identity now, in a 'post-ideological' age (and in contrast to the older, dying – and *recognisable* – vampire), has been thoroughly dispersed. Transylvania – and this is true of contemporary vampire fiction just as it is true of the modern globalised forms of capitalism much of this fiction thematises – has become simply one place among others in which they can invest.

VAMBERY THE VAMPIRE

In a fascinating article titled 'Dracula's Legacy', the German Lacanian critic Friedrich Kittler complicates Arata's reading of Harker's journey into Transylvania by offering, among other things, a different perspective on the nature of British interests in Eastern Europe in the 1890s. Made anxious about language difficulties in Bistritz, Harker is comforted by his escort to Dracula's castle (Dracula himself), who speaks 'excellent German', 'Eastern

Europe's former language of trade' (Kittler, 1989, 149). (Harker's overexcited landlady, by contrast, mixes her German 'with some other language which I did not know at all' (Stoker, 1988, 4): since German was also the official language of Roumania at this time, she no doubt unofficially returns to her Roumanian identity here. Harker seems ill at ease with hybrid identities.) Of course, Harker is himself involved in trade, selling English real estate to the foreign Count – and, later, *preserving* that same real estate from someone whose 'real' identity has now been established. His diary entries – taken in shorthand, which Dracula is unable to read (but Harker's friends can) – become crucial to this identification: Harker becomes, literally, an undercover informer. Kittler thus reads him as 'an English spy' in a novel which unfolds under 'the shadow of espionage' – at a moment when tourism is always 'imperial tourism' (152), in the service of Western interests. However, this reading focusses not so much on Harker as on a figure mentioned only in passing in *Dracula*. At one point in the novel, Professor Van Helsing authenticates his history of Dracula by referring to a living authority on the matter:

> I have asked my friend Armenius, of Buda-Pesth University, to make his record; and, from all the means that are, he tell me of what he has been. He must, indeed, have been that Voivode Dracula who won his name against the Turk. . . . The Draculas were, says Armenius, a great and noble race, though now and again were scions who were held by the coevals to have had dealings with the Evil One.
>
> (Stoker, 1988, 240–1)

The reference is to the famous Hungarian orientalist scholar and traveller, Armenius Vambery (1832?–1913), who had held the Chair in Oriental Languages at the University of Pesth. Stoker and Vambery had apparently met several times at the Lyceum Club in London. Kittler's interest is in the way Vambery's Orientalism (to use Edward Said's famous term) was codified and the uses to which it was put: he 'travelled the Orient in oriental disguise, gathering information', and, willingly sharing his 'secrets' with English politicians, he became 'a useful spy for the Empire, welcome at Whitehall and Downing Street' (151) – as well as a personal friend of the Prince of Wales. It is this combination of espionage, Orientalism and disguise that allows Kittler to claim that Vambery 'actually was some sort of vampire'; drawing a typically Freudian connection between names and things, he notes that Vambery's surname was 'found just before "Vampyre" in the old reference works' (151) – although which 'old reference works' he has in mind is not clear. In Kittler's account, Vambery – otherwise mentioned only in passing – is ultimately to blame for Stoker's novel. He, rather than Vlad the Impaler (who 'was never the vampire Dracula'), is the true source for *Dracula*. That is, *Dracula* is authorised by nothing less than an

9

'actual' vampire: 'Armenius Vambery had made the vampire Dracula possible' (152).[5]

Kittler's reading of Vambery is both engaging and disturbing, since what is suppressed in his account is that Vambery was a Jew. 'I had', he writes in his second autobiography, 'the problematic good fortune to be born of Jewish parents' (Vambery, 1904, 9). Vambery's life and work seem to have been driven by the desire to efface this particular identity – a desire which leads him to describe Jewish life through the demonised descriptions of the West: 'in this frightful labyrinth of ritualistic cavilling and grievous superstition, I spent my childhood' (28). The Jew, here, is Christianity's Other: 'In order not to have to say the word *Kreutz* [cross], I always said *Schmeiter* instead of *Kreutzer*. When I passed a crucifix I always turned my head the other way, and murmured words of disgust, and secretly spat on the ground' (29). Kittler's claim that Vambery 'actually was some sort of vampire' is thus anticipated through the latter's self-demonisation; Vambery's subsequent trajectory is a way of escaping a vampiric image of the Jew he helps to entrench. He enrols in a Protestant school; later, he gains a Catholic education at the Monastery of the Piarists in St Georghen; still later, he converts to Islam. He learns German, Hungarian, Slavic, Hebrew, French and Latin; moving to Budapest, he learns Turkish, Danish, Swedish, Spanish, Russian and Arabic. His Jewish identity becomes, now, thoroughly dispersed. A 'polyphonic' figure, he no longer has an essence: 'From my earliest youth I had learned to imitate the outward expression of various kinds of people; thus I had accustomed myself to wear alternately the mask of Jew, Christian, Sunnite, Shiite' (191). The 'imitated' identity is taken as 'real': there is no difference. In 1857, Vambery travelled to Turkey, moving around freely: 'everywhere I feel at home' (428). Yet this trajectory is by no means liberating for Vambery – quite the opposite, in fact. The more he tries to disperse his identity, the more a certain paranoia overtakes him. He feels as if he is being watched as he travels through the Orient, and his identity, he complains, is always misread:

> to be taken for a Bokharist in Meshed, for a man from Meshed in Bokhara, and all throughout the journey now for a Turk, now for a Russian, a European and what not! Truly upper Asia is a land of disguise and incognito, especially in the case of a traveller. How my heart yearned towards the West; how I wished to escape from this world of deceit and dissimulation!
>
> (Vambery, 1884, 281)

The 'imitated' Orientalist identity consoles itself here by locating the 'real' elsewhere – in the West. In England, however, Vambery's identity is still problematic: 'a few days after my arrival in London, I noticed that some of my friends began to have a shy look, and that they treated me with a good amount of caution, if not suspicion. . . . In Asia they suspected me to be a

European, and in Europe to be Asiatic' (333). Now, the 'imitated' and the 'real' collapse into each other: there is still no difference between the two. It is precisely the dispersal of his identity – his 'polyphonic' speech, his adaptability, his mobility – that reminds him that he is, still, a 'Jew'. And this is because both conditions produce the same paradoxical effect: either way, he is 'at home' everywhere and, simultaneously, 'a stranger everywhere' (Vambery, 1904, 394) – able, indeed (as Kittler suggests), to spy, but conscious also of always being spied *upon*.

VAMPIRES AND NATIONAL IDENTITY

Vambery's autobiographies evoke a crisis in self-representation which no doubt inheres in a range of what Patrick Brantlinger calls 'imperial Gothic' literatures (Brantlinger, 1988) – that is, Victorian and Edwardian British fiction which reflects Britain's interests in, fantasies about and suspicions of the East. But the ethnographics of this self-representation are particularly appropriate to *Dracula*. I would not want to say, with Kittler, that Vambery 'actually was some sort of vampire'; nevertheless, he engaged the kind of tropes, the kind of representations of deeply-felt feelings, that at this time enabled certain vampirisms to materialise. His 'polyphonic' and imitative abilities, whereby many 'races' are mixed into his character, served as a reminder to Britain of the undesirable 'diversity' of Eastern nations – undesirable in any way other than as a spectacle. Stephen D. Arata quotes a passage from Charles Boner's *Transylvania*, a source-text for *Dracula* and, in fact, the 'standard Victorian work on the region':

> The diversity of character which the various physiognomies present that meet you at every step, also tell of the many nations which are here brought together. . . . The slim, lithe Hungarian . . . the more oriental Wallachian, with softer, sensuous air . . . a Moldavian princess, wrapped in a Turkish shawl. . . . And now a Serb marches proudly past, his countenance calm as a Turk's; or a Constantinople merchant sweeps along in his loose robes and snowy turban. There are, too, Greeks, Dalmatians, and Croats, all different in feature: there is no end to the variety.
>
> (Arata, 1990, 629)

The passage anticipates Jonathan Harker's 'panoramic perception' of the many 'races' in Roumania – 'in all sorts of attire' (Stoker, 1988, 3) – as he journeys to Dracula's castle. This is certainly a wonderful spectacle, a means of displaying the region for the tourist's gaze. But Dracula's own account of 'the whirlpool of European races' (28) in constant conflict with each other presents the darker side of this picture. Diversity means instability: it invites contestation: identities become confused: one can no longer tell 'who was who'. In short, diversity means the *loss* of one's nationality – hardly

appropriate for an imperialist ideology which depends upon a stable identi-
fication between nation and self. The more diverse a nation, the less claim it
has to national identity; and this 'weakening' of identity makes it more
vulnerable to absorption by imperialistic nations elsewhere. Arata also
quotes from Emily Gerard's *The Land Beyond the Forest* (1888), to this
effect:

> The Hungarian woman who weds a Roumanian husband will neces-
> sarily adopt the dress and manners of his people, and her children will
> be as good Roumanians as though they had no drop of Magyar blood in
> their veins; while the Magyar who takes a Roumanian girl for his wife
> will not only fail to convert her to his ideas, but himself, subdued by her
> influence, will imperceptibly begin to lose his nationality. This is a fact
> well known and much lamented by the Hungarians themselves, who
> live in anticipated apprehension of seeing their people ultimately
> dissolving into Roumanians.

(Arata, 1990, 630)[6]

For Arata, this passage is more or less directly transplanted into *Dracula*: the
fear of 'dissolving into Roumanians' becomes, in Stoker's novel, the fear of
dissolving into vampires. Vampirisation is colonisation – or rather, from the
British perspective, *reverse* colonisation. Arata's article is precisely about
the way even the most apparently stable, imperialist nations can evoke
horror fantasies in which self-identities are invaded by and absorbed into the
Other – and he identifies a subgenre of fiction from around the 1880s and
1890s, to which *Dracula* belongs, in which this is articulated. Another
example is H.G. Wells's *The War of the Worlds* (1898), which was serialised
in 1897, the same year that *Dracula* was published. Wells's Martians, it is
worth noting, also drink human blood; and, interestingly enough, the novel
rests its structure of 'reverse colonisation' on the example of the 'extinction'
of the Tasmanian Aborigines by the British. (*Dracula* and *The War of the
Worlds* are discussed together as 'invasion novels' in Dingley, 1991.) In
Dracula, the vampire returns colonisation to the colonisers; he is shown to
be more of an imperialist than the British. But this is not just because his
identity is even *more* stable than theirs (he has no such anxieties about
belonging to 'a conquering race'); it is also because it is simultaneously able,
precisely, to disperse itself across Europe. Count Dracula is certainly fiercely
nationalistic, a 'proud' Szekely, but his lineage is already thoroughly mixed:
as he tells Harker, 'in our veins flows the blood of many brave races' (Stoker,
1988, 28). Moreover, he has mastered the languages and cultures of modern
Europe: as well as his 'excellent German', he speaks 'excellent English' (15)
– though with 'a strange intonation' – and has a library full of books about
English life and customs. He tells Harker that he wishes to circulate freely in
England, to efface his otherness and resemble the West:

a stranger in a strange land, he is no one; men know him not – and to know not is to care not for. I am content if I am like the rest, so that no man stops if he sees me, or pause in his speaking if he hears my words, to say, 'Ha, ha! a stranger!' I have been so long master that I would be master still – or at least that none other should be master of me.

(20)

Later, Harker expresses the horror of 'reverse colonisation' which he has unwittingly helped to realise: 'This was the being I was helping to transfer to London, where, perhaps for centuries to come, he might, amongst its teeming millions, satiate his lust for blood, and create a new and ever widening circle of semi-demons to batten on the helpless' (51). This fantasy is realisable because of the collapsing together of resemblance and 'mastery', where to be 'like the rest' is to ensure that the rest are like you. It never happens, however, because the novel disentangles the two, maintaining Dracula's difference through (among other things) that 'strange intonation'. In an arrangement we have already seen, it is by being so 'at home' with other languages that Dracula remains always a 'stranger'. The international-ism of Dan Simmons's modern, post-Ceausescu vampires – who have 'removed all barriers . . . national . . . ideological' – is gestured towards here, but not yet reached: like Vambery, Dracula is a character whose 'polyphony' and ability to circulate freely – to traverse national boundaries – signify nothing less than his irreducible Otherness.

VAMPIRES AND ANTI-SEMITISM

Nina Auerbach's analysis in *Woman and the Demon: The Life of a Victorian Myth* (1982) of 'mythologies' about women which preoccupied the Victorian 'cultural imagination' opens with a particular 'key tableau' evoking sexual menace:

> three men lean hungrily over three mesmerised and apparently charac-terless women whose wills are suspended by those of the magus/ master. The looming men are Svengali, Dracula, and Freud; the lushly helpless women are Trilby O'Ferrall, Lucy Westenra, and (as Freud calls her) 'Frau Emmy von N., age 40, from Livonia'.

(Auerbach, 1982, 16)

The latter is the focus of Freud's notorious case study in *Studies in Hysteria* (1893–5). Jules Zanger, in his article 'A Sympathetic Vibration: Dracula and the Jews', notes that all three men are either Jews or are strongly identified with Jews, and that their mesmeric powers were inscribed into this particular identification. Zanger focusses on Svengali – a frightening character from George du Maurier's popular novel *Trilby* (1894), later a stage melodrama – and Dracula. In du Maurier's explicitly anti-Semitic novel, Svengali is from the 'poisonous East', 'birthplace and home of an ill wind that blows nobody

good'; he is tall and thin, 'of Jewish aspect, well featured but sinister', with 'bold, brilliant black eyes'. He resembles 'a sticky, haunting, long, lean, uncanny, black spider-cat', a 'dread powerful demon who . . . oppressed and weighed on [Trilby] like an incubus' (cited in Zanger, 1991, 35). In London, Dracula's features are similarly described: 'a tall, thin man, with a beaky nose and black moustache and pointed beard' (Stoker, 1988, 172); he is also, of course, identified with animals (wolves, a dog, a bat) and similarly 'oppresses' his victims (men *and* women; he mesmerises Harker, too).

Auerbach's 'key tableau', then, reproduces popular mythologies not only about women, but about Eastern European Jews (Freud, incidentally, was born in Moldavia) – and these popular mythologies are mobilised in *Dracula*. The connection between these representations of the 'Jew' and Dracula is extended in Stoker's novel by showing the vampire to be a hoarder of money and gold. His 'treasure' is buried in various discrete locations, each one carefully marked. At one point, Harker secretly enters the Count's room in his castle: 'The only thing I found was a great heap of gold in one corner – gold of all kinds, Roman, and British, and Austrian, and Hungarian, and Greek and Turkish money' (47). Dracula's money is an indication of his mobility: his trade traverses national boundaries, without allegiance to any one nation. Zanger places these representations in the context of Jewish immigration into England in the 1890s and anti-Semitism in Europe – but more can be added here. Popularised stereotypes of the 'Jew' certainly prevailed in Victorian England. The Jews, among ethnic minorities in London, were second only to the Irish (Englander, 1989, 551) – a fact that might have interested Stoker, himself from Dublin. The Irish were poor; the Jews, by contrast, were perceived as rich. Englander quotes from the many surveys of the Jews in London at the time, including Charles Booth's massive *Life and Labour of the People in London* (1889–1903):

> It is this dominant race impulse that has peopled our Stock Exchange with Israelites. . . . But in the case of the foreign Jews, it is a competition unrestricted by the personal dignity of a standard of life, and unchecked by the social feelings of class loyalty and trade integrity.
>
> (Englander, 1989, 556)

Foreign Jews – from the East – were liable to be represented as 'uncheckable' in another sense, too. These exhaustive Victorian surveys were a means of monitoring the movements and habits of ethnic minorities; but the Jews, figured as 'nomadic', were difficult to monitor. The mobility of the foreign Jew was both admirable (since they accumulated capital) and the source of national anxiety (since they drained capital by moving it elsewhere).

Daniel Pick, in his study *Faces of Degeneration* (1989), places *Dracula* in the context of a series of powerful discourses of degeneration which prevailed at the end of the nineteenth century. For Pick, these discourses permeated many different social zones, disease (especially syphilis), over-

population, criminality and the insane, the declining aristocracy, even early forms of feminism. In short, he says, 'there was no one stable referent to which degeneration applied' (Pick, 1989, 15). Pick rightly reads *Dracula* in this pluralised context: the novel evokes the discourses of degeneration in their many forms. But one of these forms inheres, precisely, in the anxieties caused by the influx into London of Eastern European Jews – 'a perceived "alien invasion" of Jews from the East who, in the view of many alarmists, were "feeding off" and "poisoning" the blood of the Londoner' (173). The Eastern Jew is vampirised in order to be recognised and, it follows, *restricted* – the surveys cited by Englander tended to ghettoise the Jew, curtailing free circulation by moving them into certain designated areas and reinforcing already available stereotypical features in order that one might be assured at last as to 'who was who'. Pick notes that it is 'an unscrupulous Jew' in Stoker's novel who helps Dracula escape his pursuers and leave England. Immanuel Hildesheim, Jonathan Harker writes, is, significantly enough, part of a network designed to facilitate the entry and exit of illegal immigrants. He has to be bribed for his information:

> We found Hildesheim in his office, a Hebrew of rather the Adelphi type, with a nose like a sheep and a fez. His arguments were pointed with specie – we doing the punctuation – and with a little bargaining he told us what he knew.
>
> (Stoker, 1988, 349)[7]

Like Dracula, Hildesheim's financial transactions move across Europe, shifting money out of its country of origin, internationalising capital: 'He had been paid for his work by an English pound-note, which had been duly cashed for gold at the Danube International Bank' (349).

Of the three texts cited earlier as sources for Stoker's novel, Major E.C. Johnson's *On the Track of the Crescent* most clearly illustrates the application of a discourse of degeneration to the East European Jew. Stoker had reproduced parts of Johnson's account of the ethnography of Transylvania almost word-for-word in his novel. Dracula's 'inside' account of his heritage, for example, is lifted more or less entirely from Johnson's 'outsider' travelogue. Johnson seems also to have provided a direct model for Harker's journey into this 'most picturesque and romantic part of Hungary' (Johnson, 1885, 205) – Johnson certainly overuses the word 'picturesque'. The parallels are quite striking: for example, Johnson's hostess, Countess R—, sends a 'Satanic coachman' to meet him (209); and, at the Hotel Transylvania in Marosvasarhely, the carriage driver is 'this awful presence' whose 'immense hat' guards 'his tender complexion from the rays of the sun' (217). Stoker must also have been familiar with Johnson's description of the Hungarian Jews:

> One thing which must strike every traveller in Hungary is the immense number of Jews, and no one who has been in that country can still be

puzzled as to the whereabouts of the lost tribe; for at least one third of the Jews on the whole earth – some 3,000,000 – are in Hungary and Poland. Who can mistake them? The oval face; the 'parroty' beak, out of all proportion to the other features; the stooping gate and long, flowing beard; the furtive glances from under the shaggy eyebrow, now cringing, now vindictive . . . all these show unmistakably the Hungarian branch of that race 'against whom is every man's hand', and who returns the compliment with compound interest.

Here they have no Greeks to compete with, as at Constantinople, and consequently enjoy a monopoly of all the drink-shops, and pull the strings of all commercial enterprise, as they are the *vis* in the midst of the national *inertia*. In this way they are patient and industrious. . . . Those who know how pitiless the Jews are when they have the too-confiding peasantry in their clutches can understand the dreadful outbursts of anti-Semitic fury now, alas! so common in Russia, Poland, and Hungary, and the sanguinary vengeance taken on them and theirs by their improvident and exasperated victims, who have got deeper and deeper into their meshes, till the terrible day of reckoning.

(201–2)

The complaint about 'anti-Semitic fury' does not prevent Johnson from reproducing the stereotypes which enable anti-Semitism to flourish; indeed, he concludes by offering nothing less than a vampirisation of the Jews through a narrative in which a 'pitiless' oppressor is at last overthrown by his victims. The vampire lore, that he may not enter a house unless invited – 'though afterwards', as Van Helsing says, 'he can come as he please' (Stoker, 1988, 240) – quite possibly articulates this image of the 'Jew' as a moneylender. In other words, the anti-Semitic mythology of the Eastern European Jew folded in to what became – through Stoker's novel – the 'Dracula myth'.

Johnson also reproduces the identification of the 'Jew' as an *internationalised* accumulator of money: 'they have accumulated most of the wealth of the world, and control an immense proportion of the business transactions on the civilised globe' (Johnson, 1885, 202). These are the characteristics of Dracula: like the 'Jew', he is presented as, in a sense, always already 'recognisable' (through particular features, habits, etc.) – and this is necessary in order to restrict his perceived desire to circulate without restriction. The lore restricting Dracula's movement might be read in this context: although he can, as Van Helsing says, 'at times vanish and come unknown', nevertheless he has a 'limited freedom' and 'cannot go where he lists' (Stoker, 1988, 239–40). The desire for *unlimited* freedom is associated with the increasing internationalisation of capital: in this kind of representation, the 'Jew', like Dracula, must be restricted precisely because he moves money so easily through so many nations. The internationalisation of capital disturbs national identity; money changes hands and crosses boundaries; it is

16

mobile, nomadic, 'polyphonic', everywhere 'at home'. The Jews – and the vampire – are located as the 'source' of this movement; they must themselves be restricted (stereotyped, alienated, demonised, exorcised) to enable nations to imagine that the flow of capital is still theirs to control. That is, in order for a nation to restore an identity that might otherwise have been lost, it is necessary that Dracula – an increasingly internationalised figure who accumulates capital from one place and stores it in another – remains always, essentially, a vampire.[8]

VAMPIRES AND CAPITAL

The above remarks provide an appropriate context for Franco Moretti's compelling 'allegorical' reading of *Dracula* in the chapter 'Dialectic of Fear', from *Signs Taken for Wonders* (1988). Moretti practices what he calls 'a sociology of symbolic forms' (Moretti, 1988, 19); his project is to analyse the means by which literary forms enable us to give our 'consent' to those ideologies which determine the way of the world. This project is a corrective to – for example – those analyses which read fantasy or horror as 'transgressive' or 'subversive' because they make manifest prohibited unconscious desires or confront the 'unseen' of culture (Jackson, 1981). For Moretti, by contrast, fantasy – in fact, literature generally speaking – is designed to 'train' us into achieving a 'compromise' with reality: 'literature . . . is – however paradoxical it may seem – one of the clearest manifestations of the reality principle . . . its "educational", "realistic" function consists precisely in training us without our being aware of it for an unending task of mediation and conciliation' (Moretti, 1988, 40). *Dracula* is a particularly blunt example of this – for Moretti, popular fiction always performs these tasks more overtly, more crudely, than other literatures. It frightens the reader into accepting a social system which is in reality 'based on irrationality and menace' (108). It is accordingly 'illiberal in a deep sense' (107), doing away with the ability to 'think for oneself, to follow one's own interests' (107) by ensnaring the reader in its design. Moretti boldly begins his account by discarding the conventional but ultimately erroneous representation of Dracula as a 'noble' (albeit degenerate) aristocrat. For one thing, he has no servants. Drawing on Marx's striking observation in *Capital* – 'Capital is dead labour which, vampire-like, lives only by sucking living labour, and lives the more, the more labour it sucks' (cited in Moretti, 1988, 92) – Moretti instead characterises Dracula as 'a true monopolist: solitary and despotic, he will not brook competition' (92). He continues:

Hence the horror, for the bourgeois mind. . . . The vampire, like monopoly, destroys the hope that one's independence can one day be brought back. He threatens the idea of individual liberty. For this reason the nineteenth-century bourgeois is able to imagine monopoly only in the guise of Count Dracula, the aristocrat, the figure of the past,

17

the relic of distant lands and dark ages. Because the nineteenth-century bourgeois believes in free trade, and he knows that in order to become established, free competition had to destroy the tyranny of feudal monopoly. For him, monopoly and free competition are irreconcilable concepts. Monopoly is the *past* of competition, the middle ages. He cannot believe it can be its future, that competition itself can *generate* monopoly in new forms.

(92–3)

This is why, for Moretti, the American character in Stoker's novel, Quincey P. Morris, is also associated with Dracula. Morris represents, precisely, the *future* of monopoly in the New World: he has this 'excessive' mode of capitalism in common with the vampire. The connections Moretti draws between the two are perhaps tenuous; Morris's origins are, however, suitably mysterious and like the vampire he has 'been to so many places' – he, too, is particularly mobile, an international traveller and financier. Morris is also 'sacrificed' at the end of the novel: in Moretti's reading, it is necessary to Stoker's 'sociological design' (95) that he, as well as Dracula, must die.[9]

Thus *Dracula* defeats the spectre of an excessive form of monopoly capital by rendering it 'foreign' – Moretti does not connect Dracula with late nineteenth-century representations of the Jews, however – and matching it against a coherent national (i.e., British) identity in which money '*refuses to become capital*' (94). The vampire himself is defeated by the formation of an integrated community of like-minded people who, among other things, *share* the (great deal of) money they have. Dracula, by contrast, is a 'selfish' being: as Van Helsing says, 'his action is based on selfishness, he confines himself to one purpose. That purpose is remorseless' (Stoker, 1988, 342) – in Moretti's reading, it is to remorselessly accumulate capital. Mina expresses the opposite sense that money must not be hoarded but must be used for the collective good (her inclusion of Morris here, however, would seem to go against Moretti's view of the American as the 'future' of monopoly):

> it made me think of the wonderful power of money! What can it not do when it is properly applied; and what might it do when basely used! I felt so thankful that Lord Godalming is rich, and that both he and Mr Morris, who also has plenty of money, are willing to spend it so freely. For if they did not, our little expedition could not start.

(356)

For Moretti, this representation of a community – an 'organic' image of the national identity – which shares its money and spends it 'freely' in the name of justice (rather than hoards it or invests it elsewhere) is in fact the true fantasy of the novel:

> Money must not have its end in itself, in its continuing accumulation. It must have, rather, a moral, anti-economic end to the point where

colossal expenditures and losses can be calmly accepted. The idea of money is, for the capitalist, something inadmissible. But it is also the great ideological lie of Victorian capitalism, a capitalism which is ashamed of itself. . . . Dracula – who is capital that is not ashamed of itself, true to its own nature, an end in itself – cannot survive in these conditions.

<div align="right">(Moretti, 1988, 94)</div>

The vampire must be exorcised because he represents an excessive form of capitalism; in the process, the novel enables (British) capitalism to rehabilitate itself, to cohere as an 'organic' process with a 'human face' which uses money responsibly and sensibly.

Whether or not 'the reader' is frightened into 'consenting' to this arrangement is, of course, an open question. Allegorising *Dracula* in this way, Moretti, among other things, reduces the opportunities of identification for readers (and for capitalists!): it may be that he, rather than the novel, does away with the reader's ability to 'think for oneself, to follow one's own interests'. For Moretti, one necessarily identifies with the 'Crew of Light' – as if they *are* entirely integrated – and one does *not* identify with Dracula; but readerly identification need not be so polarised. For David Glover, by contrast, so many 'discourses' are at work in *Dracula* that the reader is offered 'no moral vantage point' from which to draw identification: this is a 'troubled text' in which 'things are not always what they seem' (Glover, 1992, 986). David Punter has also pointed to the reader's 'ambiguous' position in Gothic novels such as *Dracula* (Punter, 1980, 260, 417). James Donald is even less constraining: in his account, readers of popular fiction have 'multiple points of entry' available to them; their identification with characters and events is negotiated, rather than authorially prescribed (Donald, 1992, 67, 100). Donald's positioning of literature in the context of education and governmentality is thus less 'pessimistic' than Moretti's: his essay on vampire films and the sublime, which will be discussed in Chapter 3, even sees such texts as politically subversive (at least in terms of the 'politics of identity'). For Moretti, the reader is manipulated by 'fear' to consent to the political order of things; for Donald, horror texts utilise 'desire and terror' to destabilise the prevailing order, demonstrating 'the impossibility of its closure or perfection' (119). Certainly the claim for the variability of a reader's response is worth making – and I shall further remark on this in Chapter 4. A different reading may draw out the many differences and tensions amongst the 'Crew'; at another level, 'fear' in its conventional sense may not drive the reader at all but, rather, modes of pleasure or delight or, as Donald suggests, desire – even, at times, a desire for the vampire, a desire to be *like* the vampire. Nevertheless, Moretti's analysis of *Dracula* is certainly consistent with my earlier remarks on nineteenth-century representations of the 'Jew' as 'behind' the increasing internationalisation of capital and therefore as a threat to national identity as it is conceived *through* capital.

<div align="center">19</div>

The vampire is not an arbitrarily conceived invention; rather, it is a way of imaging what in a sense has *already* been vampirised by prevailing ideologies.

MARX AND THE VAMPIRES

Moretti's reading of *Dracula* is grounded in that striking quotation from Marx, in Chapter 10 of *Capital*: 'Capital is dead labour which, vampire-like, lives only by sucking living labour, and lives the more, the more labour it sucks.' This powerful analogy – made some thirty years before *Dracula* – reminds us, at the very least, of how familiar vampires were in the nineteenth century to both the popular imagination and the intelligentsia. Chris Baldick has drawn further attention to Marx's Gothic metaphors in his chapter 'Karl Marx's Vampires and Grave-Diggers', from *In Frankenstein's Shadow* (1987). Baldick's own reading of *Dracula* is interestingly at odds with Moretti's; rather than allegorising and healing a modern economic crisis, 'it turns . . . towards an older kind of Gothic novel in which the bourgeoisie flirtatiously replays its victory over the baronial despot: Dracula is feudalism's death warmed up' (Baldick, 1987, 148). But this somewhat dismissive account is also at odds with the way Baldick reads Marx's vampiric metaphors, which *do* function as a way of allegorising modern economic conditions. Baldick notes that, for Marx, industrial capitalism and the forms of communication it gave rise to – far from functioning rationally – in fact radically increased the production of 'irrational' myths and fabrications and sent them spiralling across the globe:

> The daily Press, and the telegraph that in a moment spreads its attentions over the whole earth, fabricated more myths in a single day (and the bovine bourgeois believes and propagates them) than could have been produced by earlier times in a century.
>
> (cited 123)

And elsewhere, at a more general level, 'Modern bourgeois society . . . is like the sorcerer, who is no longer able to control the powers of the nether world whom he has called up by his spells' (cited 127). Modern capitalism here is by its very nature excessive, driven by 'irresistible forces' to consume and accumulate. Marx drew on the metaphor of the vampire time and time again to describe its processes: in *The Eighteenth Brumaire*, the bourgeoisie 'has become a vampire that sucks out its [the smallholding peasant's] blood and brains and throws them into the alchemist's cauldron of capital'; in the *Grundrisse*, capital survives 'by constantly sucking in living labour as its soul, vampire-like', and so on (cited 129). In *Capital* itself, this imagery is intensified: the earlier quotation is only one amongst many others that describes capital as a vampire nourishing itself upon labour.[10]

20

The imagery was already prevalent in Marx's 1847 lectures, which formed a basis to *Capital*: 'capital does not live only on labour. A lord, at once aristocratic and barbarous, it drags with it into the grave the corpses of its slaves.' (Tucker, 1972, 190). This was the same year in which James Malcolm Rymer's massive sensationalist 'penny blood' *Varney the Vampire* – the first vampire novel in English – was published.[11](It was also the year of Bram Stoker's birth.) *Varney* was so huge (220 chapters, 868 double-column pages) that it might have seemed as if Rymer himself was driven by 'irresistible forces' he could not control. He closed the novel down, finally, by having (to draw on Marx again) his 'aristocratic and barbarous' lord, Sir Francis Varney, throw himself into Mount Vesuvius, 'tired and disgusted with a life of horror' (Rymer, 1970, vol. 3, 868). This arbitrary decision may testify to nothing more than Rymer's exhaustion. But the suicide also indicates the extent of Varney's on-going 'humanisation': few other vampires have chosen to exit in this way. He begins the novel as a lean, giant creature with 'metallic' eyes like 'polished tin', whose appearance is heralded by lightning and fire – significantly enough, perhaps, in the context of Baldick's claims about the pervasiveness of Frankensteinian and Promethean images of machinery in the nineteenth century. But as the novel unfolds, Varney's monstrosity is more ambiguously presented; he is claimed by the novel as more likeable, for example, than the apparently respectable 'stranger' Marchdale who, like Varney, is well-travelled in foreign lands – and who is, suspiciously enough since the motivation behind such accusations is always questionable, the first to identify Varney *as* a vampire. For Nicholas Rance, in his book *Wilkie Collins and Other Sensation Novelists* (1991), the real vampires in this novel are, in fact, upstanding capitalists. Varney's vampirism is certainly connected to the accumulation of capital: he hoards treasure, like Dracula, hiding it away. Mr Brooks, however, is another, more mundane example – a moneylender:

> He went to the city every day, and used to do so just for the purpose of granting audiences to ladies and gentlemen who might be labouring under any little pecuniary difficulties, and accomodating them. Kind Mr Brooks. He only took one hundred pounds per cent. Why should he be a Vampyre? Bless him. Too severe, really!
>
> (Rymer, cited Rance, 1991, 60)

Mr Brooks may compare with Dickens's Mr Vholes, the lawyer in *Bleak House* (1852–3), a strange, shuffling figure who has 'something of the Vampire in him' (Dickens, 1985, 876) – and who drains away his client's money and time (and health) in a profession which is shown to operate without compassion. As Rance notes, the metaphor of the vampire here is exactly as Marx describes it: capitalism is by nature driven to consume *excessively*. In this context, Varney can be read 'radically': he alarms the middle classes because he reflects their own 'real' condition. It is worth

21

noting here that Rance's view of popular fiction is quite different to Moretti's. Rather than claim that popular fiction generally speaking 'trains' (or 'frightens' or comforts) its readers into accepting prevailing ideologies, Rance notes that 'it may be more profitable to be alert to the nuances of different vogues in different periods' (Rance, 1991, 167). For him, the sensationalist fiction of the mid-nineteenth century derives its effects 'from subverting a diversity of early and mid-Victorian ideologies' (1), rather than upholding them or reproducing them wholesale.

The representation of capital or the capitalist as a vampire was, then, common both to Marx and to popular fiction in the mid-nineteenth century. It would not be an exaggeration to say that this representation mobilised vampire fiction at this time, to produce a striking figure *defined* by excess and unrestrained appetite – whose strength increased, the more victims he consumed. The connection between the vampire and the most excessive or extreme forms of capitalism remains in much vampire fiction these days – for example, the 'decadent' and mesmerising pop star vampires in Somtow's *Vampire Junction* (1984) and Anne Rice's *The Vampire Lestat* (1985), or the powerful 'mind vampires' in Dan Simmons's *Carrion Comfort* (1989). But it is also worth remembering the association between the vampire and the 'Jew' – an association Somtow preserves, incidentally. As already noted, the 'Jew' was identified as a figure who epitomised the excesses of capitalism – its appetite, its accumulative powers, its mobility, its increasing internationalisation. Indeed, Marx himself had represented this figure in precisely this way in his earlier, notorious essay, 'On the Jewish Question' (1843). For Marx, the 'Jew' was committed to 'egotistical need and huckstering', reducing every relation to 'commerce' – recalling Dracula's 'selfishness' and 'remorseless' purpose. His god was an alien and alienating thing, 'Money'; and through the 'Jew', money had become globalised, 'a world power'. Accordingly, he has only a '*chimerical* nationality' (Tucker, 1972, 46, 47, 49). To emancipate society from these conditions – from capitalism itself – meant, also, to 'make the Jew impossible': 'His religious consciousness would evaporate like some insipid vapour in the real, life-giving air of society' (46).

A threefold connection exists here: the 'Jew', capital, the vampire. But Marx was himself Jewish: so how can his anti-Semitism be accounted for? In his book *Jewish Self-Hatred* (1986), Sander L. Gilman looks at the ways in which Eastern European Jews were demonised by Jews from Western Europe. Like Armenius Vambery, Marx converted to Christianity at an early age: his father wanted him to assimilate into German society. The adoption of a national identity made it necessary for Marx to distance himself from conventional anti-Semitic images of the Jews, and this was achieved by, among other things, *reproducing* those images – in particular, that Jews had *no* nationality, no language other than the internationalised language of finance. Thus, in *Capital*, he writes,

The national language of the Jews may shift. They may articulate their nature in English or German or French, but the national language that they employ is but camouflage for the true language in which they dupe their prey, 'haggling'. And this is unalterable.

(cited Gilman, 1986, 203)

For Gilman, the negative image of the Eastern European Jew was displaced by a negative image of the 'unassimilated' Jew during the nineteenth century precisely because of the increasing need to secure a national identity. The ways in which this arrangement is reproduced in *Dracula* – as an 'imperial Gothic' novel which, in the process of exorcising the vampire, enables an 'organic' and nationally conceived identity to cohere – have already been noted. It only remains to add that the representation of the vampire as 'unassimilated' – as a 'cosmopolitan' or internationalised character who is excessive to national identities, whose lack of restraint threatens the very *notion* of identity – has been exploited by vampire fiction in one way or another for some time now.

2

VAMPIRES IN GREECE:
BYRON AND POLIDORI

We have looked into the destination of the vampire – its internationalisation – but what of its origins? After all, the vampire's identification with Transylvania comes rather late in the day: was it associated with other places before this? In fact, it is difficult to pin the vampire down to one original place and moment – and it is equally difficult to avoid surrendering to the cliché (often utilised in vampire fiction) that it is as 'ancient' as the human race itself. Van Helsing's account in *Dracula* places no limits on the vampire's whereabouts and history:

> For, let me tell you, he is known everywhere that men have been. In old Greece, in old Rome; he flourish in Germany all over, in France, in India, even in the Chersones; and in China. . . . He have follow the wake of the beserker Icelander, the devil-begotten Hun, the Slav, the Saxon, the Magyar.
>
> (Stoker, 1988, 239)

Most histories of the vampire similarly gesture towards a multiplicity of origins, whereby the vampire's identity is thoroughly dispersed across history and across place. Radu Florescu and Raymond T. McNally's *In Search of Dracula* (1972) and Gabriel Ronay's *The Truth About Dracula* (1972) take up the kind of narrative outlined above, returning to 'sources' only to pluralise them so that one is as good as another – as if every country and every moment in history has had its vampires. It should be noted that two East European sources for Stoker's Count Dracula are usually privileged over others: Vlad the Impaler or Vlad Tepes (1431?-76) and Countess Elizabeth Bathory (1560–1614).[1] Stoker would have read of Vlad Tepes in William Wilkinson's *Account of Wallachia and Moldavia* (1820), which he consulted during his research at Whitby in Yorkshire; he may have known about Bathory from Sabine Baring-Gould's popular *The Book of Were-Wolves* (1865). But both figures only return us to the issue of identity dispersal, albeit in different ways. As a Wallachian, Vlad Tepes was literally caught in the middle of a war between Hungary and Turkey. Captured by the Turks, he learnt their language and practices, returning to Wallachia both to

24

'cleanse' it and to defend it from an enemy he was now familiar with and for whom he was often mistaken. His Orientalisation – as we saw with Vambery in the previous chapter – no doubt contributed to his subsequent demonisation (see Florescu and McNally, 1973).[2] Bathory, a Hungarian and part of a family who ruled Transylvania, was a cross-dresser who was also a sadist: she reputedly tortured and killed peasant girls, drinking and bathing in their blood in an attempt constantly to renew (or alter) her identity. These two sources, however, stand amongst many others (there is in fact no mention of Bathory in *Dracula*; and Vlad Tepes is only mentioned incidentally); their more recent historians allow a range of other influences and sources in their account of Stoker's work (Florescu and McNally, 1973; McNally, 1984). Florescu and McNally's *Dracula: Prince of Many Faces* (1990) confirms the multiplicity of origins – as does Brian J. Frost's *The Monster with a Thousand Faces* (1989), an inventory of stories featuring the 'vampire motif' which concludes at the outset that the vampire, evolving from 'obscure' conditions, 'is a polymorphic phenomenon with a host of disparate guises to its credit' (Frost, 1989, 1).

Montague Summers's two monumental histories, *The Vampire: His Kith and Kin* (1928) and *The Vampire in Europe* (1929), also show the vampire to be both 'ancient' and everywhere. Indeed, it is internationalised as a 'citizen of the world' – Summers takes this phrase from the title of Oliver Goldsmith's literary work of the same name (1760–2) (Summers, 1928, 22). His second history, however, focusses on those European countries in which vampirism is or had been most intensive. Interestingly, Hungary is not the only source: 'In no country has the Vampire tradition more strongly prevailed and more persistently maintained its hold upon the people than in modern Greece' (217). Summers here reproduces an orthodoxy which folklore studies – a discipline which consolidated itself in the latter part of the nineteenth century – had maintained for some time. Indeed, there is even a case to be made for suggesting that folklore studies cohered as a discipline in the nineteenth century through its interest in popular Greek beliefs about vampires. This point will be taken up shortly – in the development of an argument about the importance of folklore, with its enshrining of the folk as Other and its schematisation of their beliefs and practices, for vampire fiction. But in fact the connection between vampire fiction and Greece has itself been long-standing. The first English vampire story – Dr John William Polidori's 'The Vampyre' (1819) – has its hero Aubrey journey to Greece just as Jonathan Harker journeys to Transylvania in *Dracula*. And the 'Vampire tradition' seems even at this stage to have had a strong hold upon 'the people' there.

GREECE AND THE GRAND TOUR

Polidori's story has a complicated history, but a brief outline can be given here. In 1816 Polidori accompanied Lord Byron – as his physician – on a Grand Tour of the Continent. In Geneva, Byron met Percy Shelley, Mary Godwin and Claire Clairmont (who he had already known), and they took accomodation near the shores of Lake Leman. Their stay together is now legendary and has been well documented by biographers and critics. One night in mid-June, after reading among other things J.B.B. Eyries's collection of horror stories *Fantasmagoriana* – published in English as *Tales of the Dead* (1813) – Byron suggested they each write a ghost story themselves. Mary Godwin worked on the narrative that became *Frankenstein* (1818); Byron wrote a fragment of a horror story which may or may not have been about a vampire, which he dated 17 June 1816 (but published in 1819, after Polidori's story); and Polidori, probably a short while after June, wrote 'The Vampyre'. It is usually claimed that Polidori, under Byron's influence, slavishly plagiarised Byron's fragment for his narrative. My own view is that, although Polidori certainly did draw on Byron's fragment as well as on an earlier vampire poem by Byron, 'The Giaour' (1813), he used this material creatively (even ironically) rather than slavishly. We should also note that, although Polidori had in fact never been to Greece (just as Stoker had never been to Transylvania), Byron had already travelled through Greece and Turkey during an earlier Grand Tour in 1809–10. 'The Giaour' and his 'vampire' fragment were no doubt shaped by his experiences there, and these and other 'Byronic' representations of Greece may certainly in turn have influenced Polidori.

Byron's support for Greek independence – Greece was under Turkish rule at this time – was, of course, shared by other Romantics with an Oxbridge education in the classics, including Shelley and Leigh Hunt. He had gone to Athens to engage in the 'purity' of classical Greece, with its antiquities and monuments; he found, however, that Athens was populated with Turks and Albanians, and that the Greeks were administered from Constantinople. A discourse of degeneration was already available to describe this ethnic mixture, in particular the 'barbarity' of the Turks whom Byron came increasingly to dislike. He noted sourly, 'The pines, eagles, vultures, and owls were descended from those Themistocles and Alexander had seen, and not degenerated like the humans' (Marchand, 1971, 77). After the first Grand Tour, Byron melodramatically lamented the 'fall' of Greece in *Childe Harold's Pilgrimage* (1812) – 'Far Greece! sad relic of departed worth!' (Canto II, verse 73). His popularity helped to entrench such sentiments; indeed, as James Buzard has pointed out, this poem did much to establish certain perceptions about the Continent (the romance of one place, the decadence of another) for subsequent British travellers. Buzard looks at the democratisation of travel and tourism in the early part of the nineteenth century, when the Grand Tour was increasingly accessible for the British

middle classes. But the numbers of tourists on the Continent (an 'unprece-dented flood') made travel seem no longer special or 'individual'. What was needed was a mode of 'anti-tourism' which captured the romance of travel in the terms expressed by Hazlitt – 'to leave ourselves behind, much more to get rid of others' (cited in Buzard, 1991, 33). Byron's poems answered this yearning, providing a set of perceptions about countries such as Greece which 'held out the promise of making Continental experience "live", of saturating it anew with poetical evocations, and even the *frisson* of a sexual daring that was not for domestic consumption' (35). The Byronic image of a solitary wanderer in a perpetual state of exile became, paradoxically enough, immensely popular as a touristic posture. Indeed, the poems laid the foundation for a tourist industry which thrived by marketing those perceptions, making them *available* for domestic consumption – so much so that abridged versions of them were incorporated into travel guides.

BYRON'S 'THE GIAOUR'

Byron described Athens in *Childe Harold* as 'The city won for Allah from the Giaour' (Canto II, verse 77), *Giaour* being a derogatory term used by Turks to describe Christians. In his poem, 'The Giaour' – subtitled 'A Fragment of a Turkish Tale' – Byron produces a kind of revenge fantasy for Athens' occupation. The poem's events take place in the late 1770s – coinciding in particular with Hassan Ghazi's brutal campaign in the Morea. (For an account of 'The Giaour's' historical context, see Watkins, 1987, 35–6.) Greece, now, is lost and overrun: the poem begins with an image of pastoral Greece 'trampled' by the Turkish colonisers and no longer 'alive':

> 'Tis Greece, but living Greece no more!
> So coldly sweet, so deadly fair,
> We start, for soul is wanting there.
> Hers is the loveliness in death,
> That parts not quite with parting breath . . .
>
> (lines 91–5)

A hero appears who is neither Greek nor Turkish – the Giaour in this poem was once a Moslem ('Apostate from his own vile faith', line 616), but is now 'Christian in his face' (line 811). His Venetian or Albanian identity is sometimes recognisable ('now array'd in Arnaut garb', line 615) and some-times not; indeed, by the end he appears suitably nationless, with no 'name or race' (line 1329) of his own. The Giaour has eloped with Leila; she in turn is murdered – thrown into the sea – by the Turk Hassan, to whom she was betrothed; and the Giaour takes his revenge by ambushing and killing Hassan. Clearly, Leila is made to stand for Greece itself: while alive, her 'Soul beam'd forth in every spark' (line 477) and was, for the Giaour, inspirational, like a muse. Byron had figured Greece in precisely this way:

the 'air of Greece', he claimed, had made him a poet (Marchand, 1971, 99).[3]
More specifically, the poem is based on Byron's intervention in the punish-
ment of a Turkish woman who was caught fornicating (see Marchand, 1971,
89–90). Byron's self-projection as the Giaour[4] is typical of his self-
monumentalisation, but it also articulates his sense of powerlessness in
Greek affairs. The Giaour's revenge is localised as a minor skirmish in the
mountains; the national struggle remains beyond him. He subsequently
occupies a position – a posture – somewhere in between engagement and
disengagement: aware of the struggle, but isolated from it; attracted to the
nationalist cause, but in a permanent condition of exile – residing in Greece
only for a short while, but figuring his engagement with the Greek struggle as
eternal. In the poem, this posture is graphically represented by turning the
Giaour into a vampire after his death (a transformation never mentioned,
oddly enough, in Watkins's 'social' reading of the poem). The relevant
passage is particularly purple and was subsequently lifted out of the poem to
preface a number of vampire narratives – including Polidori's story (it is cited
in the introduction – which may not have been written by Polidori – to the
first edition of 'The Vampyre'), and the various popular stage melodramas
which derived from that story:[5]

> But first, on earth as Vampire sent,
> Thy corse shall from its tomb be rent:
> Then ghastly haunt thy native place,
> And suck the blood of all thy race;
> There from thy daughter, sister, wife,
> At midnight drain the stream of life;
> Yet loathe the banquet which perforce
> Must feed thy livid living corse:
> Thy victims ere they yet expire
> Shall know the demon for their sire,
> As cursing thee, thou cursing them,
> Thy flowers are wither'd on the stem.
> But one that for thy crime must fall,
> The youngest, most beloved of all,
> Shall bless thee with a *father's* name –
> That word shall wrap thy heart in flame!
> Yet must thou end thy task, and mark
> Her cheek's last tinge, her eye's last spark,
> And the last glassy glance must view
> Which freezes o'er its lifeless blue;
> Then with unhallow'd hand shalt tear
> The tresses of her golden hair,
> Of which in life a lock when shorn,
> Affection's fondest pledge was worn,
> But now is borne away by thee,

Memorial of thine agony!
Wet with thine own best blood shall drip
Thy gnashing tooth and haggard lip;
Then stalking to thy sullen grave,
Go – and with Gouls and Afrits rave;
Till these in horror shrink away
From spectre more accursed than they!

The melancholy self-projection is grounded here not so much in national as *familial* identity. Showing the vampire preying upon those women closest to him in familial terms, Byron juxtaposes a sentimental fantasy of fatherhood with a horror of infanticide and incest (he was, as it happens, embarking on an affair with his half-sister Augusta around the time of publication). But the vampire is in one sense only a Gothic intensification of a posture already well developed in this poem and in others. The figure in perpetual exile, condemned to wander the earth, never at peace, unable and unwilling – as Byron described it in *Childe Harold* – to 'herd with Man; with whom he held/ Little in common' (Canto III, verse 12), a witness to rather than a partici-pant in national struggles, and above all, *suffering*: this is the typical Byronic hero. Andrew M. Cooper has analysed this posture, noting the Byronic hero's flâneurian mode of traversing the earth 'invisible but gazing' – a posture which Anne Rice takes up much later in her vampire fiction, as we shall see in Chapter 6. The poems become, in effect, 'self-contained, animated system[s]' (cited in Cooper, 1988, 541), entirely divorced from the historicality of their sites. The extent of this divorce is, of course, debatable; certainly, by placing the poems in the context described by Buzard – the increasing democratisation of the Grand Tour, and the subsequent forging of a Romantic self-image through which the British traveller's individualism can be preserved – their historicality is restored at the level of representation. Moreover, the poem's idealist calls for a resurrected Greek nationhood are in tune with sentiments already in vogue at the time. Conversely, the Giaour is unable to realise this resurrection – indeed, he is himself presented as a degenerate figure who is more destructive than creative, more of a problem to national identity than a solution. At one level, the protean Byronic vampire becomes a figure for the utterly self-conscious 'citizen of the world' (Marchand uses this phrase to describe Byron, 1971, 93), drawing life out of each nation he visits; at another level, he is romantically involved with a Greece whose identity remains lost or unrealisable; at another level still, he symbolises the depths to which nationhood, with its mixture of 'races' and its lost classical heritage, has sunk. Like so many vampire narratives, the fantasy indulged in here is one of *incompletion*; the Giaour remains a vampire so long as national identity is unattainable.

BYRON, POLIDORI AND POPULAR FICTION

Byron's 'fragment of a novel' also describes the beginning of a Grand Tour, undertaken by the young narrator and a mysterious older man he greatly admires, Augustus Darvell. Darvell 'had already travelled extensively' (Byron, 1988, 3): he is another of Byron's 'citizens of the world', a restless, protean figure who has no 'original' identity of his own. His physiognomy makes this fact particularly visible: 'the expressions of his features would vary so rapidly . . . it was useless to trace them to their sources . . . none could be fixed upon with accuracy' (3). The narrator is pleased to accompany Darvell; as they journey towards the East, however, he is concerned to see Darvell appear 'daily more enfeebled' (3), his health rapidly declining. In a Turkish cemetery somewhere between Smyrna and Ephesus, close to 'the broken columns of Diana – the roofless walls of expelled Christianity, and the still more recent but complete desolation of abandoned mosques' (4), Darvell comes to rest at last. The journey, it seems, was planned from the beginning: Darvell has, he confesses, visited this empty, uninhabited place before. Dying, he arranges a solemn pact with the narrator – to 'conceal my death from every human being' (5), to throw his seal ring ('on which there were some Arabic characters', 5) into the Bay of Eleusis, and then 'repair to the ruins of the temple of Ceres' (5) at a designated time. A stork appears on one of the tombstones, with a snake in its beak which it 'does not devour' (6). The narrator watches it fly away; at which point Darvell expires, his face suddenly turning black. The narrator buries him in a Turkish grave, and the fragment closes with an uncertain response to the events, as if nothing so far lends itself to diagnosis: 'Between astonishment and grief, I was tearless' (6).

It is difficult to read this fragment, since – as well as being unfinished – much of it (the image of the stork and the snake, for instance) *is* cryptic, functioning as 'unexplained ritual' (Skarda, 1989, 256n). Nevertheless, its ethnographics are reasonably clear: in his connection to the site, Darvell reaches back into an 'original' classical antiquity, beyond Turkish occupation, beyond Christianity, to the temples of Diana or Ceres. There are no resurrected vampires in the fragment; however, Polidori had written an account of Byron's intentions for the remainder of the narrative:

> Two friends were to travel from England to Greece; while there one of them should die, but before his death, should obtain from his friend an oath of secrecy with regard to his decease. Some short time after, the remaining traveller returning to his native country, should be startled at perceiving his former companion moving about in society, and should be horrified at finding that he made love to his former friend's sister.
>
> (cited in Skarda, 1989, 257)

Polidori's own vampire story is certainly close to this sketch of Byron's tale: his vampire, Lord Ruthven, does indeed resurrect himself to 'make love' to

Aubrey's sister. Also, the travellers' destination – given here as Greece – is precisely the destination of Aubrey and Ruthven. But in Polidori's story, the travellers – Aubrey especially – find a very different kind of Greece. Byron's poem and his narrative fragment were solitary psychodramas, depopulated texts – the 'social' is missing from them. But the Byronic return to antiquity, to a 'source' which one can contemplate in solitude, is now ironically displaced by Polidori. Greece, now, is an *inhabited* country – where 'the people' are callously used and discarded by just such Byronic, vampire-like, 'citizens of the world'.

Critics like Skarda and Barbour (1992), who see 'The Vampyre' as a crude narrative written under the influence of a greater and more subtle talent, ignore the ironic mode of Polidori's story – and reproduce the usual academic prioritising of (great) literature over sensationalist fiction. It is, of course, certainly reasonable to read the relationship between Lord Ruthven and Aubrey as a projection of the relationship between Byron and Polidori – the latter under the former's spell, overshadowed by him, even haunted by him, but resolutely documenting his bad habits. In fact, Polidori had taken the name of his Byronic vampire from Clarence de Ruthven, Lord Glenarvon, the rakish villain modelled on Byron in Caroline Lamb's notorious novel, *Glenarvon* (1816) – which, when he read it, Byron considered libellous. 'The Vampyre' is in this sense a work transmitting 'gossip' through a Gothic mode; Polidori was both trading on Byron's already fictionalised reputation, and adding his own Gothic inflexion to it. This is hardly a passive writerly position: Skarda's claim, with its offensive simile – that 'Polidori, like a willing rape victim, sacrifices himself in life and Aubrey in his fiction to the father-god he found in Byron' (Skarda, 1989, 262) – comes from reading the story for its hysterics only.

The feminising and subordination of Polidori in relation to a masculine, assertive Byron perhaps recalls Andreas Huyssen's argument in his influential essay 'Mass Culture as Woman: Modernism's Other', which opens with a discussion of Flaubert's relationship to his character Madame Bovary. For Huyssen, the latter is positioned as a consumer of popular fiction – 'subjective, emotional, passive' – as opposed to the former, who is taken as a 'writer of genuine, authentic literature – objective, ironic, and in control of his aesthetic means' (Huyssen, 1986, 189–90). Polidori and Byron are conventionally figured in exactly these terms. The same configuration is at work in Polidori's story, too, through the relationship between Aubrey and Lord Ruthven – but it is treated ironically, rather than surrendered to wholesale. The story opens by *distancing* itself from Aubrey's attraction to 'high romantic feeling' (Polidori, 1988, 8). In fact, just like Madame Bovary, Aubrey's view of the world is shaped by the illusions of popular fiction, 'the romances of his solitary hours' (8). At the moment of his *disillusion* – just as he is about to find that 'there was no foundation in real life for any of that congeries of pleasing pictures and descriptions contained in those volumes,

from which he formed his study' (8) – he meets Lord Ruthven. The prioritising of Byron/Lord Ruthven – as original or authentic – over Polidori/ Aubrey – as plagiarising, inauthentic – is then playfully reversed. Aubrey in fact self-consciously *invents* Lord Ruthven: 'He soon formed this object into the hero of a romance, and determined to observe the offspring of his fancy, rather than the person before him' (8). The story goes on to trace out the oscillation between illusion and disillusion. Aubrey finds that Ruthven's financial affairs 'were embarrassed' (9), that he gambles and inhabits places of 'vice'. Aubrey's guardians beg him to leave such a 'dreadfully vicious' associate. Both in spite of this and because of it, Ruthven comes to assume for Aubrey's 'exalted imagination . . . the appearance of something super-natural' (10). The discovery that Ruthven is a vampire folds illusion and disillusion into each other: it is impossible (only an 'exalted imagination' could conceive it) and yet it is true. The oath Aubrey swears to Ruthven operates in the same way: he must not tell anyone that Ruthven is a vampire – no one would believe him anyway – and yet the story itself brings this 'fact' to the public's attention. Polidori was commissioned by John Murray to keep a diary of his Grand Tour with Byron; it was not published until 1911, but 'The Vampyre' serves as a kind of substitute, relying as it does on the disclosure of a terrible knowledge that only a most intimate companion – someone who, like Aubrey, watches Ruthven's every move – can possess.

'THE VAMPYRE', ANTIQUITY AND THE FOLK

For Skarda, 'Polidori eliminates his master's poetic and thematic vitality while muddling his own story with exotic but pointless Eastern allusions that blur his narrative and call attention to his source' (Skarda, 1989, 255). In fact, Polidori's evocation of Greece in 'The Vampyre' is very different to Byron's – and, far from being 'pointless', it is integrated into the story in a purposeful way. In 'The Giaour', Byron had feminised Greece, figuring it through the lost figure of Leila, who remains absent throughout the poem. In 'The Vampyre', Aubrey – having left Lord Ruthven after an argument – travels to Athens where he meets the beautiful Ianthe. The connections between Leila and Ianthe are also ironically conceived. In order to imagine Leila's eyes, Byron's narrator asks the reader to

> gaze on that of the Gazelle,
> It will assist thy fancy well;
> As large, as languishingly dark.

(lines 474–6)

Polidori, however, rejects the fanciful comparison when he describes Ianthe:

As she danced upon the plain, or tripped along the mountain's side, one would have thought the gazelle a poor type of her beauties; for who would have exchanged her eye, apparently the eye of animated

nature, for that sleepy luxurious look of the animal suited but to the taste of an epicure.

(Polidori, 1988, 12)

For Skarda, this 'correction' is 'a clumsy attack on Byron's admiration for the gazelle's eyes' (Skarda, 1989, 254)! Polidori, it seems, can do nothing right: his sensationalist story is eternally condemned to the subordinate position. But his 'correction' is also a rejection of Byron's image of Greece: Ianthe's beauty is not 'languishing' but 'animated', not absent (so that, for Byron, one needs the simile of the gazelle to describe her eyes) but present (one does not need any similes to describe her: she *is*). In 'The Vampyre' Aubrey had typically gone to Greece to contemplate the *inanimate* – 'tracing the fading records of ancient glory upon monuments that apparently, ashamed of chronicling the deeds of freemen only before slaves, had hidden themselves beneath the sheltering soil or many coloured lichen' (Polidori, 1988, 11). But he is constantly distracted from his classical studies by Ianthe – and in particular, by the stories she tells him. In effect, two images of Greece, two kinds of texts with two very different effects, compete for Aubrey's attention: the classical and 'almost effaced' narratives of antiquity, patiently awaiting their 'proper interpretation' (12), and Ianthe's tales of vampires, which are animated enough to 'excite' Aubrey and make his 'blood run cold' (12). Although immersed in the 'romance' of popular fiction, Aubrey tries to disillusion Ianthe; but she implores him to believe that her stories are real:

turning to subjects that had evidently made a greater impression upon her mind, [she] would tell him all the supernatural tales of her nurse. Her earnestness and apparent belief of what she narrated, excited the interest even of Aubrey; and often as she told him the tale of the living vampyre, who had passed years amidst his friends, and dearest ties, forced every year, by feeding upon the life of a lovely female to prolong his existence for the ensuing months, his blood would run cold, whilst he attempted to laugh her out of such idle and horrible fantasies; but Ianthe cited to him the names of old men, who had at last detected one living among themselves, after several of their near relatives and children had been found marked with the stamp of the fiend's appetite; and when she found him so incredulous, she begged of him to believe her, for it had been remarked, that those who had dared to question their existence, always had some proof given, which obliged them, with grief and heartbreaking, to confess it was true. She detailed to him the traditional appearance of these monsters, and its horror was increased, by hearing a pretty accurate description of Lord Ruthven; he, however, still persisted in persuading her, that there could be no truth in her fears, though at the same time he wondered at the many coincidences

33

which had all tended to excite a belief in the supernatural power of Lord Ruthven.

(12–13)

The word 'excite' is repeated several times: these animated stories in turn animate Aubrey. The distinction is drawn between classical texts – which require contemplation and 'proper interpretation' – and what we might see here as popular fiction, which immediately realises its content through a direct stimulation of the reader's imagination. The former are dead texts, while the latter are very much alive – and seductive, too, for Aubrey's 'excitement' as he listens to Ianthe is surely also sexual. But Aubrey is by now the perfect reader of popular fiction: he is *easily* seduced: he comes to believe in the illusion of vampires because they are now already familiar to him. What triggers the belief in such 'foreign' creatures is Aubrey's recognition of Lord Ruthven – so that, in these terms, the story is close to Freud's account of 'The "Uncanny"' (1919): the source of one's anxiety about the unfamiliar lies much closer to home.

But for the purposes of this chapter, what is interesting about this passage – and what distinguishes it from Byron's depopulated vampire narratives, with their solitary, anti-social heroes – is that these beliefs, and the 'excitement' they generate, are shared by others, who readily communicate them to Aubrey. Ianthe and her nurse believe in vampires; various 'old men' do, too; later, Ianthe's parents 'affirmed their existence, pale with horror at the very name' (13); and after her death, a group of villagers have no trouble identifying the cause, 'A Vampyre! A Vampyre!' (15). In other words, this story grounds the vampire in the everyday life of 'the people' – the *folk*. The journey to Greece brings Aubrey into contact with the folk, which is where the origins of vampire superstitions are located. Whereas Byron's vampire narratives *remove* their characters from socialised contexts, Polidori's characters are immersed in them. Indeed, the distinction between classical texts and folk or popular narratives in 'The Vampyre' sits alongside a further distinction between the folk and 'society' itself – meaning the fashionable, leisured classes. Thus, Ianthe – an image for the folk, with her natural innocence and her love for stories – contrasts with Lady Mercer, a notorious socialite. Ianthe is 'unconscious' of love, while Lady Mercer is a wily seductress immersed in 'vice'. Lord Ruthven moves freely around in 'society', unnoticed, while in the forests of Greece he is immediately recognised and feared – and, of course, it is suggested, he murders Ianthe. Polidori's story seems to suggest that 'society' itself is vampirish; its aristocratic representatives prey upon 'the people' wherever they go.

VAMPIRES, FOLKLORE AND MODERN GREECE

It would be possible to argue that vampire fiction consolidated itself because of (or, in relation to) the establishment in the nineteenth century of folklore

as a modern discipline with an identifiable field of study: the folk, or 'the people'. Vampire fiction as it developed intermittently through the century – Polidori's story, J. Sheridan Le Fanu's 'Carmilla' (1872), R.L. Stevenson's 'Olalla' (1885), Stoker's *Dracula* – usually required the existence of rumours or gossip or 'rustic' superstitions to enable the vampire to exist. A context of belief has to be established, but kept at a distance: 'the people' are shown to be both superstitious ('excitable', prone to exaggeration) and right. More literate, educated characters who speak up for the vampire – like Professor Van Helsing in *Dracula* – must operate in relation to this context. He is a scientist who mediates between folkish superstitions and enlightened knowledge, 'the people' (subjective) and science (objective), equally at home in these otherwise contradictory spheres. Thus he is both rational and clear-headed, and yet given to 'regular fit[s] of hysterics' (Stoker, 1988, 174), behaving excessively, becoming excitable and highly animated by his subject. He never says, as scientists might, that the vampire is an illusion; his job is not to disillusion, but – quite the opposite – to make the illusion *real*.

Contemporary vampire fiction and film sometimes reproduce this structure. In Stephen King's *'Salem's Lot* (1975), the last section of Somtow's *Vampire Junction* (1984) and Joel Schumacher's *The Lost Boys* (1987), for example, small communities are imagined which are vulnerable to vampires, but which are defended by those who understand and respect folk or popular culture. The heroes here are often (male) teenagers who are immersed in the 'lore' of popular culture: the more 'lore' one knows, the more equipped one is to do battle with vampires. This kind of popular narrative makes a 'scientific' knowledge of the details of popular culture redemptive. No mediators are required, however, because popular culture for these teenagers can *only* be known 'scientifically' – the various 'lores' are systematised into an archive of specialist knowledge, enabling a subculture of serious 'fans' to cohere around it. Indeed, vampire fiction is peculiar in this sense: although it is flexible in so many other ways, it depends upon the recollection and acting out of certain quite specific 'lores' for its resolution – that vampires must be invited into the house before they can enter, that they are repelled by garlic, that they cannot cross rivers, that they need their own earth to sleep on and so on. Some recent vampire fiction, of course, depends on the *frustrating* of the kinds of 'lore' one assumed would work against them: modern vampires can thus themselves have a *disillusionary* function, moving around in the daylight and not fearing crucifixes any more. The fiction now uses 'lore' as a point of reference, trading on the reader's familiarity with it – taking it 'seriously', even exaggerating its use and effects (as in the Hammer vampire films), or parodying it or modifying it.

In the early nineteenth century, the best-known chronicler of folk superstitions was Sir Walter Scott. Influenced by Goethe and German collectors of folk narratives – the Grimm brothers produced their major texts in the second decade of the nineteenth century – Scott folded folk superstitions

into a mode of romance that unpacked itself as it went along, ending, precisely, with disillusion. His novels (*The Pirate* (1822) is a good example) inscribed the folk into the past – as archaic, unwilling to adapt (politically) to the present day, naive, marginal. At the same time, they laid the groundwork for a developing field of study and a particularly influential conception of the Scottish national identity. In fact the nineteenth century saw an increased commitment to the folk and 'folklore'. The term itself was not coined until 1846: in an article in *Athenaeum*, William John Thoms introduced the 'good Saxon compound, Folk-Lore' to replace the 'circumlocutions' in current usage at the time, 'Popular Antiquities' and 'Popular Literature' (cited in Herzfeld, 1982, 111–12). Certainly, the connections between 'folklore' as an emergent discipline of study and representations of the folk – rustic types, rural communities – in popular fiction (as well as ballads, street songs and so on) ought to be noticed. But it is also important to note the connection between the emergent discipline of 'folklore' and the formation of modern national identities. The term may have been coined in England, but it was already in circulation in other forms in other European countries – in particular, the two centres for folklore studies in the nineteenth century, Germany and Greece.

The Romantic investment in the Hellenic struggle has already been noted. Greece was identified as the origin of Europe itself, the most ancient of all European countries – and yet, under Turkish rule at the beginning of the nineteenth century and with an ethnically mixed population, its modern identity as a nation-state had not yet cohered. Observers at this time were nevertheless imagining a national identity: the aristocratic British traveller F.S.N. Douglas, in his *An Essay on Certain Points of Resemblance between the Ancient and Modern Greeks* (1813), saw the 'essential' Greeks as descended from the Hellenised *barbaroi* – thus explaining, as Michael Herzfeld notes, 'the features which to his mind bespoke decadence and superstition' (Herzfeld, 1982, 77). The Greek war of independence galvanised Hellenism and received much sympathy from foreign observers – radical Romantics like Byron, who returned to Greece to take part, and died there in 1824. Indeed, Hellenism may have been more of a projected image than a self-image – a means of attracting the support of cautious nations like Britain. Nevertheless, it gave folklore studies in Greece its impetus. It enabled the formation of a discipline which saw the ancient become visible in the modern; with the realisation of Greece as a modern nation state, it brought the ancient back to life – it demonstrated the ability of antiquity to live again. Of course, folklore as it developed in other European countries during the nineteenth century also revived the ancient, showing its lingering influence in the present day – Jacob Grimm's *Deutsche Mythologies* (1835), for example, was important in this respect for the nationalisation of folklore, ancient and modern, in Germany. The debates in Britain between what Mary Douglas has called the progressionists (who saw the 'primitive' as

almost vanished) and their opponents, such as W. Robertson Smith, who emphasised 'the common elements in modern and primitive experience' (Douglas, 1991, 14), have been well documented.[6] But Greece had a particular investment in the latter position, precisely because of its projected image as the 'source' of Europe itself, its 'originality' – what Herzfeld calls its 'special ancestral status' (Herzfeld, 1982, 11).

Herzfeld's study, *Ours Once More: Folklore, Ideology, and the Making of Modern Greece*, emphasises the importance folklore studies had in the creation of an 'organic' national identity built around an 'originally' conceived Greek people. The folk were construed as a kind of muse upon which a cultivated culture could ground itself – a one-way relationship which Polidori's story both confirms and vampirises, showing Aubrey 'distracted' by a feminised folk-image, but also showing 'society' preying upon the folk for its own gratification. Nevertheless, the image of the folk as original – and inspirational – and *Other* – to culture seems to have remained with folklore studies for much of the nineteenth century. Lucy M.J. Garnett had collected and published Greek folksongs during the 1880s and 1890s; her two-volume *Greek Folk Poesy* (1896) was a best-seller, reprinted several times. It contained several vampire stories and verses. Garnett's volumes were published under the heading 'New Folklore Researches' and were introduced by the famous Celtic folklorist, J.S. Stuart-Glennie, who also included his influential essay, 'The Survival of Paganism'. For Stuart-Glennie, folklore is attached to the 'lower races' while 'culture-lore' is attached to the 'higher races': the former has magic, while the latter has science (Garnett, 1896, vol. 2, 517). These two formations had always been in conflict with one another: civilisation, for Stuart-Glennie, evolves out of an original and irreconcilable *difference* between races (rather than, as was commonly held, an original sameness) – a view that underwrites *Dracula*, published two years later. But Stuart-Glennie's essay is also interestingly post-imperialist. His theory of 'mutual determination' describes the modern age where, now, 'higher' and 'lower' races not only interact with but *invent* each other. 'Folklore' and 'culture-lore' are by no means distinct – their relation to each other anticipates Ferdinand de Saussure's account of *parole* and *langue*, language in its spontaneous or animated mode and language as a systematised totality. Science is simply the 'verification' of magic and folk-intuitions. Stuart-Glennie had also claimed that the modern Greek was 'neo-Hellenic', nearer to his 'sources' than any other national. This was the Greeks' difference from other 'races': the folk were the living manifestation of classical culture – an 'animation' of Greece's 'origins'.

Herzfeld notes the connections drawn at this time between revolution and 'resurrection' in Greece: the declaration of Greece as a nation-state brought the dead back to life (Herzfeld, 1982, 22). But in his account, the nationalisation of Greek identity – through a view of the modern as an animated realisation of the ancient – ran into trouble precisely when it turned *towards*

the object of study, the folk, which was supposed to enable it to cohere. In the early part of the nineteenth century especially (but Stuart-Glennie's work shows this to be on-going), the promotion of a Greek national identity was largely the work of foreigners and expatriate bodies. In contrast, Herzfeld notes,

> It is difficult to know what the rural population thought of these developments. Their scanty acquaintance with Classical culture made it easy for European enthusiasts and western-educated Greeks to promote the ideal of a regenerated Hellas over their heads. Some historians have argued that the rural folk preserved no knowledge or memory of the Classical past at all. The rural Greeks certainly seemed to have been puzzled by the expectations which the philhellenes entertained of them, to judge from the accounts of those non-Greeks who returned to tell the tale.
>
> (Herzfeld, 1982, 15)

Polidori's arrangement in 'The Vampyre' would seem to be close to the truth here: the 'folk' seem oblivious to the classical antiquities around them – the latter being of interest only to foreigners like Aubrey. Moreover, as folklore studies moved closer to ethnography, the folk were by no means found to be the site of a pure and 'original' Greek identity. Greece was declared a nation-state in 1822, and the Turks were expelled by the end of that decade; but Turkish influences remained. The German nationalist J.P. Fallmerayer (1790–1861) outraged Hellenes by further corrupting Greek identity, claiming Slavish and Albanian influences. Ethnographic work carried out in the provinces and close to the borders only confirmed the extent of these corruptions: the folk identity seemed always already to be ethnically mixed. And intimately associated with this realisation – even, bringing this realisation into being, enabling it to be articulated – was the (re)discovery of the vampire.

GENUINE VAMPIRES

Rennell Rodd's popular study, *The Customs and Lore of Modern Greece* (1892) – partly a late Victorian travelogue, and partly an ethnographic work with scientific pretensions – depended upon a distinction between the classical and the folk for its appeal. One arrives in Greece expecting to see and examine the former; but the latter slowly makes itself visible, the longer one stays:

> It is only after a long sojourn in this land of myth and fable, of art and inspiration, and after many wanderings, that one is able to learn how, in solitary islands, in sequestered valleys . . . there lives a people who

38

seem to have preserved, in manner and in look, that old-world freshness of our dreams.

(Rodd, 1968, x)

The folk keep the ancient 'fresh', 'preserved': this is where the real Greece – the Greece of 'our dreams' – resides. Although Rodd seems familiar with the texts of modern Greek folklore – he cites the work of Johann Georg von Hahn, Nikolaos G. Politis and Charles Fauriel's influential *Chants populaires de la Grece moderne* (1825) – his own study is too 'leisurely' to engage in the various debates. Nevertheless, by focussing solely on the folk – in particular, those people living at the edges of the nation – Rodd presents a 'hitherto rather neglected' (xvi) account of the ethnically mixed nature of Greece. His remarks on the etymology of the vampire express this mixture – while wishing to maintain a sense of Greece itself as an authentic source:

> The genuine vampire is the Vourkolakas, of whom a number of stories are still current, though Colonel Leake [William Martin Leake, *Researches in Greece* (1814) and *Travels in Northern Greece* (1835)] more than fifty years ago expressed the opinion that it would be difficult in Greece to find any one who still believed in such a barbarous superstition. The Albanians call it Wurwolakas, and the name has a number of slightly varying forms in different parts of Greece. The word itself is undoubtedly of Slavonic origins, being found in Bohemia, Dalmatia, Montenegro, Servia, and Bulgaria; while it reappears as Vilkolak among the Poles, with the signification of weir-wolf (*sic*). The superstition itself is, however, of extreme antiquity, and the name only was introduced by the Slavonic immigrants.
>
> (188)

In this account, the vampire seems to be simultaneously indigenous and introduced – 'genuinely' Greek, and yet 'undoubtedly' Slavonic, nationally identified and yet leaked across the border by immigrants from the north. In the context of Hellenism, these countries are in fact related to each other in terms of purity and corruption, the genuine and the derivative. John Cuthbert Lawson's *Modern Greek Folklore and Ancient Greek Religion* (1910) – influenced by Politis' *Modern Greek Mythology* (1871, 1874) – returns to this arrangement, consolidating it through ethnographic practices and an extensive knowledge of philology. For Lawson, Macedonia was an important source for the vampire, for here 'the Greek population lives in constant touch with Slavonic people' (Lawson, 1964, 378). He spends some time trying to sort out the vampire's etymological origins: 'Is the superstition a foreign importation, or is it only partly alien and partly native?' (381). Finally he makes the following two claims:

> first, that the word *vrykolakas* was originally borrowed from the Greeks by the Slavs in the sense of 'were-wolf', though it is now almost

universally employed in the sense of 'vampire'; secondly, that whatever ideas concerning vampires the Greeks may have learnt from the Slavs, they did not adapt the Slavonic word 'vampire' but employed one of those native Greek words . . . which are still in local usage; whence it follows that some superstition anent re-animated corpses existed in Greece before the coming of the Slavs.

(383)

For Lawson, then, the Greek vampire is more original than the Slavonic vampire. And, underwriting the Hellenism at work in this study, the latter is presented as a *debasement* of the former: 'The Greeks had believed in reasonable human *revenants*; the Slavs taught them to believe in brutish, inhuman vampires' (391). In fact, Lawson's project is to recuperate a Hellenic image of the vampire that is, in effect, Romantic. He had presented the familiar thesis that the revenant had been someone excommunicated by the Church. By sanctioning excommunication, the Church thus brought vampires into existence. For Lawson, the Church was as much to blame for the debasement of modern Greece as the Slavs:

> The Devil is a Christian conception, just as the vampire is Slavonic. Both must go, if the modern superstition is to be stripped of its accretions, and the genuinely Hellenic elements discovered. What then remains? Simply the belief that the bodies of certain classes of persons did not decay away in their graves but returned there-from, and the feeling that such persons were sufferers deserving of pity.
>
> (407)

The vampire, essentially, 'suffers': this is close to the Byronic image of the vampire in 'The Giaour'. But what is interesting about this passage is that the 'modern superstition' does, finally, remain intact. Lawson does nothing to disillusion the belief: he is concerned only to establish its 'genuine' credentials. Indeed, to enable the discovery of the Hellenic ideal, the illusion of the vampire must be rendered *real*. The Turks have been driven out, the Slavish influences – along with Christianity – have been stripped away. All those Others which introduce or produce vampires have been expelled – and yet still the vampire remains. It would be tempting to say that the vampire has now come to stand for originality itself; at the same time, however, it signifies those very 'accretions' that Lawson is attempting to remove. As Rodd had noted, the vampire is both 'genuine' *and* introduced, pure and corrupted, nationally identified and alien, a 'foreign importation'. But, of course, the illusion here resides with the folk, 'the people': it is *their* originality which is being claimed and contested. The point is important for the kind of popular fiction – early vampire fiction, in this case – which depends on the one hand upon a representation of the folk or 'the people' and their lore or superstitions as original to the nation, while on the other hand moves its vampire nomadically through and across nations, letting it gather up 'accretions' as it

goes. As we saw in the previous chapter, the vampire thus both enables a national identity to cohere, and ceaselessly disturbs that identity by showing it to be always at the same time foreign to itself.

VAMPIRES AND THE UNCANNY:
LE FANU'S 'CARMILLA'

James Donald's essay 'What's at Stake in Vampire Films?' – mentioned
briefly in Chapter 1 – draws on the Gothic to diagnose contemporary
political culture. Written under Margaret Thatcher's regime in Britain, it
turns to the identity-formations enabled through fantasy texts as a means of
demonstrating the inadequacy of 'total' government, the 'impossibility of
political closure' (Donald, 1992, 121). By problematising identity, Gothic
fantasy brings about another, alternative politics, one which 'is aware of . . .
the pleasures of the confusion of boundaries' and in particular, which
engages in the 'critical manipulation and *enjoyment* of symbolic forms' (121,
my italics). Donald's dispute with Franco Moretti has already been noted; his
sense that readers enjoy fantasy texts (and his theorising of the politics of
enjoyment) contrasts markedly with Moretti's notion that the reader of
horror fiction is obliged to consent to 'normality' through the arousal of fear.
In the context of his dispute with Moretti, Donald also quotes an equally
'reductive' passage from Fredric Jameson's chapter 'Magical Narratives' in
The Political Unconscious (1981). Jameson had been discussing the genre of
romance and its ethical organisation – which (Moretti would agree) requires
an Other in order to legitimate its structures of 'power and domination':

> Evil thus, as Nietzsche taught us, continues to characterise whatever is
> radically different from me, whatever by virtue of precisely that
> difference seems to constitute a real and urgent threat to my own
> existence. So from the earliest times, the stranger from another time,
> the 'barbarian' who speaks an incomprehensible language and follows
> 'outlandish' customs, but also the woman, whose biological difference
> stimulates fantasies of castration and devoration, or in our own time,
> the avenger of accumulated resentments from some oppressed class or
> race, or else that alien being, Jew or Communist, behind whose
> apparently human features a malignant and preternatural intelligence
> is thought to lurk: these are some of the archetypal figures of the Other,
> about whom the essential point to be made is not so much that he is
> feared because he is evil; rather he is evil *because* he is Other, alien,

42

different, strange, unclean, and unfamiliar.

(Jameson, 1981, 115; cited in Donald, 1992, 102)

For Donald, the implied connections between the psychic, the historical and the 'mythic' are too neat in this passage – and so is the polarising of Self and Other, which depends on the assumption that the former is always 'coherent' and thus is always *able* to identify that which is different to it. He turns firstly to Tzvetan Todorov's account of 'the fantastic' (Todorov, 1973) to complicate the picture. Todorov had defined 'the fantastic' in terms of the reader's (and the protagonist's) hesitation over the unfamiliar nature of certain events involving supernatural occurances. Can they be explained, or not? Are they an illusion, or will the text eventually bring about disillusion? Because nothing is resolved in 'the fantastic', one can never properly identify the Other as Evil, so that the Self is unable to rest in the security of Jameson's polarisation.

In fact, the early part of *Dracula* works in this way, with Jonathan Harker wondering – as he stumbles across various strange goings-on in Dracula's castle – whether he is dreaming or awake, trying unsuccessfully to unpick 'facts' from 'nocturnal imaginings' (Stoker, 1988, 33). Harker becomes increasingly *incoherent* – until his diary entries, at last, come to an end. Moreover, the differences between Self and Other begin to collapse – through mimicry, for example, or the exchanging of places. Thus, Harker is surprised to see Dracula emerge from his window wearing his (Harker's) clothes; shortly afterwards, a woman from the village sees Harker at the window and identifies *him* as the vampire: 'Monster, give me my child!' (44–5). The novel does go on to establish Dracula's difference as an alien or a stranger with 'real' supernatural power – so that, in Todorov's generic scheme, it slides into 'the marvellous'. It does this by moving away from Harker's incoherence – away from his diary and the uncertainties that reside there – offering instead a context of reportage and diagnosis in which the vampire's identity (Other) and the identity of those who see it (Self) can be more or less stabilised. But it is still possible to read the vampire as a Self-image, a means of figuring socio-political-sexual excesses which, although represented as foreign, actually lie much closer to home. 'The fantastic' in fact draws Self and Other together, showing the boundaries between them to be fragile and easily traversed. In 'the fantastic', the Self is thus ontologically destabilised by an Other which, far from being different, turns out instead to be disconcertingly familiar.

FREUD'S 'THE "UNCANNY"'

Donald's discussion then shifts from Todorov's 'the fantastic' to Freud's 'the "uncanny"': it is here that the route from the unfamiliar to the familiar is charted. Freud had defined the uncanny as 'that class of the frightening which leads back to what is known of old and long familiar' (Freud, 1987,

340). His essay begins, famously, by noting the convergence of the two apparently opposite German words, *unheimlich* (unfamiliar) and *heimlich* (familiar): they coincide around a sense of 'something hidden and dangerous', particularly in relation to sexual knowledge. Something seems unfamiliar only because one has 'alienated' it – repressed it – from consciousness, so that its (re)appearance or (re)animation provokes anxiety. After analysing a number of texts and events through which 'the distinction between imagination and reality is effaced' (367), Freud comes to a conclusion which stands with one foot in the psyche and the other in ethnography and folklore studies: 'an uncanny experience occurs either when infantile complexes which have been repressed are once more revived by some impression, or when primitive beliefs which have been surmounted seem once more to be confirmed' (372). For Donald, however – drawing on Hélène Cixous's critique of 'The "Uncanny"' (Cixous, 1976) – Freud's neat resolution prevents him from analysing just how unstable the 'in between' state can be: the boundaries *dividing* imagination and reality, the animate and the inanimate, the living and the dead, can never be properly distinguished. The uncanny is precisely this 'dubious' in-between condition where, in Cixous's words, there is *'a bit too much* death in life, *a bit too much* life in death'* (cited in Donald, 1992, 108, my italics).

'The "Uncanny"' has influenced much contemporary theorising about horror fiction and fantasy (see also Jackson (1981) and Monleon (1990)). I shall return to some particular uses of this essay shortly; in the meantime, it can be used to introduce a vampire story which will become the focus of this chapter. J. Sheridan Le Fanu's 'Carmilla' was included in his famous collection of horror stories, *In a Glass Darkly* (1872). The stories in this collection are presented as 'case histories', told privately in the first instance to Dr Hesselius – a sort of pre-Freudian psychoanalyst or 'metaphysician' who is now dead – but since made public, as the 'editor' remarks, for the interest of the 'laity'. 'Carmilla' is narrated by Laura, who lives with her widowed father in a castle beside a 'picturesque' forest in Styria, an older designation of Slovenia – also the setting, incidentally, for Stoker's short story, 'Dracula's Guest' (1914). Laura and her father are, however, bourgeois rather than aristocratic: the castle was a 'bargain' and their income is small.

Laura, who is 19 as she relates her history, recalls the 'first occurence in my existence, which produced a terrible impression upon my mind' (Le Fanu, 1988, 74) – a trauma which took place when she was 6 and still in the nursery. Aware at one point that the nursery-maid has left her alone, Laura becomes agitated; she is surprised, however, to see a 'pretty lady' leaning over her bed, who soothes her to sleep. Soon afterwards, Laura awakens with the sensation of two needles pushing into her breast, causing her to cry out: 'The lady started back, with her eyes fixed on me, and then slipped down upon the floor, and, as I thought, hid herself under the bed' (74). Much later – in her

44

adolescence – Laura and her father witness a coach accident. An older woman begs them to look after her 'lifeless' young daughter – Carmilla Karnstein – and Laura's father, perhaps too readily, agrees. Laura immediately recognises her: 'I saw the very face which had visited me in my childhood at night, which remained so fixed in my memory, and on which I had for so many years so often ruminated with horror, when no one suspected of what I was thinking' (85).

Carmilla, then, is not known to Laura – but she is *recognised*, she is familiar. Interestingly, the story goes on to mirror this uncanny effect: Carmilla recognises Laura, too, from a dream *she* had 'twelve years ago' (85), so that, ultimately, it is difficult to tell who has been haunting who. The two girls become, quite literally, familiar with each other – Laura wonders, at one point, if they are actually related. The story then provides a number of variations on this theme of recognition-without-knowing. Laura and her father meet an old friend, General Spielsdorf, after ten months' absence. But he seems strangely unrecognisable to them, as if 'time had sufficed to make an alteration of years in his appearance' (115). The General himself produces an uncanny effect when he tells the story of how he had met an older woman and her daughter at a masquerade: by creating a distance between his listeners and the event, he enables Laura and her father to recognise what had recently happened to *them*. (This point is worth noting: that the General's story inhabits the host story which Laura tells, in order to make the latter more familiar to itself. A structural connection is produced here with the theme of 'Carmilla', where fathers and daughters play host to vampires, who inhabit their homes as guests. In this sense, the vampires likewise enable the hosts to become more familiar with themselves.[1]) But there is also something unrecognisable which occurs in the General's story. The General and his daughter (oddly enough) do not wear masks at the masquerade; but the older woman does, so that her identity remains unknown. She claims, however, to have known the General – perhaps, even, in a sexual sense:

> Availing herself of the privilege of her mask, she turned to me, and in the tone of an old friend, and calling me by my name, opened a conversation with me, which piqued my curiosity a good deal. She referred to many scenes where she had met me – at Court, and at distinguished houses. She alluded to little incidents which I had long ceased to think of, but which, I found, had only lain in abeyance in my memory, for *they instantly started into life at her touch*.
>
> (119, my italics)

Carmilla had been recognised, but not known. In this case, however, the woman is known but not recognised – she is (or has been) familiar with, rather than to, the General – and she enables him to recall that familiarity. The vampires, although they are supposed to bring about death, thus also

45

have an animating function: the General is more alive with the older woman than he otherwise was. Indeed, she literally brings him *back* to life with 'her touch' in the above passage. The knowledge she possesses – and he shares – may well be explained through the uncanny convergence of *unheimlich* (the unfamiliar, the foreign) and *heimlich* (familiar, closer to home). Like Laura's father, the General is widowed: the wife and mother in both the main story and the General's inserted story is effaced or repressed. In each case, she returns with a daughter to produce this uncanny effect. Indeed, Laura's original waking dream in the nursery reads in this context very much like a trauma of *separation* from the mother – who remains, for her at least, forever young and pretty – not different at all but, like the portraits she sees of Carmilla's ancestors, the Karnsteins, always the same. Interestingly, Laura is herself connected to the Karnsteins on her mother's side; and the General's 'dear wife' was also 'maternally descended from the Karnsteins' (116). The story clearly draws a connection between (dead) mothers and vampires: mothers are ruled out of the story proper, but return as the undead, with knowledges (about fathers) which remain always subtextual. Laura's mother is recalled only once in the story, in a dream – where her words to Laura, 'Your mother warns you to beware of the assassin', are followed by the appearance of Carmilla at the foot of the bed, 'bathed . . . in one great stain of blood' (106). The ambiguity of the mother's warning is worth noting: it may refer to Carmilla herself, or (more likely) it may refer to those who would seek to *kill* Carmilla, men like Laura's father and the General. The mother becomes, in effect, identified with Carmilla. And certainly, both their stories are the 'unspeakable' component of the narrative – as Carmilla tells Laura at one point, 'I dare not tell my story yet, even to you' (100).

THE SUBLIME

I shall return to 'Carmilla' shortly; but my account of James Donald's important essay is, as it stands, incomplete. Donald had begun by moving from Todorov's 'the fantastic' to Freud's 'The "Uncanny"'; he then shifts his focus a second time, from the uncanny to the sublime. His remarks draw on David B. Morris's influential essay, 'Gothic Sublimity' (1985), which had outlined Edmund Burke's influential conception of the sublime as an arousal of terror through the evocation of 'immensity' – a conception against which much Gothic fiction is conventionally read negatively, as if, here, the sublime is debased or 'patched together' (301). Morris, however, offers (rightly or wrongly) a different distinction between the Burkean sublime and the Gothic sublime. The former is based on 'a narrow, mechanical account of bodily processes' (301) which sees the causes of terror as exterior, abstract and universalised (Nature, or death). It amounts to a 'flight from psychology' (301–2), a refusal to theorise individual motivations and compulsions,

46

especially desire. The threat of a loss of control was implied, but always restrained (or repressed). In Gothic fiction, however, the connection be-tween individual desire and the sublime is central to the evocation of terror:

> In exploring the entanglements of love and terror, the Gothic novel pursues a version of the sublime utterly without transcendence. It is a vertiginous and plunging – not a soaring – sublime, which takes us deep within rather than far beyond the human sphere. . . . Gothic sublimity – by releasing into fiction images and desires long suppressed, deeply hidden, forced into silence – greatly intensifies the dangers of an uncontrollable release from restraint.
>
> (306)

Thus, for Morris, Gothic fiction is transgressive. He goes on – inevitably, perhaps – to draw on Freud's 'The "Uncanny"': the Gothic or Romantic sublime produces an uncanny effect, rendering something simultaneously familiar and strange, recognised and unknowable. And it does this at the level of language itself: it employs 'representation as a means of expressing and of evoking what cannot be represented . . . of what lies outside language' (311, 313). Because meaning is made unstable in this way, Gothic fiction can never be read allegorically: certainly its uncanny figures are 'substitutes' for something else, but that something else is always (*in* itself) excessive to representation.

Donald uses Morris's juxtaposition of the Burkean and the Gothic sublime to distinguish between high culture (philosophy) and popular or mass culture. The Gothic sublime is 'the low road' (Donald, 1992, 110), bringing irrationality and the unspeakable into 'everyday life' through melodrama, horror films and so on. Donald then turns to Jean-François Lyotard (hardly a champion of popular culture) for a contemporary account of the sublime. Lyotard's neo-Kantian account had emphasised the sub-lime's ability to destabilise our own relations to each other. It challenges the kind of aesthetic judgement which presupposes a shared and mutually comprehended community of taste, ideas, etc. – a community with which we are *familiar*. By turning judgement into a problem, it makes us long for just such a community – a sense of 'the people' as a stable, coherent body, to which we belong – but also enables us to recognise that it is an unrealisable ideal. For Donald, the 'popular sublime' – in particular, as it operates in horror texts – is symptomatic in this respect. Certainly these texts make themselves familiar to us in a number of ways; they do this, often, by actually presenting a community of people, characters, whom we can 'recognise' (think, for example, of horror films such as Ridley Scott's *Alien* (1979) or John Carpenter's *The Thing* (1982)). But they also evoke 'anxiety, irra-tionality and death' (119): they introduce things that fracture the community rather than hold it together. This is where their uncanny effect – their terror – is located. They thrive on the tension generated by on the one hand

gesturing towards a familiar (that is, often appealed to) image of 'the people' as, for example, nationally coherent – 'the people as an archaic myth of origins' (120) – while, on the other hand, fissuring that image from within by evoking what would seem to be unfamiliar – the unspeakable, the incoherent, the inexplicable.

COPJEC AND DOLAR:
THE LACANIAN GOTHIC

Recently, a number of Lacanians – some from Slovenia, as it happens – have turned to popular culture in order to elaborate their post-Freudian theories. Joan Copjec, Mladen Dolar and, most prolifically, Slavoj Žižek have focussed in particular on Gothic horror, science fiction, melodrama and Hitchcock's suspense films, turning to these forms precisely *because* of their 'uncanny' effects and their evocation of the sublime. These critics have all, at one point or another, had something to say about vampires. Their work is important enough to comment upon here at length, and I shall begin with Copjec's provocatively titled article, 'Vampires, Breast-Feeding, and Anxiety' (1991).

As with Donald's essay, Copjec in fact barely mentions vampire fiction in the course of her argument: it is there as a kind of ideal, an imaginary text. She is concerned with the Romantic uses of the Gothic – discussing *Frankenstein* towards the end – but her analyses are better addressed to late Victorian vampire fiction, 'Carmilla' and *Dracula* in particular, for reasons which will become clear shortly. Copjec begins by thinking about anxiety – a condition which contact with vampires brings about. Anxiety is located as somehow 'original', 'the most primitive of phenomena' (Copjec, 1991, 26): nothing precedes it, and nothing – no perceived 'lack', for instance – causes it. As such, it is therefore not a 'signifier' – for if it were, its 'meaning could be doubted' (26). Rather, it is a kind of pre-Oedipal *affect*: it exists before symbolisation, before one's entry into the symbolic order and one's constitution therein as a subject (through language, through the 'Law of the Father', etc.). In other words, anxiety signals the Real in Lacanian terms. But anxiety is actually *felt* in the symbolic order (we might also see this, as Žižek does, as the realm of ideology – wherein one is constituted as a subject). A certain management of anxiety thus takes place, and Copjec's account of this process is typical of the Slovenian Lacanian school. In order to evict the Real/anxiety, the symbolic must *speak* its eviction. By doing so, far from negating it, the symbolic inevitably includes or incorporates the Real – what it is *not* – in its own formation. For Copjec, what is at stake is signification itself:

> It should be evident right away that this negation of the real by the symbolic presents a special problem. The real that is to be negated cannot be represented by a signifier, since the real is, by definition, that

which *has* no adequate signifier. How, then, can this negation take place *within* the symbolic as the requirement demands? The answer is: through repetition, through the signifier's repeated attempt – and failure – to designate itself. The signifier's difference from itself, its radical inability to signify itself, causes it to turn in circles around the real that is lacking in it. It is in this way – in the circumscription of the real – that its non-existence or its negation is signified *within* the symbolic.

(28)

The problem outlined here recalls the discussion of the uncanny and the sublime above. Here, however, the unfamiliar/the unspeakable/the Real is able to be *managed* by the symbolic. Perhaps this is why Copjec focusses on anxiety, rather than, say, terror. Her example of this process of management is a dream involving Freud himself and a woman, Irma. In the first part of this dream, Freud examines the woman, peering down her throat to discover 'the very "origin of the world"' – that is, the Real, 'what ought to have remained hidden' (27). In the second part of the dream, Freud's anxiety is dispelled when he talks over his discovery with his fellow doctors. These 'paternal figures', with their various rules and regulations for diagnosis, provide a familiar space which Freud can inhabit *without* anxiety. Together, they erect a defence against the Real by discussing it, by giving it signification.

Le Fanu's 'Carmilla', and *Dracula*, too, work in the same way: these Victorian vampire narratives spend more time diagnosing the vampire than showing it at first hand, introducing a number of 'paternal figures' – often doctors – into the story for exactly this purpose. General Spielsdorf in 'Carmilla' has already been mentioned. There is also the similarly-named Dr Spielsberg, who examines Laura; there are two physicians in the General's story; there is the mysterious and 'fantastic' scholar, Baron Vordenburg, who cites a number of other 'judicial' authorities into the bargain – and there is Dr Hesselius as well, to whom Laura's case history is directed. These men consult with one another, ruminating together privately, away from Laura's hearing, before they come to their conclusion. No wonder Carmilla tells Laura, 'Doctors never did me any good' (Ryan, 1988, 95)! The men in fact form a kind of bureaucracy which signifies Carmilla *as* a vampire precisely in order to manage the threat – and, eventually, to destroy it. An important passage in the story gives this point expression in a startling way:

If human testimony, taken with every care and solemnity, judicially, before commissions innumerable, each consisting of many members, all chosen for integrity and intelligence, and constituting reports more voluminous perhaps that [*sic*] exist upon any one other class of cases, is

worth anything, it is difficult to deny, or even to doubt the existence of such a phenomenon as the vampire.

(134)

The passage reformulates Copjec's account of the symbolic's management/negation of the Real through repetition – that is, 'through the signifier's repeated attempt – and failure – to designate *itself*'. In order to signify the vampire, a bureaucracy without end ('innumerable', 'voluminous') comes into being, hearing the same kind of testimony over and over again. At length, it is 'difficult' to doubt the vampire – but not impossible. Doubts still remain and still more testimonies, it is implied, must be heard. In Copjec's Lacanian terms, the symbolic – paternal figures, doctors, the judiciary or the law (in the above quote), bureaucracy – becomes itself to itself *because* of the Real, which is the original Thing (just as the vampire is 'ancient'). Yet the Real is always in excess of the symbolic, no matter how often signification repeats itself. The symbolic endlessly 'circles around the real that is lacking in it', never able completely to cohere as a total system. And the institutionalisation of doubt – through this 'endless' circling, through hearing more testimonies and accumulating more documents – is important to this scheme. Eventually, doubt is in effect *the* defence against the Real and the anxiety it generates since, by continually deferring belief, the system ensures its own continuance, if nothing else.

It should be clear now why Copjec's scheme is more applicable to later Victorian vampire fiction than to Romantic vampire narratives such as Polidori's 'The Vampyre'. Aubrey has no one to consult with about vampires; there is no available symbolic – no 'bureaucracy' of 'paternal figures' – through which the vampire can be diagnosed and managed. Indeed, Polidori's story is about the *inability* to testify to the vampire, since Aubrey is under an oath to remain silent about Lord Ruthven. Without an available bureaucratic structure to manage the vampire and give it signification, Polidori's story maintains its level of anxiety right to the end – with the vampire (and this would never happen in Victorian vampire fiction) triumphing and leaving the scene unharmed – remaining, in a sense, unsignified.

These remarks on 'paternal figures' and symbolic management have obscured the unusual but central connection Copjec draws in her article between vampires and breast-feeding, a connection which requires some comment here. Of course, the vampire is a creature who sucks and for whom sucking is sometimes pleasurable. It conventionally sucks at the neck – although in 'Carmilla', Laura feels 'needles' entering her *breasts* after seeing Carmilla in her bedroom. (Is this an image of the closeness of their bonding? That is, are they knitted together?) An infant also bears such a close, oral relation to another person's body – but although the mother may invoke vampirish images to describe the process (being 'drained', etc.), the image of the sucking infant at the breast does not in itself usually produce anxiety. In fact, for Copjec, anxiety comes only *after* the breast has been drained, that

50

is, when it no longer functions as a fantasy support for the infant, as its 'object-cause of desire' (Copjec, 1991, 34). The breast is both familiar, even interior, to the infant; and yet it is now also other, unfamiliar, a part of someone else's body. It is designated as *extimate* – residing 'within' us, and yet foreign to us.

In Lacanian psychoanalysis, one separates oneself from the breast in order to become a subject, but in doing so it must be recognised that what was a part of oneself is now other to oneself. Subjectivity and anxiety are thus intimately related; in order to become more 'at home' in our bodies, anxiety is managed only by maintaining a *distance* from the breast-as-it-was, by figuring the breast as a 'lost part of ourselves' about which we say nothing. But 'whenever we too closely approach the extimate object in ourselves', an uncanny effect is realised: that extimate object now belongs to 'a complete body, an almost exact double of our own, except for the fact that this double is endowed with the object which we sacrificed in order to become subjects' (35).

For Copjec, vampire fiction takes up this uncanny doubling and distorts it through the vampire itself. Her example – and it is a powerful one – is 'that horrifyingly obscene moment' (36) in *Dracula* when Van Helsing and the others burst into the Harkers' bedroom and witness Mina sucking blood from a wound in Dracula's 'bare breast' (Stoker, 1988, 282), a scene I shall discuss at length in Chapter 4. This 'distortion' of the breast – where the familiar activity of breast-feeding is now rendered radically unfamiliar – figures it as an excess, the source of an illicit and 'unnatural' pleasure or *jouissance*. Copjec reads the scene as, in itself, transgressive: 'Desire, society itself, is endangered by Mina's intimacy with this extimate object' (Copjec, 1991, 36). What follows this scene is a series of attempts by the 'paternal figures' – Dr Seward, Van Helsing and the others – to manage, i.e., incorporate, this danger.

Copjec's argument is a psychoanalytic version of the Foucauldian and now widespread notion of the Enlightenment or modernity – that, in order to define itself as the 'Age of Reason' in which individuals could think for themselves, etc., it needed to identify *unreason*.[2] Having done so, it then ceaselessly threatened individual autonomy by ensuring that more institutions, more disciplinary structures, more bureaucracies existed than ever before; but it was in turn ceaselessly threatened by the limits it had set for itself in order to come into being. Both threats are narrativised in Gothic fiction – which shows unreason inhabiting Reason rather than as Other to it. Gothic fiction thus speaks for modernity; its anxieties are *modern* anxieties. The point is also made in Mladen Dolar's article, '"I Shall Be with You on Your Wedding Night": Lacan and the Uncanny'. For Dolar, the uncanny lies at the 'core' of psychoanalysis; moreover, it arises out of the 'particular historical rupture brought about by the Enlightenment' (Dolar, 1991, 7), which desanctified the premodern equivalent of the uncanny – the sacred or

untouchable place. Society founded itself upon the exclusion of this sacred place – thus rendering it *unplaceable*, always liable to 'return' to haunt society. The coincidence of the Enlightenment and the rise of Gothic fiction is explained through this 'return': 'Popular culture, always extremely sensitive to the historical shifts, took successful hold of it – witness the immense popularity of Gothic fiction and its romantic aftermath' (7). Thus, the uncanny effect is far from 'primitive' in its origins, as Freud would have it. Rather, it is brought into existence by modernity itself. In Dolar's words, the uncanny – we could substitute 'vampire' – 'is most intimately linked with and produced by the rise of modernity. What seems to be a leftover is actually a product of modernity, its counterpart' (7).

Two of Dolar's arguments are worth elaborating here, because they engage with ways of reading the vampire which have already been discussed. Like Copjec – and Slavoj Žižek, as we shall shortly see – he figures the vampire, or Gothic monstrosities generally, as an excess, a surplus in an otherwise coherent system of identification. Since the Enlightenment took upon itself the project of giving meaning to all things in order to rationalise the world and thus to cohere its own identity, the vampire is excessive in this respect, too – that is, excessive to meaning itself. Dolar thus takes issue with Franco Moretti's allegorical reading of the vampire – and the monster in *Frankenstein* (the quote in his title is taken from this novel) – in a passage which might also be read against the quotation at the beginning of this chapter from Fredric Jameson:

> It is not that these interpretations are not correct; they are all plausible, and evidence can be found to support them. The point where the monster emerges is always immediately seized by an overwhelming amount of meaning – and that is valid for the whole subsequent gallery of monsters, vampires, aliens, etc. It has immediate social and ideological connotations. The monster can stand for everything that our culture has to repress – the proletariat, sexuality, other cultures, alternative ways of living, heterogeneity, the Other. There is a certain arbitrariness in the content that can be projected onto this point, and there are many attempts to reduce the uncanny to just this content. The important thing from a Lacanian point of view, however, is that while this content is indeed always present in the uncanny to a greater or lesser degree, it doesn't constitute it.
>
> (19)

Dolar returns to the Lacanian formula: the uncanny is always 'at stake' in ideology, which ceaselessly tries to integrate it, to make it familiar to itself in order to be rid of it. Psychoanalysis, which locates the uncanny at its 'core', is distinguished here in that – far from trying to interpret the uncanny – it maintains it '*as a limit to interpretation*' (19). Dolar's account thus turns psychoanalysis itself into 'the ultimate horror story' (23) – more Gothic than

Gothic fiction. But the argument here is closer to Moretti and Jameson than it would seem to imagine, since it reproduces the Self/Other polarity by representing the uncanny as simply another Thing in a chain of Things to be repressed. The complicated mutual inhabitation of the familiar and the unfamiliar is forgotten here; Dolar emphasises the ideological drive to make the unfamiliar seem familiar, whereas in Freud's essay the unfamiliar is *already* familiar. Moreover, Dolar relies on a view of ideology as *fundamentally* repressive and exclusive, a view that Foucault amongst others has thoroughly critiqued.

Dolar's second argument is of interest because it takes up Todorov's account of 'the fantastic', and returns us to the problem of belief in vampire fiction. For Todorov, fantastic literature had depended upon a 'hesitation' or 'uncertainty' in the reader – an anxiety, perhaps, in Copjec's terms. It might be expressed as: 'I normally don't believe such things . . . but I cannot be sure one way or the other.' Or, in short: 'I don't believe . . . but I also don't know.' Many horror stories, however, do not require the reader to hesitate at all. After a certain point in Stoker's novel, there is no doubt that Dracula is a vampire – yet he may still produce an uncanny effect. In this case, the relation of knowledge to belief is changed: it can be expressed as: 'I know there are no vampires . . . but I believe in them.' Or, in short: 'I know . . . but I believe.' For Dolar, the former is a conscious negation, while the latter is an unconscious affirmation – so that this is a truer expression of the uncanny. We can recall Copjec's point about the originality of anxiety – it is so original that it *cannot* be doubted. Dolar takes up this point, distinguishing the relations between knowledge and (un)certainty noted above from 'the terrible certainty on the level of the object' (22). This is realised in horror fiction in an arrangement which is opposite to Todorov's 'the fantastic': that is, when 'what is horrible is that one knows in advance precisely what is bound to happen, and it happens' (22). This is now a conscious *affirmation*. One may respond, however, by attempting to negate it at an unconscious level, not wishing to believe that what one knows is unavoidable will happen. So this final response can be expressed as, 'I don't (want to) believe . . . yet I am certain.' For Dolar, then, the uncanny also arises from too *much* certainty, 'when escape through hesitation is no longer possible, when the object comes too close' (23). One's subjectivity would be 'annihilated' by this proximity; but, as Copjec had noted, the uncanny can be managed through the maintenance of doubt at the institutional or bureaucratic level – where, precisely *because* one has testified to it, because it has been spoken and thus signified, further testimonies must follow and so it can no longer be believed outright.

In fact, this combination of 'terrible certainty' and bureaucratised doubt is at work in a split common to Victorian vampire fiction. In 'Carmilla', Laura's father is bourgeois and modern: like some of the doctors in the story, he does not believe in vampires. But the 'paternal figures' who diagnose Laura are

[Margin note, handwritten:] Carmilla – only vampire because this is being labelled this by men at end of ... be getting rid of.

patriarchal
'terrible
certainty'

mobilised by much older men who are shown to have had the kind of close proximity to vampires Dolar describes: the aging General (who, as already noted, is related by marriage to the Karnsteins), the Moravian nobleman (who was Carmilla's lover long ago), the old woodsman (who represents an original 'folk' which has worked in the forest for countless generations) and the 'ancient' Baron Vordenborg. We might see these men as patriarchal rather than paternal – aristocratic or feudal, rather than bourgeois and modern. Their 'terrible certainty' mobilises Laura's father and the other doubters – and eventually the vampire, Carmilla, is brutally executed. The General actually draws attention to Laura's father's non-belief before he relates his strange story: 'you believe in nothing but what consists with your own prejudices and illusions. I remember when I was like you, but I have learned better' (Le Fanu, 1988, 115). In this context, the 'illusion' is ideology itself; the General's story *disillusions* that illusion to produce in Laura's father the 'terrible certainty' – vampires are real – that is needed to destroy Carmilla. One might note, of course, that it does so only to re-establish that illusion at another level: it *is* an illusion (i.e., it is ideological) that vampires exist, but it is necessary to believe it in order for the men to rid themselves of a perceived threat. Thus ideology itself requires the kind of belief Copjec and Dolar would ascribe only to the object, the Real; it may be flexible enough to cohere (to believe with a 'terrible certainty') and be incoherent (to continue to doubt, to bureaucratise doubt) simultaneously.

A similar arrangement is at work in *Dracula*, and it is worth spending a moment here to comment on it. Van Helsing's 'open mind' enables him to believe in vampires with the kind of 'terrible certainty' just mentioned; and for his project to succeed, he must mobilise the same level of belief in his younger colleagues. He explains at one point to Dr Seward:

> 'My thesis is this: I want you to believe.'
> 'To believe what?'
> 'To believe in things that you cannot. Let me illustrate. I heard once of an American who so deemed faith: "that which enables us to believe things which we know to be untrue". For one, I follow that man. He meant that we shall have an open mind.'

> (Stoker, 1988, 193)

Van Helsing's pursuit of the 'big truth' (193) – that the illusion of vampires is real – is, of course, ideological: it shows that his mind is *closed* rather than open. He is another patriarchal figure who tries to mobilise the young into believing in illusions. But not every patriarchal figure in *Dracula* works in this way. Old Mr Swales is one of those neglected minor characters who in fact plays an important role in the novel. He talks to Lucy and Mina as they sit together beside a graveyard in Whitby. And his task is, precisely, to *disillusion* them: they are shocked to hear him say that the epitaphs on the tombstones in the graveyard are nothing but 'lies'. Mr Swales gives two

examples. The first is an epitaph which says that the grave contains the body of a master mariner who was murdered by pirates – whereas, in fact, the grave is empty. The second tombstone says that a widowed mother grieves for her son, who died falling off some rocks. But Mr Swales informs them, 'the sorrowin' mother was a hell-cat that hated him because he was acrewk'd – a regular lamiter he was – an' he hated her so that he committed suicide in order that she mightn't get an insurance she put on his life' (67). Van Helsing asks that we believe in the truth of illusions; Mr Swales shows us that truth *is* an illusion. Graves are empty, and happy families are in fact unhappy: Lucy is disillusioned enough by all this to change the subject. It would seem, then, that Van Helsing and Mr Swales are opposite characters: the former claims that 'doubting' is Dracula's 'greatest strength' (321), while the latter *embodies* doubt. (Mr Swales, incidentally, is Dracula's first victim in England, as if his disillusionary function is too much even for the vampire to bear!) And yet, in a sense, these patriarchs are two sides of the same coin, since they both eventually replace belief with 'terrible certainty' – Van Helsing's 'faith' and Mr Swales's matter-of-factness. They both do not need to believe, because they know.

SLAVOJ ŽIŽEK AND THE VAMPIRES

The work of Slavoj Žižek is too extensive and sophisticated even to begin to do justice to it here – but in the light of the above remarks on belief and ideology, some further points can be made. His book, *The Sublime Object of Ideology* (1989), gave us the Lacanian structure already described – that the Real (the 'sublime object') is always a surplus, in excess of the symbolic or of ideology – but it was less inclined to polarise the two. If ideology were an 'illusion' (i.e., false consciousness) and the Real was reality, then Dolar's second equation would apply: 'I know there are no vampires/ideology is not true, but I believe in them/it anyway.' For Žižek, however, reality is *already* its own illusion, already ideological. He gives the example of the Law, the judiciary: we may not believe in it at one level (we know it often does not work, it is not concerned with 'truth', etc.), but in a fundamental sense we already believe precisely because it is what it is, the Law. Indeed, the Law's perceived 'irrationality' may be the very condition which produces our belief in and obedience to it. Its 'irrationality' is the surplus or leftover which both enables us to doubt it and ensures that we *continue* to believe. This surplus 'irrationality' is the Real: its function is to maintain the illusion of reality.

The testimonies concerning vampires in that striking passage in 'Carmilla' express this necessarily 'irrational' component of the Law. Any authority or authority-figure is shown to be similarly 'irrational'. Think, for example, of the General; but think, also, of his story. He is a figure of authority, certainly; however, his story does not *require* belief or assent from Laura's father. That is, in itself the story has no authority outside of the fact that it is

what it is; moreover, as with the Law, it actually throws reality and illusion, truth and disguise, into question. There is room in it for doubt, as the General notes before he begins it, but Laura's father believes in it because he *already* believes: the story simply gives back to him what he already knows is true. It does not upset his 'illusions' at all by appearing so irrational; its irrationality, in fact, is exactly what confirms them. The General's story works, paradoxically, by putting Laura's father into closer proximity with Carmilla than he 'really' was: far from 'annihilating' his subjectivity (in Dolar's terms), there is no more effective way of cohering it, of mobilising his belief in an ideological fantasy.

Žižek turns to vampire fiction in his more recent publication, *For They Know Not What They Do: Enjoyment as a Political Factor* (1991). Here, as elsewhere, he discusses philosophy and popular culture together in a kind of democratising strategy which would seem to break down the distinctions between high theory and low culture – although the latter is used always to 'illustrate' the former. Thus, for Žižek, a discussion of Kantian ethics provides the base for a superstructural account of vampire fiction. For Kant, we behave ethically because God (God-as-Thing, as real) has never disclosed Himself to us, because his inaccessibility has been preserved. If we ever did come to know what God 'thinks', we could no longer behave ethically because there would no longer be any need to. The equation would then read: 'I know, therefore I need no longer believe.' One can never bridge the distance between 'I think' and 'the Thing [e.g. God] that thinks'. To do so, in the apocalyptic terms of these Lacanians, would be 'catastrophic' – although we might note that this kind of knowledge is not unusual: the paranoiac bridges this distance, a point I shall take up in Chapter 7; so does the fundamentalist. For Žižek, however, 'the apparitions in the Gothic novels are precisely this: *Things that think*' (Žižek, 1991, 220). Žižek's example is, inevitably, from *Dracula* – the 'typical' scene (as he puts it) in which Lucy, now a vampire, is killed by her fiancé Arthur, who drives a stake through her heart:

> The Thing in the coffin writhed; and a hideous, blood-curdling screech came from the opened red lips. The body shook and quivered and twisted in wild contortions; the sharp white teeth champed together till the lips were cut and the mouth was smeared with a crimson foam.
>
> (Stoker, 1988, 216)

For Žižek, the scene shows the 'desperate resistance of the Thing, of enjoyment fighting not to be evacuated from the body' (Žižek, 1991, 220). The vampire-Thing is thus excessive in this respect, something *more* than ideology: 'The paradox of the vampires is that, precisely as "living dead", they are *far more alive* than us, mortified by the symbolic network . . . the real "living dead" are we, common mortals, condemned to vegetate in the Symbolic' (221). The vampire is, in effect, 'the return of the real' – a

conclusion that is, however, not very far away from Robin Wood's classically Freudian reading of monsters in American horror films, that they symbolise 'the return of the repressed' (see Wood, 1985).

It might seem churlish to point out, here, that although Lucy dies 'excessively' in Stoker's novel, Dracula himself dies very quietly indeed – simply turning to dust, without a murmur. Christopher Craft has noted that Lucy's 'climax' in death contrasts markedly with the 'disappointing anti-climax' of Dracula's death at the end of the novel (Craft, 1990, 233). For the novel's 'King Vampire', death and cremation (a technology established, incidentally, in the 1870s) occur together: far from showing a 'desperate resistance', the body is in fact instantaneously disposed of. So why is it that Lucy dies in one way ('excessively'), and Dracula dies in quite another (insignificantly)? The point is worth pursuing since, in Žižek's project, for which all vampires (and all vampire fiction) are the same, what is never addressed is the question of sexual *difference*. Indeed, in their account of an abstracted Real, Copjec, Dolar and Žižek each completely bypass this topic. It is not just that every Gothic text is reduced to the same structure (producing the uncanny effect, showing the 'return of the Real', etc.); it is also that this structure relies on the abstraction of desire as fundamentally heterosexual – so that, for Copjec, the vampire, who sucks, is always by implication male, while the victim is always female (see Copjec, 1991, 34n). The reading of the vampire as an 'excess' is, for me at least, highly appealing; so is the reading which connects the vampire to the 'uncanny' – indeed, it is important to arguments elsewhere in this book. Nevertheless, as they are formulated by these Slovenian Lacanians, such readings are unnecessarily constrained by a (conscious or otherwise) 'normalisation' of sexuality. Certainly Copjec had looked at sexual 'distortions' in *Dracula*, turning to the scene in which the Crew of Light break in to Mina's bedroom and see her sucking the blood from Dracula's breast. But by viewing this *as* a 'distortion', 'normalisation' is allowed to recover – more so, perhaps, than it does in the novel itself. By showing the scene to be deviant, a dominant mode of sexuality, heterosexuality, is left intact – in spite of the claims for this scene as 'transgressive'.

For Copjec, the scene is somehow outside the symbolic, beyond significa-tion. It may be, however, that the scene is shocking not because it refuses signification altogether but because it is, as it were, *under*signified, under-coded (which would still account for the agitation amongst the various 'paternal figures' as they go about diagnosing it). The uncanny can certainly reside here – in a scene which is familiar in its unfamiliarity, normal (after all, Dr Seward is immediately led to think of a child making his or her kitten drink from a saucer of milk) in its 'queerness'. This undersignification may not imply an act of repression, however, so much as an inability to access certain codes precisely *because* the 'normal' and the 'deviant' have been polarised – with the latter being always subordinated to the former by

depending upon it for its very articulation. That is, one can only comprehend 'deviancy' through the discourses of 'normal' sexual practices. Since late Victorian vampire fiction is so densely populated with 'paternal figures', these discourses tend to prevail and 'deviancy' is thus registered as shocking; but we need not surrender to this narrativised response in our own readings. If these 'queer' scenes are undercoded, then part of the pleasure of reading lies in retrieving those codes and giving the scenes a 'significance' they do not appear to have in the text itself – and certainly, as we shall see in Chapter 4, those scenes involving 'queer' sexual exchanges in *Dracula* have been the most heavily interpreted of all.

The Lacanians have done this by reproducing the shock-effect already articulated in the scene itself: normality 'flees' the deviant in order to maintain its coherence. But there is no room here for a reading which turns *towards* the 'queerness' of such a scene, seeing it as, among other things, a site of pleasure – the pleasure, even, of recognition. In these Lacanian accounts, the 'queer' scene evokes anxiety; but the assumption behind this evocation, which privileges heterosexual structures over other sexualities – homosexuality, for instance – is unexamined. No doubt *Dracula* is convenient to these accounts: its several 'queer' scenes are perhaps not sufficient to disturb the 'normalised' heterosexual relations elsewhere in the text (although this is arguable). But there are other vampire stories – 'Carmilla', for instance – which signal another sort of tradition. Under the influence of these Lacanians, I have not yet mentioned what is most obvious – and yet is nonetheless undercoded, 'unspeakable' at the level of narration – about 'Carmilla'. It is, in fact, a story about lesbian love. This particular 'queerness' runs through it from beginning to end. It is time to turn *towards* this topic, rather than elide it; thus, the next section will offer ways into vampire fiction that refuse to subordinate 'queerness' – and that even see vampire fiction as *essentially* 'queer'.

QUEER VAMPIRES

In the previous chapter, I commented on the vampire narratives of Byron and Polidori. Both Byron's unfinished story and Polidori's 'The Vampyre' present a relationship between a younger and an older man – the former being deeply attracted to the latter. In Byron's story, it is some 'peculiar circumstances' in Darvell's 'private history' that make him attractive to the young narrator (Byron, 1988, 2). I have already noted that this is a highly coded text, with its own hermetic 'rituals'. Darvell himself is a coded figure – 'he had the power of giving to one passion the appearance of another, in such a manner that it was difficult to define the nature of what was working within him' (2–3) – and this enables the young narrator both to read him accurately (Darvell is therefore 'queer') and to disavow that reading (Darvell is mysterious and nothing accurate can be said about him). Two kinds of sexual

identifications are set in motion which are in no way contradictory: firstly, 'it takes one to know one' ; and secondly, 'you can't tell who is and who is not'. These are both specific to 'queer' texts and they give us another variation on Dolar's equations above: 'I know (you are "queer") . . . because (in the context of "normalised" society; to avoid persecution) I don't know.'

Louis Crompton has documented Byron's 'queerness' in his fascinating study, *Byron and Greek Love: Homophobia in 19th Century England* (1985). The phrase 'Greek love' was itself a code for homosexual relations for those, like Byron, familiar with the classics. Indeed, Greece and surrounding countries (Albania, Turkey) were figured during this time as places in which homosexuality flourished. Crompton describes Byron's relations in Athens with a young boy named Eustathius Georgiou (Crompton, 1985, 146–8) and, later, Nicolo Giraud (150–7). Nothing is said of Byron's relations with Polidori – 'that Child and Childish Dr Pollydolly' (Marchand, 1976, 81) – during his second trip to Greece, and there is no need to speculate here. Nevertheless, as I have noted, Polidori sketches a younger man's attraction to an older man in 'The Vampyre'. This story in fact derives its suspense precisely from Aubrey's promise to Lord Ruthven to remain silent about him: 'It shall not be known' (Polidori, 1988, 17). As in Byron's fragment, Aubrey both recognises Lord Ruthven for what he is, and, simultaneously, cannot be sure. But *unlike* Byron's fragment, the story does not leave the 'uncertainty' hanging: the codes are finally broken and Lord Ruthven's identification is uttered (or 'outed') melodramatically at the very end, just as Aubrey expires. Moreover, whereas Byron's narrator is bewildered by his older partner, Aubrey becomes increasingly paranoid in relation to Lord Ruthven – he now 'knows too much', but he also knows that no one will believe him if he speaks. Of course, there is another difference between Byron's fragment and 'The Vampyre', too: in Byron's story, there are no female characters.

Eve Kosofsky Sedgwick's account of the Gothic and 'homosexual panic' in her book *Between Men* (1985) may help in our understanding of 'The Vampyre'. Sedgwick draws attention to the 'erotic triangle' in Gothic novels, taking up the work of René Girard who had noted that the bond which links the two rivals in such a triangle is as strong – or stronger – than the bond which links either of the rivals to their beloved (think, for example, of Dracula and the Crew of Light in their struggle over Lucy, and later, Mina, in *Dracula*). The former bond is always 'between men'; the latter is between men and women. And what unfolds in these novels is a mutual inscription of the one upon the other – where the bond between men and women is always secondary. Of course, the bond between men may be homosocial rather than homosexual – 'or some highly conflicted but intensively structured combination of the two' (Sedgwick, 1985, 25). But under both arrangements (and their variations) the woman is positioned not as a third and equal

partner in the triangle, but rather (following Lévi-Strauss) as an object of exchange between the already-bonded men.

Certainly Ianthe and Aubrey's sister function in this way in Polidori's story: at one level, they simply intensify the bond that already exists between Aubrey and Lord Ruthven, confirming the power men have over them. But they also destabilise that bond, producing Aubrey's paranoid relation to Lord Ruthven – which we can easily figure, following Sedgwick, as 'homosexual panic'. For Sedgwick, in fact, the 'male paranoid plot' is typical of the Gothic (Sedgwick, 1986, ix): the image of Dr Frankenstein towards the end of Shelley's novel chasing the monster over a desolate landscape – 'murderous or amorous?' (ix) – is a notorious example, akin to the relation between Aubrey and Lord Ruthven. But a woman is required for this slippage to come about: because she remains inside the triangle, the ambiguity – 'murderous or amorous?' – remains. (There is no male paranoia in Byron's fragment because there is no triangle and no women.) This is where the origins of Copjec's anxiety may really lie: in the constant fuzziness of the boundaries separating the homosocial from the homosexual, the homophobic from the homoerotic. Sedgwick draws attention to the 'crystallisation of the aristocratic homosexual role' (Sedgwick, 1985, 94) in nineteenth-century Gothic fiction, important enough for vampire fiction with its 'queer' Lords and Counts.[3] She also notes the structural importance of what is designated as 'unspeakable' in this fiction: one knows what the 'unspeakable' is precisely *because* it has no name. In vampire fiction, vampirism becomes the means of animating the 'unspeakable', of bringing it to life. We can, at least, say that Lord Ruthven is a vampire – and this is because we cannot say that he is gay.

In Le Fanu's 'Carmilla', male homosociality is both more coherent and more extensive. The alliances between the various 'paternal figures' in the story have already been noted; nevertheless, the 'male paranoid plot' is even more evident here than elsewhere, their homophobia this time directed against 'queer' women, outwards rather than inwards. The 'erotic triangle' is refigured in this story: it now consists of two women – one daughter, and one guest – and one man or one group of men (fathers and father-figures). The level of paranoia is thus increased: the very fact of such a triangle threatens these fathers' ascendency over their otherwise dutiful daughters, and the guest has to be evicted.

We can think about the authorial investment in this level of paranoia – after all, the story was written by a man. Certainly there is no evidence of irony in 'Carmilla'. It mobilises a range of undercoded but no doubt recognisable representations of the aristocratic lesbian: Carmilla is 'languid', 'apathetic', sleeping well into the afternoon – yet highly sexed, obsessive.[4] Her behaviour is 'queer' enough to make Laura wonder at one point if she is a boy in disguise (Le Fanu, 1988, 91) – Laura decides, however, that her 'languour' is precisely what distinguishes her as female, not male.

For the 'paternal figures', the lesbian is clearly threatening – she drains the life from their daughters – and they enact their revenge against her in a particularly brutal way. At the same time, however, the story elicits sympathy for Carmilla in a number of ways. The Victorian view of lesbianism conventionally saw it as 'unnatural', against Nature; the illness that overtakes Laura and the village nearby is an indication of this. Carmilla, however, refuses this position: 'this disease that invades the country is natural. Nature. All things proceed from Nature – don't they? All things in the heaven, in the earth, and under the earth, act and live as Nature ordains? I think so' (95). The story, at least, allows Carmilla to speak – and to cut across the ideologies which otherwise enable the 'paternal figures' to cohere. Also, the story is fluid enough to eroticise same-sex relations in ways which do not appear unnatural and which do not produce horror or fear. Moreover, even after Carmilla has been killed, the 'queer' desire remains alive for Laura: 'often from a reverie I have started, fancying I heard the light step of Carmilla at the drawing-room door' (137).

Of course, it is difficult for me – a man – to retrieve traces of positive representation in a story – written by a man – which follows its vampirisation of the lesbian through to the end. I would only point to the distance the story maintains from that vampirisation by its use of Laura's narrative voice, and its refusal to dismantle the attraction Laura feels for Carmilla (Laura herself is never horrified by Carmilla, not even after the latter's 'true' identity is revealed). That is, same-sex desire between women is licensed, then managed or regulated (by 'eliminating' its object) – but continues to be licensed even after this, through Laura's 'reveries'. And I would also return to my reading of the story outlined earlier in the chapter – that the coherence of the 'paternal figures' depends upon the effacement of those women who 'know' about them – that knowing about vampires (and acting accordingly) can only come about if other things in the story remain *unknown*. All this would suggest that the alliance of 'paternal figures' in this story – extensive as it is – is nonetheless profoundly unstable and precarious – which is why it must be continually (and in this case, ruthlessly) reinforced.[5]

Sue-Ellen Case has written about the 'lesbian vampire' in her article 'Tracking the Vampire' – where she also explains the importance of what she (among others) refers to as 'queer theory'. By using the term 'queer' – as opposed to 'lesbian' or 'gay male' – same-sex desire can be foregrounded without designating which sex is the one which is desiring/being desired. A certain fluidity is achieved here: the term 'queer' not only refuses the 'gender-based construction of the lesbian in representation' (Case, 1991, 3), it also challenges the very notion of being-in-the-world (e.g. by problematising conventional notions of biological reproduction). It destabilises 'the borders of life and death', refusing 'the organicism which defines the living as the good' (3). In short, the queer is 'the taboo-breaker, the monstrous, the uncanny' (3). It is not the Other in this arrangement; it gains its effect by

continually *collapsing* the conventional polarity of 'life' and 'death', normality and the unnatural, regeneration and sterility – what is familiar and what is unfamiliar – rather than by positioning itself on the negative side of that polarity. Case mentions 'Carmilla', but her interest is primarily in 'queer' authors (Wilde, Baudelaire) who confuse gender differences in their texts, and who link pleasure *to* sterility (her comments here might well be contrasted to Copjec's account of vampirism and breast-feeding). She wishes to maintain the connection between the vampire and the lesbian – but she also wishes to locate the vampire in a realm within which representation itself is problematised. This is the realm 'queerness' inhabits: it is neither real nor not-real, but rather always in disguise, masquerading, death-in-life and life-in-death. When it is most 'proximate', it vanishes.

Although Case seems to see 'Carmilla' as merely replicating a heterosexist representation of the lesbian, I would argue that it does move towards this 'queer' space. After all, as I have noted, it confuses the usual polarities by folding lesbian and mother into each other: in this story, both are undead. Certainly, this figure vanishes when it is most 'proximate': in the nursery/ bedroom. Moreover, the masquerade attended by the General works precisely by throwing the kind of ontological assumptions Case describes into question (and 'animates' the characters – that is, produces pleasure – in the process) – as if 'queerness' actually drives this otherwise relentlessly polarised story along. Case perhaps inevitably turns to Freud's 'The "Uncanny"', but she critiques it because it locates the origins of pleasure with the mother and thus 'reinscribes Freud's patriarchal obsession with genealogy and sexuality as generative – part of the nineteenth-century proscription against homosexuality' (14). Her remarks are close to James Donald's in many ways, turning away from the heterosexist fantasy of pre-Oedipal maternal origins (life, regeneration) and towards an unoriginal 'in-between' state between the familiar and the unfamiliar, the living and the dead, that Freud (and the Slovenian Lacanians) had left relatively untouched. This is where she tracks the vampire – the 'queer' lesbian:

> we can here re-imagine her various strengths: celebrating the fact that she cannot see herself in the mirror and remains outside that door into the symbolic, her proximate vanishing appears as a political strategy; her bite pierces platonic metaphysics and subject/object positions; and her fanged kiss brings her the chosen one, trembling with ontological, orgasmic shifts, into the state of the undead.

(15)

Only the vampire could produce such an intensely erotic panegyric: certainly, it is the most seductive of all the fictionalised monsters. Its proximity always, at some level at least, involves a sexual charge – as Richard Dyer has noted, 'Even when the writing does not seem to emphasise the sexual, the act [of biting] itself is so like a sexual act that it seems almost perverse not to see

it as one' (Dyer, 1988, 55). Dyer's article, 'Children of the Night: Vampirism as Homosexuality, Homosexuality as Vampirism', gives a more extensive grounding to the kind of 'queer' identifications Case describes. For Dyer, the analogy between 'queerness' and vampirism is culturally embedded and is directed towards the problem of recognition – a problem specific to queers. The 'vampire myth' in fact involves a narrative structure which *depends* upon the tension between knowing and not knowing, recognition and secrecy – where the vampire both 'stands out' (as 'languid', distracted, etc.) and mingles unobtrusively:

> In most vampire tales, the fact that a character is a vampire is only gradually discovered – it is a secret that has to be discovered. The analogy with homosexuality as a secret erotic practice works in two contradictory ways. On the one hand, the point about sexual orientation is that it doesn't 'show', you can't tell who is and who isn't just by looking; but on the other hand, there is also a widespread discourse that there are tell-tale signs that someone 'is'. The vampire myth reproduces this double view in its very structures of suspense.
>
> (58)

The pleasure of reading – and of identification – lies in the ways in which the reader negotiates this 'structure of suspense'. For James Donald, there are many points at which a reader can enter the text and establish an identification; for Dyer, however, the 'queer' reader enters the text at those points in which recognition is avowed or disavowed – in particular, those points where the vampire is closest to its victim:

> Such reader-text relations offer specific pleasures to gay/lesbian readers. Much of the suspense of a life lived in the closet is, precisely, will they find out? An obvious way to read a vampire story is self-oppressively, in the sense of siding with the narrator (whether s/he is the main character or not) and investing energy in the hope that s/he will be saved from the knowledge of vampirism (homosexuality). Maybe that is how we have often read it. But there are other ways. One is to identify with the vampire in some sort, despite the narrative position, and to enjoy the ignorance of the main character(s). What fools these mortals be. The structure whereby we the reader know more than the protagonist (heightened in the first person narration) is delicious, and turns what is perilous in a closeted lesbian/gay life (knowing something dreadful about us they don't) into something flattering, for it makes one superior. Another enjoyable way of positioning oneself in this text-reader relation is in thrilling to the extraordinary power credited to the vampire, transcendant powers of seduction, s/he can have anyone s/he wants, it seems. Most lesbians and gay men experience exactly the opposite, certainly outside of the gay scene, certainly up until very recently. Even though the vampire is

invariably killed off at the end . . . how splendid to know what a threat
our secret is to them!

(59)

Le Fanu's 'Carmilla' would clearly offer these kind of readerly pleasures.
Carmilla's vampire identity is not difficult to guess (and, as Dyer notes,
readers today would be unlikely to begin the story without this knowledge).
So the reader's engagement must be with the behavioural codes which
produce her *as* a vampire – her 'queerness', in other words. The story turns
on the fact that the reader must know more than Laura does – or her father,
for that matter (although, as indicated, the question of knowledge in the
story – who knows what about whom – is problematic). It also allows readers
the privileged position of seeing what occurs in the privacy of Laura's
bedroom, which thus enables readerly knowledge to be contrasted with the
ignorance of the otherwise self-satisfied 'paternal figures' whose home is
literally their castle. Readers *can* identify with Carmilla in the ways Dyer
describes – through the various erotic scenes, and through her seductive
powers over Laura. And so we arrive at a strategy for identification with the
vampire in all its 'queerness' – whereby the more proximate it is, the greater
the pleasure that identification may provide. This is certainly a very different
position to the one maintained by Copjec, Dolar and Žižek, for whom the
vampire is that foreign Thing which produces 'anxiety' when it comes close to
us – a view which in this context flatly reproduces the homophobic paranoia
of Victorian vampire fiction's 'paternal figures'.

4

READING *DRACULA*

Few other novels have been read so industriously as Bram Stoker's *Dracula*. Indeed, a veritable 'academic industry' has built itself around this novel, growing exponentially in recent years and, in effect, canonising a popular novel which might otherwise have been dismissed as merely 'sensationalist'. To enable its canonisation (a process to which this chapter contributes), *Dracula* has become a highly productive piece of writing: or rather, it has become productive *through its consumption*. To read this novel is to consume the object itself, *Dracula*, and, at the same time, to produce new knowledges, interpretations, different *Draculas*. Paul O'Flinn has noted, in his article on Mary Shelley's famous Gothic story, 'There is no such thing as *Frankenstein*, there are only *Frankensteins*, as the text is ceaselessly rewritten, reproduced, refined and redesigned' (O'Flinn, 1986, 197) – and it is tempting to go along with this view as far as critical readings of *Dracula* are concerned.

What we have with the many articles and books on Stoker's novel, then, is not one *Dracula*, but many *Draculas*, which compete with each other for attention in the academic/student marketplace. Of course, it may be that *Dracula* – the 'original' novel – also in part *enables* these many readerly productions to come into being. It is, after all, a textually dense narrative, written from a number of perspectives or 'points of view', which brings together a multiplicity of discursive fields – ethnography, imperialist ideologies, medicine, criminality, discourses of degeneration (and, conversely, evolution), physiognomy (facial features are described in detail in this novel), early modes of feminism, more entrenched modes of 'masculinism', occultism and so on. The productive nature of this novel may lie in the uneasy cohabitation of these various discursive fields and in the variability of their coding – it may undercode at times and overcode at others. At any rate, it seems that there is always more to be said about *Dracula*, always room for further interpretation and elaboration: this is a novel which seems (these days, especially) to generate readings, rather than close them down.

Some academic interpretations have already been noted – for example, Franco Moretti's reading of the vampire in *Dracula* as a figure for monopoly

capital. But the keenest critical interest in the novel has centred around the topic of sexuality, and this will be the primary focus of this chapter. It is hardly a topic reserved for academic discussion alone, of course – the highly-charged sexual aura of the vampire (and, usually, his or her victims) has been the focus of numerous vampire films and of contemporary vampire fiction, too. Nevertheless, the academic investment in this topic is worth pursuing here in some detail. We shall also see that the readings produced here are post-imperialist; that is, for the most part, they work towards a prob-lematisation of the conventional self/other or good/evil polarities in the novel – and more to the point, far from reproducing the 'fear' ascribed to Moretti's passive readers (a readerly position which must, to work, be thoroughly entrenched in imperialist ideology), they draw out the vampire's positive effects. The vampire is seen, in the readings that follow, as more of a symptom than a cause. That is, the vampire is to be redeemed – the problem lies, instead, with the upstanding heroes.

SEX, PSYCHOANALYSIS AND THE VAMPIRE

As we saw in the previous chapter, psychoanalysis has been an important tool in recent critical accounts of vampire fiction and the topic of sexuality. *Dracula* itself draws liberally on psychoanalytic concepts, trading on their growing prominence in the popular mind. The novel was in fact published two years after Freud and Breuer's *Studies in Hysteria* (1895) and one year after the term 'psychoanalysis' was actually introduced. The doctors in this novel are themselves psychoanalysts of a kind, doctors of the brain or the mind. Dr Seward is investigating madness in the novel, recording his thoughts about the lunatic Renfield onto a phonograph – although Seward is on the whole psychoanalytically naive. More relevantly, Van Helsing prac-tises hypnosis and admires 'the great Charcot' (Stoker, 1988, 191), whose death he laments. Van Helsing's interest in psychoanalysis is consistent with his tendency to believe in the unbelievable, to maintain an 'open mind': his claim that hypnosis 'would have been deemed unholy' (191) by less up-to-date scientists provides an interesting auto-critique of his own view of the 'unholy' vampire (is Van Helsing, then, not up-to-date with Dracula?).

I shall return briefly to the novel's treatment of hypnosis towards the end of the chapter. What is important to note here, however, is that the psychoanalytic concepts and allusions at work in the novel are actually never put to use as a means of analysing a character's sexuality – or, indeed, the sexuality of the vampire. That is, the extensive commentary on events by doctors or analysts like Van Helsing, which runs through the novel, nev-ertheless has nothing to say – in spite of its Freudian context – about anyone's sexual motivations. Since events in the narrative are so obviously *driven* by sexual motivations, this silence on behalf of the 'paternal figures' is surpris-ing – although we need not put it down to 'repression', as some critics have

done. In other words, *Dracula* overcodes sexuality at the level of performance, but undercodes it at the level of utterance. Critical analysis intervenes at this point, enabling these deafening silences to 'speak'. This is one reason why the novel has been so productive as far as readings are concerned: there is so much to say about sexual motivation in *Dracula* precisely because the novel's own analysts have nothing to say about it whatsoever.

An early and influential psychoanalytic reading of the vampire's sexuality can be found in Ernest Jones's *On The Nightmare* (1929). Jones provides a Freudian reading which sees this particular monster as an indicator of 'most kinds of sexual perversions' (Jones, 1991, 398). The belief in vampires is, for Jones, a fantasy that returns to infantile sexual anxieties – this is where the more perverse forms of sexuality manifest themselves. In particular, an Oedipal blend of love and hate directed towards the parents – which leads to guilt – occurs in infancy, whereby one loves the mother, incestuously, and hates the father. The vampire may return as the father, evoking fear, or as the mother, in which case desire is evoked – or, indeed, both emotional attitudes may be projected simultaneously onto the vampire who then represents father and mother together. 'Carmilla' could certainly be read in terms of an incestuous desire for the mother, although for Jones the Oedipal relationship between vampire and victim is always heterosexually grounded, so that where there is a female vampire the victim must be male:

> The explanation of these phantasies is surely not hard. A nightly visit from a beautiful or frightful being, who first exhausts the sleeper with passionate embraces and then withdraws from him a vital fluid: all this can point only to a natural and common process, namely to nocturnal emissions accompanied with dreams of a more or less erotic nature. In the unconscious mind blood is commonly an equivalent for semen, and it is not necessary to have recourse to the possibility of 'wounds inflicted on oneself by scratching during a voluptuous dream'.
>
> (411)

The vampire's 'exhausting love embrace' (411) is complicated by forms of sexual perversity which return to the primitive world of infantilism. The chief form is 'oral sadism' – where sucking (love) turns into biting (hate).

Jones's reading is an attempt to demystify the vampire 'superstition', channelling it through the anxieties produced in familial relationships. He is aware of the contemporary tendency to 'rationalise all superstitions' (416) by explaining their 'essentials' away. His project, however, is to place familial anxieties at a deeper level than the superstition itself – so that, by demystifying the latter, he uncovers something even more mysterious in the realm of everyday life. We have seen the same kind of reading at work in the previous chapter with the Slovenian Lacanians, for whom vampirism exists not on its own terms, but as a means of evoking a horror much closer to home – and all the more unspeakable for that.

VAMPIRES AND INCEST

Several critics – including Franco Moretti – have taken up the taboo of incest in relation to *Dracula*. Moretti's chapter 'Dialeectic of Fear' is divided into two parts which in fact bear little clear relation to each other, a materialist reading, discussed in Chapter 1, and a psychosexual reading. In this second part, he draws on Marie Bonaparte to allegorise vampirism as an expression of the 'ambivalent impulse of the child towards its mother' (Moretti, 1988, 104). This ambivalence comes about because of the prohibition of incestuous desires. For Moretti, this prohibition is activated by turning the vampire into a man, as if it is somehow always essentially and originally female. This is where his 'dialectic' resides: horror narratives initialise tabooed desires and then repress them by shifting their significance elsewhere or hiding them out of sight. This reading is underwritten by Moretti's modernist disdain for mass culture: 'The vampire', he claims, 'is transformed into a man by mass culture, which has to promote spontaneous certainties and cannot let itself plumb the unconscious too deeply' (104). How this transformation is effected in the novel is never explained; more fundamentally, the novel's own complex association with 'mass culture', which I shall take up towards the end of this chapter, remains unaccounted for. And what about those vampire narratives in which the vampire *is* a woman – like 'Carmilla'? It must be said that Moretti has it both ways in his (conventionally heterosexual) reading of the vampire's sexuality: for the allegory of incest to be acceptable, the vampire must always be essentially female – but when the *victim* is female, like Lucy, the incest paradigm is dropped for a heterosexual account of the liberated Victorian libido as it operates *outside* the family circle.

Certainly this tendency to maintain the incest paradigm in the face of the vampire's maleness causes all kinds of interpretive problems. James Twitchell's 'The Vampire Myth' (1980) provides one kind of resolution, maintaining the incest paradigm but foregrounding the *father* instead. He draws on Freud's *Totem and Taboo* (1912–13) to read the novel as enacting a version of the Girardian triangle discussed in the previous chapter, with Dracula as the 'evil father' who does battle with his sons over the body of the mother (Twitchell, 1988, 111). Richard Astle (1980) and Rosemary Jackson (1981) give similar readings – for Jackson, indeed, 'any vampire myth' is a 're-enactment of that killing of the primal father who has kept all the women to himself' (Jackson, 1981, 119). The sons both identify with the father and fear him because they, too, desire the mother but know that such a desire is prohibited. For Twitchell, the sexual aspects of this arrangement are emphasised in vampire narratives (he seems mainly to have vampire films in mind) because – it is assumed – the audience are male adolescents. They experience 'a masturbatory delight' (113) in seeing the female seduced by the vampire – as if witnessing 'the primal scene' between parents (112). Twitchell, however, has some difficulty in explaining why *female* adolescents might also derive pleasure from the seduction scenes in vampire narratives.

His account finally settles on a familiar gender distinction, where boys are active and sadistic, and girls are passive victims:

> When the male audience interprets the action, the female represents his own displaced mother, virginal to him, who is being violated by his father, an ironic projection of his own self in the guise of the vampire. But when the adolescent female views the myth, she is the victim, virginal again, but now being swept through her 'initiation' by her gentle father – a father who must then disappear into the darkness, leaving her to other men and strange disappointments.
>
> (115)

Phyllis A. Roth, in her article 'Suddenly Sexual Women in Bram Stoker's *Dracula*' (1977), also sees the novel as enacting 'the Oedipal rivalry among sons and between the son and the father for the affections of the mother' (Roth, 1988, 60). However, for Roth a much more powerful and disturbing subtext cuts across this structure: the *hatred* of the mother. The novel allows the reader to identify with the aggressors and thus to accept their victimisation of women: matricidal desires motivate events more than patricidal desires. This reading is bolstered by collapsing Lucy and Mina together, as 'essentially the same figure: the mother' (62) – whereas, as we shall see shortly, other critics emphasise their differences. Nevertheless, Roth's argument is important for its refusal to accept the Freudian Oedipal paradigm outright, and for turning instead to a more appropriately feminist reading of gender relations in the novel. Her account of the novel's evocation of 'the desire to destroy the threatening mother, she who threatens by being desirable' (65) will be taken up by other feminist critics, discussed below.

VAMPIRES AND PERVERSION

Maurice Richardson, in his essay 'The Psychoanalysis of Ghost Stories' (1959) – part of which discusses *Dracula* – returns to Freud and notes an indebtedness to Ernest Jones's early work. The vampire, he says, takes us into 'the unconscious world of infantile sexuality with what Freud called its polymorph perverse tendencies' (Richardson, 1991, 418). Stoker's novel is 'inclusive' in this respect: it engages in 'a kind of incestuous, necrophilious, oral-anal-sadistic, all-in wrestling match' (418), whereby a sequence of perversions come into play and fold into each other – hence, the novel's 'force' (419) and its ability to produce a variety of interpretations. Richardson's analysis is on the whole fairly crude, however; it merely reinforces a view of Gothic popular fiction as sensationalist and out of control (so that Richardson doubts whether Stoker – for all the novel's many perversions – 'had any inkling of the erotic content of the vampire superstition', 420). Nevertheless, it opens up a topic which other critics have since developed: the vampire's 'polymorphous' sexuality. It is here – rather than

through incestuous structures – that taboos are broken. David Punter, in *The Literature of Terror* (1980), has emphasised the Gothic's involvement with taboo generally speaking. Although Punter identifies Gothic fiction as 'a middle-class form' (Punter, 1980, 421), he nevertheless sees it operating 'on the fringe of the acceptable' (410). For Punter, *Dracula* is 'hard to summarise' (262) for a number of reasons, some of which will be elaborated below. But the novel's power 'derives from its dealings with taboo' (262), since the vampire's function is to cross back and forth over boundaries that should otherwise be secure – the boundaries between humans and animals, humans and God, and, as an expression of its 'polymorphous' sexuality, man and woman.

Christopher Bentley's 'The Monster in the Bedroom: Sexual Symbolism in Bram Stoker's *Dracula*' (1972) also draws on Ernest Jones's study and notes that, by disguising the vampire's 'perversions' through the use of 'symbolism', the novel ensured its popularity – since an overt treatment of sexuality was prohibited. Bentley concentrates on the three scenes in the novel in which perverse or 'polymorphous' sexualities seem most manifest: the scene in Dracula's castle where Jonathan Harker is approached by three vampire women, the scene in which Arthur Holmwood drives a stake through Lucy's heart and the scene in which the Crew of Light break into Mina's bedroom and find her kneeling on the bed before Dracula and sucking blood from an open wound in his chest. Bentley goes along with Jones's connection between blood and semen, which helps to demystify the first scene. The second scene – and we have already encountered Slavoj Žižek's psychoanalytic account of it – is read conventionally as a means of bringing Lucy to orgasm through 'phallic symbolism' (Bentley, 1988, 30). The third scene is interpreted as 'a symbolic act of enforced fellatio' (29). However, this reading is complicated by the presence of a 'thin open wound' on Dracula's chest and Mina's blood-soaked nightdress. The latter – and Mina's cry that she is now 'Unclean' – would suggest 'ancient primitive fears of menstruation' (29). The 'thin open wound' on Dracula's chest suggests 'a cut or slit similar to the vaginal orifice' (29) – a means, perhaps, of bringing Mina into contact with her own sexual cycle.

This point would appear to erase the former reading of 'enforced fellatio' and the equation between blood and semen; it draws attention instead to Mina as a menstruating girl – this is the taboo that is violated in this scene. Mina's bloodstained nightdress, and the 'thin open wound', might also signify her own defloration by Dracula. After all, the scene takes place in her bedroom, and Dracula's potency is contrasted with Jonathan Harker, who – in Dr Seward's first account of what happened – is lying beside her 'breathing heavily as though in a stupor' (Stoker, 1988, 281) and who had earlier complained of feeling 'impotent' (188). But Mina's account of the scene, given shortly afterwards, returns us to the 'enforced fellatio' reading:

he [Dracula] pulled open his shirt, and with his long sharp nails opened a vein in his breast. When the blood began to spurt out, he took my hands in one of his, holding them tight, and with the other seized my neck and pressed my mouth to the wound, so that I must either suffocate or swallow some of the – Oh, my God, my God! what have I done?

(288)

At the point of swallowing, Mina is unable to say the word 'blood' – or rather, she allows the fluid at this moment to be appropriately unrepresented, making the space for its reading as semen.

As noted in the previous chapter, this scene is – in Copjec's words – a 'horrifyingly obscene moment' in the novel. It is also particularly difficult to read. The problem lies primarily in the ways in which this scene is reported. There is no single authorial voice in the novel; rather, a number of characters (Harker, Mina, Dr Seward, Lucy) give their versions of what is happening using their own voices. The 'polyphonic' aspects of *Dracula* are one reason why it is – as Punter had noted – so difficult to summarise. One must account not only for what is being said, but *who* is saying it – and to whom. Moreover, a single event may be reported by different characters in different ways. As far as the scene with Mina and Dracula is concerned, it is reported three times: twice by Dr Seward and once by Mina. Van Helsing also offers a commentary on certain aspects of the scene. And, together, these various reports are in themselves enough to make what is happening at the very least ambiguous.

In her article 'Women and Vampires: *Dracula* as a Victorian Novel' (1977), Judith Weissman wonders who exactly had caused Harker's 'stupor' in the bedroom – Dracula, or Mina? Van Helsing's remark, that 'Jonathan is in a stupor such as we know the Vampire can produce' (Stoker, 1988, 283), is difficult to interpret because 'he does not say which vampire produced this stupor' (Weissman, 1988, 75). Mina is becoming a vampire at this point, and she, rather than Dracula, may be responsible for it: 'Flushed and tired, Jonathan seems to have just had intercourse' (75). Weissman doesn't explore the more obvious possibility of hypnosis – Harker is soon awoken by Van Helsing, leaping up 'at the need for instant exertion' (Stoker, 1988, 283). Nevertheless, her reading, which turns on Dracula's ability to make the women in the novel sexually insatiable (so that Mina simply exhausts Jonathan), has a certain appeal. In the light of it, it is difficult to agree with Anne Cranny-Francis's somewhat dismissive view of Mina, that her sexuality 'has no expression; it is completely muted, neutered' (Cranny-Francis, 1988, 71)!

A fuller reading of the ambiguities of the scene, however, is given in Philip Martin's essay, 'The Vampire in the Looking-Glass: Reflection and Projection in Bram Stoker's *Dracula*' (1988). Martin also sees Dracula as the 'catalyst which awakens women's desire' (Martin, 1988, 87); the novel sees

71

'dangerous vampiric tendenc[ies]' (87) lurking in all its female characters. For Martin, the scene involving Mina and Dracula is more of a seduction than a rape, and the evidence he gives for this centres on a crucial difference between Dr Seward's first and second account of what happened. In the first account, Seward positions Dracula and Mina in the following way: 'With his left hand he held both Mrs Harker's hands, keeping them away with her arms at full tension; his right hand gripped her by the back of the neck, forcing her face down on his bosom' (Stoker, 1988, 282). In his second account – told to Van Helsing almost directly afterwards – Seward gives a very different account of Dracula's hands: 'It interested me, even at that moment, to see that whilst the face of white set passion worked convulsively over the bowed head, the hands tenderly and lovingly stroked the ruffled hair' (284). The first account sees Dracula as 'sadistic', while the second account sees him as 'affectionate'. So why are they so different?

Martin returns to Freud and the family romance for an answer, reading Seward as a child who blunders into his parents' bedroom and discovers them in the act of intercourse. The 'primal scene' is read as a contradiction – he is hurting her/he is loving her – which the child cannot reconcile. Moreover, Dracula has mutilated himself in the process, opening a vein in his chest: it is even more difficult to reconcile affection with sado-masochistic sexual behaviour. It first seems as if Dracula is dominating Mina, as men conventionally dominate women; looking a second time, however, we see affection, not domination – and it is Dracula who is in pain, not Mina. The vampire crosses gender relations here, being simultaneously patriarchal (dominating, sadistic) and yet – producing the 'thin open wound' – expressing 'the sexuality that denies phallocentric power in its mutilation, taking on thereby the role of the *women* as conceived by the narrators' (Martin, 1988, 90, my italics). The narrators *see* this perverse contradiction, but cannot give it interpretation: as I have noted above, they offer no analysis of the sexual behaviour they nonetheless bear witness to. It should be added, however, that this does not amount to the usual cliché of Victorian repression, as Moretti would have it. The narrators in *Dracula* do not obstruct investigation simply by remaining silent about such contradictions. Quite the opposite, in fact: for Martin, although the narrators cannot accurately read what they see (consequently 'undercoding' it), they nevertheless tentatively gesture *towards* a realisation of the 'massive complexity of the libido' (91).

PERVERSE VAMPIRE WOMEN

The second perverse scene in *Dracula* – where Harker meets the three vampire women – has also led to a critical discussion of the complexity of the libido. It is the most sustained piece of erotic writing in the novel. Harker describes in great detail the approach of the women, their appearance, the way one of them leans over him 'fairly gloating', and – although his eyes are

lowered – the way he looks voyeuristically up at her from 'under the lashes' (Stoker, 1988, 38). There are at least two moments in this scene which are textually undercoded. The first involves one of the vampire women, who Harker seems to recognise. She is the first to approach Harker: the others remark cryptically, 'yours is the right to begin' (38). More strikingly, while the other two women are dark-haired, she is 'fair': 'The other was fair, as fair can be, with great, wavy masses of golden hair and eyes like pale sapphires. I seemed somehow to know her face, and to know it in connection with some dreamy fear, but I could not recollect at the moment how or where' (37).

Clive Leatherdale has offered some clues to this particular 'puzzle' in the novel. He rightly dismisses the possibility (entertained by Showalter, 1990, 180) that Harker may be thinking of 'the arch-temptress Lucy' – Lucy is dark-haired – or that he may be projecting an erotic image of Mina (Leatherdale, 1985, 148). However, his own explanation is equally unlikely – namely, that Harker is recalling events described in Stoker's short story 'Dracula's Guest' (1914), where he sees a beautiful woman 'with rounded cheeks and red lips' – Countess Dolingen of Gratz – sleeping on a bier (Stoker, 1990, 16). The connection here is too imprecise; moreover, it is doubtful that 'Dracula's Guest' was ever intended as part of *Dracula* itself.[1] Leatherdale goes on to note that, because the two dark-haired vampire women are said to resemble Dracula, they are 'probably his daughters' – and the fair-haired woman, who goes first, is 'presumably their mother' (Leatherdale, 1985, 149).

This interesting (although somewhat arbitrary) suggestion nevertheless does not account for Harker's recognition of her. Two other interpretations can briefly be noted here. The first, drawing on Freud's 'The "Uncanny"' once again, would return us to the Oedipal paradigm: Harker has in fact seen his *own* mother (who is otherwise absent from the novel). The combination of Harker's 'dreamy fear' and 'delightful anticipation' (Stoker, 1988, 38) would thus recall the incest taboo, evoking the child's love for his mother – and the prohibition of that love. Indeed, Harker's descriptions of the fair-haired vampire woman are always contradictory in this sense: for example, her breath is both 'honey-sweet' and tinged with 'a bitter offensiveness, as one smells in blood' (38). Of course, we have seen something similar to this arrangement in Le Fanu's 'Carmilla' – where, interestingly enough, Carmilla also has 'golden hair and blue eyes' (Le Fanu, 1988, 86). Harker's recognition of her may even be a kind of in-house vampiric allusion (Stoker knew Le Fanu's story well).[2] The point is, however, that in both stories the fair-haired vampire women signal the (sexual) return of the mother. By intervening, Dracula – the 'evil father'? – thus serves a moral purpose similar to Laura's father and the 'paternal figures' in Le Fanu's story: he prevents the incest taboo from being violated.

A second – and not unrelated – interpretation would draw on Harker's diary entries just before the scene takes place. Harker has gone to a room in

Dracula's castle which 'was evidently . . . occupied in bygone days' (35). It has – for the otherwise anxious Harker – 'an air of comfort' (35). As he sits down at a table and begins to write in his diary, he imagines who might have written there before him: 'in old times possibly some fair lady sat to pen, with much thought and many blushes, her ill-spelt love-letter' (36). Harker is led both to contrast and to connect his own modern shorthand diary entries with this earlier moment of writing: 'It is nineteenth century up-to-date with a vengeance. And yet, unless my senses deceive me, the old centuries had, and have powers of their own which mere "modernity" cannot kill' (36). Writing in this context helps to restore Harker's sanity: he notes, in a sentence which has interesting sexual overtones, 'The habit of entering accurately must help to soothe me' (36). Finally, he decides to sleep in the room, 'where of old ladies had sat and sung and lived sweet lives whilst their gentle breasts were sad for their menfolk away in the midst of remorseless wars' (37). Harker's image of the 'fair lady' certainly reproduces conventional male views of the woman writer – confined, submissive, emotional, defining themselves through the absence of men – and poor spellers! A maternal influence seems to be operating on Harker; he is comforted by the room, soothed by these 'old' thoughts, and so on. But he also *identifies* with the image he projects, imprisoned as he is inside Dracula's castle with only his diary for company – and through that identification, he, too, is feminised.

That is, Harker *becomes* the 'fair lady' he imagines to have inhabited the room before him. In this context, his recognition of the fair-haired vampire woman – 'in connection with some dreamy fear' – amounts to *self*-recognition. Certainly, at one level, the experience with the vampire amounts to a masturbatory fantasy stimulated by the image of the blushing lady and her love-letters – something akin to Jones's description of 'nocturnal emissions'. At another level, however, it involves an 'uncanny' structure where a familiar image (of the self, of the mother; of woman) becomes, suddenly, unfamiliar: the submissive 'fair lady' of Harker's reverie now becomes an aggressive fair-haired vampire. Or rather, the two are simultaneously figured through Harker himself – who, as the fair-haired vampire woman leans over him, maintains a submissive, feminised position beneath her.

HOMOSOCIAL/HOMOSEXUAL

The second undercoded moment in this complicated scene occurs after Dracula intervenes – with the exclamation, 'This man belongs to me!' (39). The fair-haired vampire turns to Dracula with the accusation, 'You yourself never loved; you never love!' – and Dracula, after looking 'attentively' at Harker's face, replies in 'a soft whisper', 'Yes, I too can love; you yourselves can tell it from the past' (39). The scene closes with Dracula giving the vampire women a bag containing 'a half-smothered child' (39) – upon which

they presumably feed (although this, too, is undercoded). Shortly after-
wards, Harker sees the child's mother calling for her child (she mistakes
Harker for Dracula); but when she is torn to pieces by Dracula's wolves, he
considers that, given what has happened to her child, she is 'better dead'
(45).

Several critics have turned their attention to these latter events, looking at
the connection between sexually aggressive women and 'bad mothers'. For
Anne Cranny-Francis – because of the association of blood-sucking and
intercourse – the vampire women subject the child to sexual as well as
physical violence: they are not only 'homicidal maniacs', but 'child moles-
ters' (Cranny-Francis, 1988, 66). The point is confirmed later on in the novel
when Lucy becomes a vampire. As the 'bloofer lady', she reputedly lures
children away from Hampstead Heath and bites their necks – although at
least one child enjoys the experience. Later, the Crew of Light see her
clutching a sleeping (and possibly dreaming) 'fair-haired child' (Stoker,
1988, 210), which – when she sees Arthur – she throws to the ground. We
should note, however, that the vampire women's behaviour is always rep-
resented to us by men. It is Harker who suggests that – after her child has
been taken – the mother is 'better dead'. And Dr Seward judges Lucy as
'cold-blooded' in her treatment of the sleeping child. The point is taken up
by Thomas B. Byers, in his article 'Good Men and Monsters: The Defenses
of *Dracula*' (1981). Byers claims that the men in the novel not only fear
aggressively sexual women; by constructing them as 'bad mothers', they also
project onto them their *own* dependencies upon children – and upon
themselves. That is, the men in the novel invent sexually aggressive women
as 'bad mothers' as a way of disguising their own 'male dependency needs'
(Byers, 1988, 150).

Byers is one of several critics who sees the Crew of Light – Van Helsing, Dr
Seward, Arthur Holmwood and Quincey Morris – as unstable and vulner-
able, held together homosocially by 'needs' they cannot properly identify
except through the anxiety-ridden 'supernaturalising' of the vampire. Per-
haps only Dracula gives this topic expression, in his remark to the vampire
women, 'This man belongs to me!' The fair-haired vampire woman's accusa-
tion – 'You yourself never loved; you never love!' – would seem bitterly to
evoke Dracula's own inadmissible 'male dependency needs': he does not
need *them*. But Dracula has in fact just admitted that he needs Harker. This
admission – and, of course, the vampire woman's accusation – would suggest
that Dracula is homosexual. The vampire women burst into 'mirthless, hard,
soulless laughter' (39) when the accusation is made. Dracula, on the other
hand, speaks softly, staring 'attentively' at Harker. His reply to the women
does not reconcile his sexuality in any way – it certainly does not suggest that
he was once *their* lover, only that they 'can tell' that he is (or has been)
capable of loving in one way or another.

The sexualities evoked in this scene are discussed in Christopher Craft's essay, '"Kiss Me with Those Red Lips": Gender and Inversion in Bram Stoker's *Dracula*' (1990). Craft notes Harker's 'feminine' passivity here as he 'awaits a delicious penetration from a woman whose demonism is figured as the power to penetrate' (Craft, 1989, 218). Dracula intervenes at precisely this point, claiming Harker for himself just as penetration begins. For Craft, the novel never again represents so directly 'a man's desire to be penetrated' (220); nonetheless, it 'does not dismiss homoerotic desire and threat; rather it simply continues to diffuse and displace it' (220). Craft returns to a version of the 'erotic triangle', as discussed in the previous chapter – where men can touch each other only through the woman. Lucy's suitors – Dr Seward, Quincey and Arthur – bond together by transfusing their blood into her body. The Crew of Light stabilises itself by expelling Mina – for a while, at least. In order to stabilise the group homosocially, however, homoerotic desire cannot be represented directly. It is 'there', all the same, inhabiting 'normal' behaviour, 'inverting' it. That is, the novel channels homoerotic desire through heterosexual relations – and because of this, those relations are always figured as excessive or 'monstrous'. A tension arises between the pull towards homoeroticism and the need to stabilise heterosexual relations between men and women – where the imagining of 'mobile desire as monstrous' leads always to 'a violent correction of that desire' (224) and the restoration of conventional (heterosexual) gender differences.

It is doubtful whether the two perverse scenes discussed so far work in this way: they seem, to me at least, too undercoded, and (since both scenes are interrupted) incomplete – necessarily so, to preserve the undercoding. The 'mobile desires' at work in these scenes are never violently 'corrected', only curtailed. The scene Craft has in mind, however, certainly does support his case. It is the third perverse scene in our sequence, a scene which is not interrupted – it is described right through to the end – and which is, by contrast, *overcoded*: its meaning is *too* obvious. That scene is the killing of the vampire Lucy.

LUCY AND MINA

I have already presented this scene in the previous chapter, along with Slavoj Žižek's commentary on it. Žižek is not interested in gender relations; for Craft, however, the description of Arthur Holmwood hammering the stake into Lucy's body is the novel's 'most . . . misogynist moment' (230). Anne Cranny-Francis agrees: '[t]he scene in which Lucy is killed is one of the most brutal and repulsive in the book' (Cranny-Francis, 1988, 68). Carol A. Senf suggests that the scene 'resembles nothing so much as the combined group rape and murder of an unconscious woman' (Senf, 1988, 100). For Elaine Showalter, '[t]he sexual implications of this scene are embarrassingly clear': like Senf, she reads the killing, where the Crew of Light use such an

'impressive phallic instrument', as 'gang rape' (Showalter, 1990, 181).[3] This is where the feminist backlash against *Dracula* coheres: following Phyllis A. Roth's argument, outlined above, these and other critics (for example, Dijkstra, 1986) see the novel as acting out a hatred towards sexually independent women typical of misogynist *fin-de-siècle* culture. For Stoker – according to this account – women, rather than Dracula, are the central horror in the novel: the vampire is simply the means by which that horror can be realised.

Feminist critics have thus analysed the ways in which women are both unleashed and contained, or constrained, in *Dracula*. Before she is visited by Dracula, for example, Lucy reveals through her letters to Mina that she already has a sexual 'appetite' – as if her transformation into a vampire later on simply makes manifest what was privately admitted between friends. In an often-quoted passage, written after she turns down Dr Seward and Quincey's proposals of marriage in favour of Holmwood, Lucy remarks: 'Why can't they let a girl marry three men, or as many as want her, and save all this trouble? But this is heresy, and I must not say it' (Stoker, 1988, 59). For Gail B. Griffin, Lucy is a 'carnal woman' who must be – and is – punished (Griffin, 1988, 144). Before her punishment takes place, however, Lucy's 'heresy' is acted out in a highly-charged sequence of scenes, when Dr Seward, Arthur Holmwood, Quincey and Van Helsing each transfuse their blood into Lucy's ailing body. Van Helsing makes the connection between the blood transfusions and marriage (and intercourse) clear, remarking on Holmwood's observation that – with his blood inside Lucy's body – she was 'truly his bride' (Stoker, 1988, 176). Van Helsing's subsequent comments, made with the kind of hollow laughter we had seen from the vampire women, are particularly revealing:

> If so that, then what about the others? Ho, ho! Then this so sweet maid is a polyandrist, and me, with my poor wife dead to me, but alive by Church's law, though no wits, all gone – even I, who am faithful husband to this now no-wife, am bigamist.

(176)

The passage makes the sexual nature of the transfusions explicit: the men each become Lucy's lovers and husbands, pouring their bodily fluids into her. Critics have not commented on Van Helsing's account of his *own* wife, however. Is she mad? Perhaps like Rochester's wife Bertha in Charlotte Brontë's *Jane Eyre* (1847), who, incidentally, is inscribed at one point as a vampire, a 'foul German spectre' (Brontë, 1984, 311). More to the point, has Van Helsing driven her mad? The only other character with 'no wits' in the novel is Renfield, who is metonymically connected to Dracula. The passage is one of a small number which gives an insight to life *after* marriage in the novel: while the husband goes off to kill vampires, the wife remains at home like one of the undead, 'dead to me, but alive. . . .'.

Mina also confesses to an excess of sexual desire, writing in her journal that she and Lucy, together, 'would have shocked the "New Woman" with our appetites' (Stoker, 1988, 88). The 'New Woman' was a designation for the late-Victorian feminist – unmarried, sexually independent, career-minded. Thomas Hardy had dealt with this figure through Sue Bridehead in *Jude the Obscure* (1895), published two years before *Dracula*. Elaine Showalter (1990) provides a good account of representations of the 'New Woman' in the 1880s and 1890s, noting in particular the misogyny directed towards this figure – categorised as 'nervous', anarchic, disruptive. In her journal, Mina shows her familiarity with 'New Woman' writers – the literary representation was, by this time, generic – when she thinks, significantly enough, about how attractive Lucy is when she is sleeping:

> Some of the 'New Woman' writers will some day start an idea that men and women should be allowed to see each other asleep before proposing or accepting. But I suppose the New Woman won't condescend in future to accept; she will do the proposing herself. And a nice job she will make of it, too! There's some consolation in that.
>
> (Stoker, 1988, 89)

Anne Cranny-Francis argues that Mina always accepts 'patriarchal ideology' and remains 'sexually passive, submissive, receptive' (Cranny-Francis, 1988, 72). Unlike Roth, who sees both Lucy and Mina as essentially mothers, Cranny-Francis polarises the two heroines through their sexuality: Lucy is 'sexually aggressive', while Mina accepts conventional notions of sexual normality. The above passage, however, would seem to complicate matters: Mina can even outdo the 'New Woman' in her evocation of female sexual independence. The problem with Cranny-Francis's reading of events in *Dracula* is that, like Moretti, she relies on a somewhat conventional notion of repression as the fundamental driving force behind events – and this, in turn, relies upon the assumption that 'patriarchal ideology' in the novel (which does the repressing) is always coherent. David Glover has shown, however, that 'patriarchal ideology' in *Dracula* is in fact incoherent enough even to be fissured by moments of 'feminisation', through Harker's breathless passivity in the scene with the vampire women, or – to give another example – through Van Helsing's unpredictable 'male hysteria' (Glover, 1992, 995).

A number of critics have suggested that, at any rate, Stoker enables us to *see* 'patriarchal ideology' acting itself out in *Dracula* – and by seeing it, we are allowed to critique it, determine its limits, comprehend its 'lack of moral vision' (Senf, 1988, 96), its vulnerability (Byers, 1988, 150), and so on. Cranny-Francis also allows for this kind of recognition; her claim, however, is that 'the socially/psychologically/politically repressive apparatus of late-nineteenth-century British bourgeois ideology' is powerful enough to 'resolve' or 'neutralise' whatever contradictions have been raised along the way

(Cranny-Francis, 1988, 78). My own view is that although the novel does resolve itself to some degree at the end, there are crucial spaces in the text – such as the perverse scenes discussed above – in which irresolution and ambiguity (or, indeed, 'queerness') prevail. Mina herself may be one of these unresolved or ambiguous 'spaces': she can be maternal (as Roth has it), passive and submissive (as Cranny-Francis reads her) and yet also sexually independent and 'in touch' with feminist thinking. Furthermore, as noted above, she shares the most intimate moment with Dracula himself – a moment she repudiates soon afterwards in front of Van Helsing and the others, certainly, but which also allows her to feel (as no other character does) 'pity' for the vampire whose blood she has tasted and who she is now helping to destroy.

MINA, WRITING AND MASS TECHNOLOGY

William Veeder begins his excellent Foreword to Margaret L. Carter's collection of essays, *Dracula: The Vampire and the Critics* (1988), by wondering where academic criticism of the novel will go next – in the 1990s. He locates three possible areas of study for *Dracula* critics: the political context, including the novel's connections to imperialism and racism (which I have drawn attention to in Chapter 1) and its representations of class differences; psychoanalytic and feminist approaches, developed out of the kind of criticism examined so far in this chapter; and close studies of the novel's form, paying particular attention to textual 'details'. This third area of study would be particularly important to the on-going history of this novel's canonisation. Veeder himself takes it up by turning our attention to a number of minor characters in *Dracula*, usually ignored by critics – looking at how they problematise reader's assumptions about relationships. I have already discussed one example, Mr Swales, in the previous chapter. Veeder draws attention to Mrs Canon and Mrs Westenra, two more 'bad mothers' in the novel, wondering why it is, for example, that Mrs Westenra (whose health declines, with Lucy's, at the arrival of Dracula) removes the garlic from Lucy's room (Stoker, 1988, 133) – and why, when she sees the head of a wolf at Lucy's window, does she accidentally-on-purpose strip the wreath of flowers away from her daughter's neck (143)? Lucy is quite literally oppressed by her mother in this latter scene; so much so, that Veeder is led to consider whether Mrs Westenra is 'unconsciously in league with Dracula' (Veeder, 1988, xiv).

Veeder points to another aspect of family life in *Dracula* which is also worth noting: all the fathers or father-figures – Mr Hawkins, Lord Godalming, Mr Westenra, Mr Swales – die relatively early in the novel. In the light of this, it is difficult to talk about 'patriarchy'; indeed, the vulnerability of the Crew of Light is heightened precisely because there are no fathers urging them on, as there was in 'Carmilla'. Harker, for example, 'begins to doubt

himself' after Mr Hawkins's death (Stoker, 1988, 157) – and not for the first time. Of course, in some of the readings outlined above, Dracula himself is a father-figure – the 'evil father' or 'primal father' – in which case, the novel acts out a battle *against* 'patriarchy' by a group of men we might, as the novel goes on, better designate as 'paternal': less threatening, more able to negotiate with women, even to draw on their skills. It may be that the Crew of Light are 'patriarchal' with Lucy and 'paternal' with Mina. Certainly, some profound changes take place in male–female relations as the novel shifts its focus from one woman to the other.

Several critics have – directly or indirectly – responded to Veeder's challenge, drawing all three specified areas of study together to provide sophisticated readings of events in the novel. These readings generally centre on Mina who, far from being dismissed as 'passive' or 'maternal', is retrieved as – among other things – a figure for modernity, the most *modern* character in the novel. In her article 'Writing and Biting in *Dracula*' (1990), Rebecca A. Pope[4] turns away from Cranny-Francis's 'repressive hypothesis' – which had seen 'patriarchy' in the novel as coherent, and had accordingly read events through its supposedly dominant voice – to account for the novel instead in Bakhtinian terms, as a patchwork of voices and textualities which play off against one another. In short, the novel is 'polyphonic': there is, as I have already noted, not one dominant voice running through it, but many voices. Pope turns to the word 'vamp', which has two meanings in the *OED*: an alluring woman who exploits men, and – interestingly enough – a 'patched-up article' or improvised (usually musical) piece. The latter meaning might well describe the novel itself, with its 'spectacular array of speakers and genres' and 'flaunted textuality', bringing together 'so many languages, literal and metaphorical – "languages" of gender, class, and ethnicity' (Pope, 1990, 199, 200).

Pope focusses on what Lucy and Mina have to say in the novel – in particular, what they have to say to *each other*. Lucy's letters to Mina, imparting intimate 'secrets' (Stoker, 1988, 55), are an example of writing by women for women. They evoke 'wish-formations' which transgress male prohibitions (such as the desire to marry three men). Her letters also connect her to previously 'misread' women in literature, such as Desdemona – it is interesting in this context that she compares her American suitor, Quincey Morris, to Othello (57). Pope also comments on the scene where Harker – in the 'comforting' room in Dracula's castle – imagines how, long ago, blushing women would write love-letters to their men-folk. For Pope, Harker thinks his own modern mode of writing has displaced 'female passion' – but it returns with a vengeance soon afterwards, with the vampire women. The scene is important in the context of Pope's reading of the novel, since she claims that *Dracula* calls up a 'tradition' of women writers (Mina's 'New Woman' writers, for example) which constantly destabilises 'patriarchy'. Mina is particularly important here, a textual 'knitter and weaver' in the

tradition of Arachne and – when she is silenced, excluded from the Crew of Light – Philomela. Nevertheless, her 'vamping' – where, with her typewriter and copying facilities, she records everything and arranges it 'in chronologi- cal order' (Stoker, 1988, 225) – enables disparate documents (for example, Dr Seward's phonograph) to 'speak', and even to say more than they might otherwise have meant to (but still, perhaps, not enough). At the same time, however, her own writings are overseen by Van Helsing: women are under surveillance in this novel, 'marked' by them (although the men may 'mis- read' what they see). But the relationship is, as I have suggested, always unstable; at the very least, the dialogue between women's writing and men's writing enables Stoker to display – rather than to conceal – 'the strategies patriarchy uses to sustain itself' (Pope, 1990, 210). Men do have the final word in the novel, cohering as a group through 'little Quincey' and through Mina's closing domestication. But the 'Bakhtinian framework' in *Dracula* should by now have made us 'suspicious of master discourses and "final words"' (214): the end of the novel is particularly fragile in this respect, not least because it is – as I have suggested in Chapter 1 with regard to Harker's closing disclaimer about the 'authenticity' of the documents – by no means secure about its status *as* writing.

The reading of *Dracula* which sees it as a 'patchwork' of voices, or 'discourses', is extended in two fascinating articles, Jennifer Wicke's 'Vam- piric Typewriting: *Dracula* and Its Media' (1992) and Friedrich Kittler's 'Dracula's Legacy' (1989). The latter article has already been mentioned in Chapter 1. The key issue for these critics is precisely the kind of anxiety Harker expresses over 'authenticity', an anxiety (not entirely unrelated to Copjec's use of the term) which is seen as appropriately *modern*. Wicke's title comes out of her interest in Mina's professionalisation as a typist and stenographer, skills which modernise Mina, who already has a career as an assistant schoolmistress (Stoker, 1988, 55). In fact, Mina is embedded in modern technological forms. She is, among other things, a 'train fiend', memorising railway schedules. Later, she expresses her gratitude to 'the man who invented the "Traveller's" typewriter' (350), which she uses to record all that happens as the Crew of Light pursue Dracula back to Transylvania. Mina also learns how to use Dr Seward's phonograph, producing typewrit- ten transcriptions by listening to the phonographic cylinders – and thus enabling Seward and the others to access information efficiently. With her Remington typewriter's 'Manifold' function, she can make up to three copies, a fact that is crucial to the Crew of Light's cause when Dracula burns the phonographic cylinders and what he assumes is the only copy of Mina's manuscript. She is certainly very different to Harker's archaic fantasy of blushing women writing 'ill-spelt' love-letters to their husbands! This may in fact explain why Mina never actually becomes a vampire – she has, as it were, an alternative profession. Kittler puts her modernity into context, noting that Remington brought the first mass-produced typewriter onto the market

in 1871 (Kittler, 1989, 155). By the early 1880s, a 'bureaucratic revolution' had taken place which tied transcription and copying skills to the profession-alisation – even, the 'emancipation' – of women (155–6). Van Helsing praises Mina at one point for her 'man's brain' (Stoker, 1988, 234), as if, through her various modern skills, she crosses gender boundaries (her 'heart', however, remains for Van Helsing resolutely female). Kittler makes a similar point – elaborating on Pope's view of Mina as both a 'weaver' of texts and as textually 'marked' by the men around her – by noting that women's entry into the age of mechanical reproduction did away with conventional male/female divisions:

> machines remove from the two sexes the symbols which distinguish them. In earlier times, needles created woven materials in the hands of women, and quills in the hands of authors created another form of weaving called text. Women who gladly became the paper for these scriptorial quills, were called mothers. Women who preferred to speak themselves were called overly sensitive or hysterical. But after the symbol of male productivity was replaced by a machine, and this machine was taken over by a woman, the production of texts had to forfeit its wonderful heterosexuality.
>
> (Kittler, 1989, 161–2)

It is Mina's work, of course, which gives rise to Harker's closing anxiety: 'there is hardly one authentic document! nothing but a mass of typewriting' (Stoker, 1988, 378). In the context of Kittler's argument, Harker may be expressing an anxiety about the loss of his ('authentic') masculinity in a 'new age' of mechanised textual (re)production. Nevertheless, it is difficult to agree that, through her role as a secretary to the Crew of Light, Mina somehow transcends her inscribed femininity. I would say that gender roles are destabilised here, but not done away with altogether. Kittler's conclu-sion, that *Dracula* is essentially 'the written account of our bureaucratisa-tion' (164), simply ignores the relentless gendering that feminist critics have rightly drawn attention to. This can have banal consequences in an other-wise exhilarating sequence of arguments – for example, he reads the scene where Mina sucks the blood from Dracula's bosom as indicating 'nothing more than the flow of information' (167). Although they are both influenced by Lacan, Kittler's reading of this scene is about as far away from Joan Copjec's – discussed in the previous chapter – as it is possible to be! On the whole, he sees Mina as petty-bourgeois, utilising modern 'weapons' to reduce the threat of the Other through 'the gathering of information' (162). But this account effaces the perverse forces of desire at work in the novel; it simply replaces one 'repressive hypothesis' (the conventionally feminist view that 'patriarchal ideology' wins the day) with another.

Wicke, however, maintains the connection in *Dracula* between modern forms of mass production and female desire. Like Kittler, she notes that – by

incorporating such things as stenography and typewriting and copying – the novel thematises 'the bureaucratisation of writing' (Wicke, 1992, 471). But other forms of mass production, or mass circulation, are brought into play. The novel includes a number of newspaper reports, often collected by Mina and included in her journal. It becomes clear that the novel's action actually depends upon such examples of 'mass-produced testimony' (474), which Wicke sees as just as authentic and authoritative as any other 'voice' in the text.[5] The *Westminster Gazette*'s account of the 'bloofer lady', for example, alerts the Crew of Light to Lucy's afterlife: her 'tabloidisation' (474) is necessary for events to go forward. The various newspaper reports help to realise the 'narrative patchwork' effect which Pope had earlier described (Wicke also uses this term); the democratisation of 'voices' in *Dracula* comes about precisely because of the various mass medias the novel pulls together.

But because it *is* a novel, *Dracula* represents those mass medias 'hysterically', and it does this primarily by associating them with women. Wicke's train of association here recalls Andreas Huyssen's argument in his essay 'Mass Culture as Woman: Modernism's Other', mentioned briefly in Chapter 2. Rather than looking at mass (re)production, as Kittler had, Wicke's account of mass cultural forms focusses on *consumption*. The consumer of mass culture is, as Huyssen had noted, feminised – represented from the masculine, 'modernist' perspective as passive or submissive, vulnerable to mass culture, and yet shown also to possess an 'appetite' that can never be satiated. Consumption in the novel is an obsession which leads to madness, as illustrated in the novel through the lunatic Renfield. Or rather, it leads to vampirism: the 'icon' for consumerism here is, of course, Dracula himself. He 'comprises the techniques of consumption' (Wicke, 1992, 475), working through the most receptive characters – Lucy, in particular – who, like Renfield, become obsessive, deranged, uncontrollable (both Lucy and Renfield are ritualistically killed, in not dissimilar ways). An 'ancient' monster is thus used to signify the dangers of the modern world; Stoker's novel is really coming to grips with the latter, rather than the former. Wicke charts Dracula's metaphorical connection to the various mass cultural forms present in the novel (mechanised forms of reproduction – Dracula also replicates, producing copies of himself; the photographic image – Harker uses a Kodak; the telegraph; consumable mass medias and so on), drawing out their shared 'protean' features and highlighting their ability to 'circulate' freely. Indeed, she echoes Marx's equally 'hysterical' characterisation of mass media, noted in Chapter 1, as driven by 'irresistible forces' to spread relentlessly across the globe. But this internationalisation hides the true destination of mass cultural forms: the home. In this kind of representation, vampiric mass medias enter the domestic scene, and women invariably let them in, surrendering to their overwhelming powers of seduction: 'The vampire yokes himself to the feminine because the mass cultural creeps in on little female feet, invades the home and turns it inside out. . .' (479).

Wicke emphasises the different treatment given to Lucy and Mina in the novel. When Mina is 'vamped', the 'textual investment shifts' (484). Whereas Lucy's 'appetite' was her main feature – making her a passive consumer, acted on rather than acting – Mina's mode of consumption is, paradoxically, more *productive*. The perverse scene with Dracula perhaps testifies to this: more than Lucy, she is *engaged* in vampirism, consciously reciprocating (whereas Lucy is always taken in her sleep). She becomes, as the novel goes on, 'more and more the author of the text' (485), collating texts, coordinating events, giving out information. Perhaps her hypnosis by Van Helsing towards the end of the novel would seem to argue against this reading. After all, hypnosis usually involves the female patient's subjection to the male doctor, where he literally places her under his control. Freud and Breuer had seen hypnosis as the means by which the hysterical woman relays information – which she does not 'know' – to someone who is able to transform it into knowledge. That is, it reproduces the polarisation of passive female and active, knowing male, which would see the latter as authorial, rather than the former.[6]

Yet, in the hypnosis scene in *Dracula*, Mina is by no means under Van Helsing's control – quite the opposite. She is in possession of events, speaking of what she sees to Van Helsing – who is otherwise ignorant of Dracula's whereabouts. For Kittler, Mina's hypnosis is another metaphorical representation of a modern technology: relaying back images of Dracula's ship, she works like a 'sensor or radio transmitter' (Kittler, 1989, 169), turning noise (since she cannot see anything) into information. Wicke's point, however, has more to do with Mina's active role in the novel: the hypnosis scene shows her to be 'productive in her consumptive possession' (Wicke, 1992, 486), responsible, ultimately, for guiding the others to Dracula. That is, Mina is 'the consumed woman whose consumption is a mode of knowledge' (486). This is not to say, in opposition to a critic like Cranny-Francis, that Mina is therefore subversive to 'patriarchal domination' – not least because, for Wicke, 'there is no definable patriarchy available' in the novel (487). Rather, it is to show that – through Mina – the novel traces a more complicated relationship between consumption and production than had hitherto been noted.

Wicke had taken Mina as, increasingly, a figure for the author in the novel; the novel, we might note, describes Dracula himself as 'the author of all this' (Stoker, 1988, 217). Wicke's claim, however, presents problems for her argument about the democratisation of 'voices' in *Dracula* – where, as an indication of its modernness, no single author-figure is privileged over any other, and where authority and authenticity are dispersed rather than concentrated. I would rather see Mina as a figure for the *reader*, or rather, as a hybrid figure who comes to confuse the two together. This chapter began by noting that readers, while consuming this novel, have nevertheless also *produced* it in various ways. In this 'new age', consumption is never just

consumption; it always entails the production of new knowledges, new interpretations, new texts. The 'investment' here is mutual. To use Harker's words, an 'ever-widening circle' (Stoker, 1988, 51) of consumed and consuming texts is produced, and – as far as *Dracula* itself is concerned – there is still no sign that it is coming to an end. Indeed, it is difficult not to invoke the novel's own metaphor of vampirism in this respect; Wicke herself does this by noting that *Dracula*'s evocation of mass culture's seductive 'embrace' has ensured its own entry into the vampirish domain of mass cultural forms – where production and consumption have become inseparable. The novel is 'like' a vampire in that it folds the productive author and the consuming reader into each other; the 'perversity' of *Dracula* lies precisely in the mingling of their fluids.

5

VAMPIRES AND CINEMA: FROM *NOSFERATU* TO *BRAM STOKER'S 'DRACULA'*

Suzy McKee Charnas's novel *The Vampire Tapestry* (1980) begins with a character who, at last, is able to recognise vampires: 'On a Tuesday morning Katje discovered that Dr. Weyland was a vampire, like the one in the movie she'd seen last week' (Charnas, 1992, 15). This novel gives us, tongue-in-cheek, the truth about vampire recognition: it comes out of the cinema first and foremost. Most people, certainly, would 'know' about Dracula from films rather than from Stoker's novel, popular as it has been. But the figure of Count Dracula is, now, just one vampire amongst many others in the cinematic world. Around 3,000 vampire or vampire-related films have been made so far, and – although I have only seen about forty of these – it seems safe to say that their differences are often more striking than their similarities. F.W. Murnau's silent German classic *Nosferatu: A Symphony of Horror* (1922), with its rat-like Count Orlok, has little in common with, for example, Alan Gibson's *The Satanic Rites of Dracula* (1973) – which has a smartly-dressed Dracula administering a modern corporation. Paul Morrisey's high camp (and made-for-3D) *Blood for Dracula* (1975) – which, issued under Andy Warhol's signature, combines trash-horror effects with pastoral nostalgia and intensely moving moments of pathos (and has a self-styled 'revolutionary' peasant, inspired by the Russian Revolution, dispatching the vampire aristocrat) – has little in common with Tony Scott's *The Hunger* (1983), which tells of an elegant, rich, bisexual female vampire living in New York, and announces its difference from the classical Hollywood vampire film by opening with the glam-Goth pop group Bauhaus singing 'Bela Lugosi is Dead'. Later vampire films may need to assert their difference from earlier ones; nevertheless, they are often also highly conscious of their predecessors, drawing on or modifying (or, as in *The Hunger*, aggressively rejecting) aspects of them, parodying them, 'recreating' them, and so on. Each new vampire film engages in a process of familiarisation and defamiliarisation, both interpellating viewers who already 'know' about vampires from the movies (and elsewhere), and providing enough points of difference (in the narrative, in the 'look' of the vampire, and so on) for newness to maintain itself.

BRAM STOKER'S 'DRACULA' AND
THE 'ORIGINS' OF CINEMA

This chapter will look at five vampire films: Murnau's *Nosferatu*, Terence Fisher's Hammer horror film *The Brides of Dracula* (1960), Joel Schumacher's *The Lost Boys* (1987) and Kathryn Bigelow's *Near Dark* (1987), and, briefly, Francis Ford Coppola's *Bram Stoker's 'Dracula'* (1992) – which, in America at least, returned Bram Stoker's novel to the best-seller lists. But, as I have indicated, this small selection is only the tip of the iceberg. The publicity surrounding Coppola's 'remake' of Stoker's novel drew attention to some twenty-five vampire films known to be under production during that year alone – including a sequel to *The Lost Boys* and two sequels to Ted Nicolaou's *Subspecies*, a film mentioned in Chapter 1 (Timpone, 1992, 62–5). Clearly, David Pirie's lament in *The Vampire Cinema* (1977) – that 'much of the vampire cinema is coming to an end' because the vampire 'has ceased to be a part of western civilisation's dreams and nightmares' (Pirie, 1977, 173) – was somewhat premature (and had more to do with the closing down of Hammer Films in England at this time).

Indeed, it would seem that cinema is – and has been for some time – the rightful place of occupation for the vampire. David J. Skal comments that '*Dracula* didn't begin in Hollywood, but it travelled there with an inexorable momentum' (Skal, 1990, 4). In fact, in his account of the circulation of various prints of the German film *Nosferatu*, which I shall comment on shortly, it would seem that the vampire was likely to travel to any place with the means (financial and technical) to produce, and to show, a film. Cinema may be a suitably nomadic home for the vampire: it, too, eventually goes everywhere – it has become an internationalised medium. Moreover, the 'dream industry' is drawn to the fantastic – it has a magical 'aura' about it that ideological analyses of film often have difficulty accounting for. After all, film is an animating medium, bringing images to life in an otherwise darkened room, in a simulation of the night – a feature to which horror films in particular often speak directly. Terry Castle has described the 'prehistory' of cinema, the late eighteenth and early nineteenth-century 'ghost shows', highly popular forms of entertainment which used early 'spectral technologies' – and spectatorial technologies – to make the dead (often, lost loved ones of members of the audience) appear to come to life again. For Castle, there was something essentially Gothic about this kind of precinematic activity. It 'supernaturalised' the mind, making ghostly illusions seem, paradoxically, '*more real than ever before*' (Castle, her italics, 1988, 58).

Accounts of early forms of modern cinema – Edison's Kinetoscope, or the Lumière brothers' Cinematograph – likewise focus on its ability to fascinate, to make 'images come to life', to overcome death itself (Neale, 1985, 50–5), and to appear more alive than we imagine ourselves to be (so that, leaving the cinema afterwards, one feels 'let down' by the outside, everyday world, as if it is now somehow *less* real than it was before). Moreover, cinema

'recruits' its audience, calling them back again and again: the 'dream industry' was, from its very beginning, driven by the need for profitability, successfully combining what Jean-Louis Comolli has called 'commerce and the imaginary' (cited in Neale, 1985, 57). This is certainly a place which the vampire might inevitably inhabit – as a seductive, fascinating creature of the night, tied to the reproductive technologies of the modern age and to the accumulation of capital – a creature who, like cinema itself, throws the usual polarity of the real and the illusory, belief and disbelief, into question.

These connections may seem somewhat whimsical; nevertheless, we can seriously entertain the suggestion that the vampire is, in some respects, a 'naturally' cinematic creature. Tom Ganning has remarked on audience reactions of astonishment and terror to early forms of cinema – even while they were aware of the kinds of technologies which produced those reactions. The audience response to early forms of film might be summarised in this way: 'I know, but yet I see' (Ganning, 1989, 33) – a position that recalls Dolar's formula given in Chapter 3, which has the reader of horror fiction simultaneously invoking a conscious negation ('I know it is not true') and an unconscious affirmation ('. . . but I believe it all the same'). Ganning's thesis is directed primarily at a famous early film, Lumière's *Arrival of a Train at the Station* (1895), and at claims that audiences panicked as the cinematic train rushed towards them – as if they took it as, essentially, real. Ganning instead opts for an audience reaction which – as in the uncanny effect – vacillates 'between belief [it is real] and incredulity [it is an illusion]' (35), not least because of the sophisticated technical knowledges of cinematic audiences. The early cinematic experience was not a 'primitive' or child-like belief in the illusion-as-real but, rather, 'an encounter with modernity' (43) which enabled illusion and disillusion to coexist. A delight in film's 'illusionistic capabilities' (43) *combines* with an awareness of its illusory nature. I mention Ganning's argument because, in Francis Ford Coppola's *Bram Stoker's 'Dracula'* – which purportedly offered a faithful reproduction of Stoker's novel – there is in fact an extended scene which has nothing at all to do with that novel, which has the Count and Mina visiting the Cinematograph in London, circa 1896. And one of the films being shown at the Cinematograph is, as it happens, Lumière's *Arrival of a Train at the Station*.

One of the interesting things about Coppola's film is its attempt to modulate its narrative about Dracula through an affectionate recuperation of early cinematic styles. In fact, as Coppola had claimed in an interview,

in certain scenes, we actually used the old Pathé hand-cranked camera. We tried to do all the special effects as they would have been done in those days, in the camera – with double exposures, mirrors, all the naive effects – and not even attempt to get into the modern, computer-generated visuals.

(Timpone, 1992, 31)

The film occasionally fades into sepia tones, or – during crowd scenes in London in particular – it 'staggers' the frames and speeds up the movement, to give the illusion of early cinematic technology at work. There are also a number of 'shadow-theatre' effects which gesture towards the prehistory of the cinema, as well as a repeated motif of the eye-as-lens. Coppola makes it clear that cinema 'began' around the same time as Stoker's novel – the Lumière brothers actually opened their Cinematographie auditorium in London in 1896, the year before *Dracula* was published. It is as if the project of filming Stoker's novel about Dracula also involves filming the beginnings of film itself – as if the return to the 'original' vampire source is merely the means by which another kind of return can be achieved, a way of representing (or, reinventing) film's own original moment, its coming-into-being.

Cinema is, we should note, one of the few popular modern technologies which is *not* mentioned in Stoker's *Dracula*: there is a certain amount of ingenuity (and self-monumentalisation) involved in placing it at the centre of a cinematic 'remake' of the novel. For Coppola's Count Dracula, cinema (so he gathers) 'is the wonder of the civilised world', an example of the limitless power of science. (Its commercial role, incidentally, slips past unmentioned: he doesn't pay to get in. Coppola's film, according to Elaine Showalter, is by contrast *entirely* commercial, more 'about coffers than coffins', Showalter, 1993, 14.) Mina takes a rather more prim view: science has more to do with 'the work of Madame Curie' – cinema, at this point in the film, can barely hold her attention. However, her seduction begins inside the cinema (literally, behind the screen) and is predicated on her increasing disillusion with reality: she tells Dracula later, 'Take me away from all this . . . death!' In a certain precise sense, Mina becomes a figure for the audience, sceptical at first but soon completely enthralled – but it is a feminised, 'primitive' audience, of the kind critiqued by Ganning above. She finds Dracula irresistible – just as cinema itself is irresistible. She 'escapes' into its seductive embrace. She is overtaken by it, resisting any attempt (by Van Helsing, her husband Jonathan and the other male vampire-killers) to convince her to maintain a suitably critical distance.

It is worth remarking on another example of early film glimpsed during the Cinematograph scene in *Bram Stoker's 'Dracula'*, which emphasises the seductiveness of cinema, but in a different way. We see a 'peep-show' film, with a naked woman walking towards the camera. Even at such an early point in its history, in this account, film is thus an erotic medium which splits the audience in terms of gender: while the women are 'carried away', men are positioned voyeuristically. And Coppola's film, generally speaking, reproduces this split. The previous chapter had suggested that, in Stoker's novel, Mina is able successfully to manage modern technologies – her Remington typewriter, Dr Seward's phonograph and so on. In Coppola's 'remake', however, cinema is featured as the representative modern technology – and Mina has a passive, even submissive, role in relation to it. That is,

Mina is in control of her own modernity in the novel, but in the film she is out of control – surrendering totally (and mysteriously) to an irresistible force. This is consistent with the film's rewriting of the novel, which among other things situates almost everything that happens under the umbrella of the Hollywood romance genre – drawing romance and the experience of (going to) the cinema together. Dracula, in Coppola's film, is a romantic and 'naturally' cinematic hero who sweeps Mina off her feet: after just a little while, she simply cannot say no to him.[1]

VAMPIRE FILMS AND GENRE

The posters for Coppola's *Bram Stoker's 'Dracula'* used the tag, 'Love Never Dies': it was, in some respects, a 'New Age' love story, with Mina as the reincarnation of Princess Elisabeth, once the young wife of Vlad the Impaler who took her own life when she was falsely told that her husband had been killed in battle. By opening with this narrative – and by declaring itself as a romantic epic – the film inevitably drew attention to just how far it had *departed* from the novel – even though, by putting author and text together into its title, it seemed to promise (finally . . .) the real thing. In fact, to accompany the film's release, a novel titled *Bram Stoker's 'Dracula'* was published – written not by Stoker, but by the experienced American vampire novelist, Fred Saberhagen. Although Saberhagen (following James V. Hart's screenplay) reproduces some passages from Stoker's novel more or less wholesale, *departure* is the operative word: at the very least we can say, following Tony Bennett and Janet Woollacott's account of the various films of Ian Fleming's James Bond novels, that *Dracula* has been 'worked over' (Bennett and Woollacott, 1987, 191).

Bennett and Woollacott's study of what they call the 'texts of Bond' (232) offers some useful points of comparison in relation to what we might call here the various 'texts of Dracula'. Of course, overall, the James Bond films comprise a more coherent body of work to analyse than vampire films – not least because, for the most part, they were produced by the same people, Broccoli and Saltzman. Nevertheless, we can outline some similar features and note some shared approaches as far as analysis is concerned. Firstly, these films each bear only a nominal relationship to their literary source(s). Moreover, as they begin to comprise a distinctive genre, these films speak to themselves – as it were – much more than they speak to any 'original' novel(s). This may happen at the relatively concealed level of filmic allusion – as in the farcical 'roast beef' scene in Coppola's film, which is lifted from Tony Scott's *The Hunger* (Coppola's film in fact incorporates a number of allusions to earlier horror films). But vampire films have offered more immediate points of viewer recognition than this which similarly generate self-referentiality – for example, the kind of recognition that centres on the principal actor.

To elaborate, we can turn briefly to those vampire films which *were* produced under an umbrella organisation – Universal Pictures and Hammer Films – and in doing so, we can draw at least some comparisons with the James Bond films. The vampire films produced by these two organisations primarily featured two principal actors, Bela Lugosi and Christopher Lee. For many viewers, the Hungarian-born Bela Lugosi might well be the 'original' Dracula: this is often where vampire recognition begins, in the role and image (and voice) that Lugosi perfected in the theatre and which continued to be marketed well after his death. Universal Pictures and Hammer Films both exploited the 'Dracula' title, which enabled them, among other things, to build the identity of the vampire around their principal actors. The title of Universal's vampire films – *Dracula* (1931), *Dracula's Daughter* (1936), *Son of Dracula* (1943) and so on – indicate just how self-referential they were: a stable of films was created around Lugosi's 'original' (and family-oriented) Count. In fact, Lugosi played Dracula in Hollywood only three times, in Universal's 1931 film (which brought them their first profit in two years), in MGM's *Mark of the Vampire* (1935), and in *Abbott and Costello Meet Frankenstein* (1948), also a Universal Picture. But he was subsequently condemned to 'be' the Count in one way or another – while Universal began systematically either to ignore or exploit him.[2] Lugosi's personal identification with (the role of) Dracula is now, of course, the stuff of Hollywood legend. David J. Skal, in *Hollywood Gothic* (1990), claims – in a manner that makes the parallels between his book and Kenneth Anger's *Hollywood Babylon* books clear – that Lugosi's tragedy is 'second . . . only to the (*sic*) that of Marilyn Monroe as the story of the complete entrapment of a performer by an archetypal screen persona' (Skal, 1990, 184). Lugosi was even made up to look like Dracula in death, displayed to the public in an open coffin. Bennett and Woollacott remark on the various ways in which Sean Connery and Roger Moore, the principal actors in the James Bond films, became 'Bondianised' (Bennett and Woollacott, 1987, 273), subordinated to the characteristics of a dominant screen image. We might also note the more macabre way in which Lugosi was 'Dracularised' during and after his own somewhat limited screen career.

By contrast, Christopher Lee, although he emphasised the seriousness he brought to the role, maintained off-screen an ironic distance between his star persona and (the role of) Dracula. Of course, it would be wrong to see Lee as Lugosi's 'replacement' in the same sense that, say, Roger Moore replaced Connery in the role of Bond. Lee's first Dracula film was made almost thirty years later with a different organisation, Hammer Films, which had already had some success with its projected series of horror classic 'remakes', beginning with *The Curse of Frankenstein* (1957). Lugosi was inevitably a point of reference for the new Dracula identity, but Lee was also able to distance his Dracula from the earlier one. Lee adopted the Lugosi Dracula's elegance and charm, the sleek, back-brushed hair, the arched eyebrows –

but dropped the 'foreign' accent and underscored Dracula's sexual attractiveness and ferocity (Lee describes his screen Dracula as a 'juggernaut', Timpone, 1992, 47). Interestingly, Lee's role as Dracula was contemporaneous with Connery's role as Bond, spanning the 1960s and early 1970s: these tall, dark, violent, sexually attractive men have much in common.[3] A striking trademark was Lee's red eyes: Hammer Films generally exploited the blood-red colour in an otherwise darkened film set, whereas Lugosi's vampire films had been in black and white.

Lee's Dracula, then, departed from Lugosi's in a number of ways; what is interesting, however, is that both actors were keen to portray their own Dracula in the *same* way in each vampire film they made. Thus, in MGM's *Mark of the Vampire*, Lugosi – although outside of Universal's jurisdiction – appeared (as Count Mora) just as he had in the 1931 *Dracula*, except for a ruffled shirt and, inexplicably, a bullet hole in the side of his head (Haining, 1987, 114–15). He recreated the 'look' again in the 1948 horror comedy. Christopher Lee, who played the Count for over fifteen years, had complained that the Hammer Dracula had moved further and further away 'from the original concept of the character': 'In whatever context I play Dracula', he said, 'I don't change. I remain the same' (cited in Haining, 1987, 89). In other words, both actors tried to make their role as Dracula original to themselves – and to fix it as a point of reference for viewer recognition in subsequent films. Following Bennett and Woollacott, we can note that Bram Stoker is as absent from these identifications as Ian Fleming is in popular perceptions of the James Bond films. Bennett and Woollacott's remarks on the various cinematic James Bonds – Sean Connery (the 'real' James Bond), George Lazenby, Roger Moore – are in some respects useful as a means of thinking about Bela Lugosi and Christopher Lee. As they suggest, the author and his 'original' novel are by no means the issuing sources of meaning in the various 'texts of Bond', or, in our case, the 'texts of Dracula'. These films instead establish their own 'look' – through the principal actor, in particular – which then stands as a constant point of reference for viewer recognition, both in those films and beyond them. Rather than being dependant upon an 'original' novel – Bram Stoker's *Dracula*, in this case – this 'look' becomes original to *itself*.

We can make a second point about vampire films – as a genre – by drawing again on Bennett and Woollacott's study of James Bond films. For these critics, the Bond films do not simply re-present the same set of topics over and over again. Rather, these films engage in a constant process of ideological and cultural 'remodelling' (Bennett and Woollacott, 1987, 232) which both reflects and comments upon changes over time in society in sexual (Bond and 'the girl') and national (Bond and England) identifications, the two main focusses of their study. This constant 'remodelling' makes it difficult to dismiss these films as, merely, formulaic; rather, the focus should be on the discourses (sexual, national) which such 'remodellings' mobilise,

which may pull the 'formula' in various directions. The same can be said about vampire films – a point I shall elaborate on when I look at specific examples below. Bennett and Woollacott draw on Stephen Neale's work to emphasise the way in which genre should be seen not as something fixed at the level of textual formula, but, rather, as something which is 'culturally variable', which depends upon 'the relative weight and specific articulation' of the discourses it mobilises (95–6). Neale notes that different genres – detective fiction, the western, Gothic horror – may in fact mobilise similar discourses: his example is legal discourse, discourses about crime, social order, property, civic responsibility, and so on. But the mobilisation of these discourses is never the same in each case; it is a question of 'the modification, restructuration and transformation they each undergo as a result of their interaction' with, among other things, the specific features of the genre itself (Neale, 1980, 6–7). These narratives move from an initial (or 'pretextual') equilibrium, to a series of interruptions which produce disequilibrium, and finally to 'a new equilibrium whose achievement is the condition of narrative closure' (6). In westerns, detective fiction and Gothic horror, disequilibrium is inaugurated by violence to the social order, and (an often legally sanctioned) violence is usually the means by which a renewed equilibrium is restored at the end. But '[w]here they differ from one another is in the precise weight given to the discourses they share in common, in the inscription of these discourses across more specific generic elements, and in their imbrication across the codes specific to cinema' (7). Horror films, for instance, have the 'special option' (8) of yoking legal discourses ('the Law/disorder dichotomy', 8) to discourses about civilisation and Nature, the natural and the deviant and so on. The 'relative weight' of these discourses in each film, however, is subject to change.

As far as vampire films are concerned, we may think that they are more formulaic than most – after all, there would seem to be a number of things (blood, stakes, crucifixes, garlic, a spectacular climax) that they simply could not do without. Certainly, at one level, vampire films are highly recognisable – the more so if, as I have noted above, they centre around the same principal actor, the same organisation and so on. But they are nonetheless 'culturally variable' for all that: the movement from equilibrium to disequilibrium to renewed equilibrium can manifest itself in a number of ways. Those discourses identified by Neale to be at work in horror films, concerning Law and disorder, civilisation and Nature, the natural and the deviant, are given a particularly sexual inflexion in vampire films. That is, the tension between equilibrium and disequilibrium is often primarily inscribed through a character's sexuality – which has been, of course, one of the *most* 'culturally variable' features of cinematic representation. Vampire films thus often focus on youth, when sexuality is in its most formative moment. Finally, in vampire films these discourses (with their sexual inflexion) are put to work through two sites in particular – the nation and the family – drawing

attention not just to the 'cultural variability' of these discursive terrains but, more to the point, their downright instability.[4]

F.W. MURNAU'S *NOSFERATU*

David J. Skal's *Hollywood Gothic* is a fascinating and unconventional history of early vampire films: as Skal himself notes,

> A completely straightforward academic history would simply not do the subject matter justice; the *Dracula* legend rudely refuses to observe conventional parameters of discussion and touches upon areas as disparate as Romantic literature and modern marketing research, Victorian sexual mores and the politics of the Hollywood studio system.
>
> <div align="right">(Skal, 1990, 7)</div>

The account of Murnau's silent German film *Nosferatu* – the first film made about vampires – is particularly interesting. After Bram Stoker's death in 1913, his widow Florence relied on income derived from the sales of *Dracula* in particular, and she accordingly retained its copyright. In 1922, she complained about an unauthorised cinematic adaption of *Dracula* in Germany: *Nosferatu: Eine Symphony des Grauens*. The production company was Prana-Film: the name was derived from the Buddhist concept of 'breath-in-life', and *Nosferatu* was the only film they produced. In order to be compensated for the unauthorised film-rights, Florence had to obtain injunctions on every country in which the film was shown. She was only partly successful in her 'relentless campaign against *Nosferatu*' (59) – for, as Skal notes, 'a vampire has numerous hiding places' (60). Skal's account becomes increasingly overtaken by vampirish images: when the film turns up in London, Florence's legal advisers are like the Crew of Light in their search for its origins (63); the film is Florence's 'waking nightmare'; the British importer disappears without a trace; the film seems, finally, to have 'achieved a life of its own', moving 'through her world as it pleased' (63).

Nosferatu may have been an unauthorised copy but, in many respects, it bears little relation to Stoker's novel. The script was written by Henrik Galeen, who had collaborated in 1914 with Paul Wegener on the script of the first *Golem*. All the characters' names were changed: Dracula was Count Graf Orlok, Jonathan's last name became Hutter, Mina was called Ellen – although in later prints, their names were restored, except for Mina, who is named Nina. Lucy (who is married) had only a minor role. Renfield – in a significant change – was Hutter's employer: he is, it turns out, insane, and enslaved to Orlok. Van Helsing was renamed Bulwer and – again, significantly – is rendered completely powerless against the vampire. There is no Crew of Light: in this film, Ellen destroys the vampire through her courageous self-sacrifice. The events are shifted into the German town of

Bremen (or Wisborg, depending on the print) and set in 1838. In
only narrative events in common with *Dracula* involve Hutter's journ
Transylvania to negotiate a property deal with Orlok, and Orlok's attractio
to Mina/Ellen – which similarly concludes with the vampire 'replacing'
Hutter in their bedroom as her (sexual) partner. Undoubtedly, the most
striking feature of this film was the 'look' of the vampire itself. Orlok was
played by Max Schreck – the surname means 'terror' in German.[5] He
featured a bald head and pointed ears, a large hooked nose and two rat-like
front teeth. When Hutter first meets him, he is wearing a cap and rubbing his
hands together – he has long claws for nails. He wears a three-quarter length
jacket, buttoned up tightly. Schreck's Orlok dominates the film; indeed, for
film critic Eric Rhode,

> [w]hen he emerges high on the edge of a horizon, or framed in a
> doorway, or walking the deck of a ship, he seems to take possession of
> these places and rob them of their identity. Coffins and doorways
> become apt niches for his emaciated body, and bare fields seem to
> distend from his gnarled form.
>
> (Rhode, 1976, 183)

In this account, Orlok colonises – or vampirises – the entire landscape of the
film.

It is commonplace in film histories to contrast German silent cinema, and
early European black-and-white art-horror films generally speaking, with
the Hollywood mainstream. S.S. Prawer, for example, clearly privileges
'aesthetically shaped' films such as Murnau's *Nosferatu*, Robert Wiene's *The
Cabinet of Dr Caligari* (1919) and Carl Dreyer's *Vampyr* (1932), over later
American and English 'exploitations' of the horror genre (Prawer, 1980, 48).
Prawer draws heavily on the 'uncanny' in his film readings, using it primarily
to mean the creation of a sense of 'uneasiness' – although he draws on
Todorov's sense of the 'uncanny', that is, the ambiguity of whether what one
sees is real or imagined, in his reading of *Vampyr*. In this context, the more
shocking and sensationalist tactics of recent horror films are seen simply as
crude and unsubtle. But Murnau's *Nosferatu* is also highly sensational
(David J. Skal's presentation of the film's publicity certainly supports this
point) and, arguably, one of the crudest vampire narratives of all. Skal
rightly notes that (unlike, say, Dreyer's *Vampyr*) *Nosferatu* 'is starkly devoid
of the consciously ambiguous or knowingly ironic' (Skal, 1990, 54). Its
shock-value relies entirely on the grotesqueness of Orlok and in his associa-
tion with the bubonic plague – which he brings (unwittingly assisted by
Hutter) into Bremen. Hutter has carried *The Book of Vampires* home with
him – he found it in his room at the inn, during his stay in Transylvania. The
book makes it clear that only a woman 'of pure heart', who offers her blood
freely to Nosferatu, can end the plague. When she discovers the book, Ellen
decides, melodramatically, to sacrifice herself: she destroys the vampire,

*...fact,
the
...y to*

...until the sun rises, and shortly afterwards dies in her
...s arms.

...er (who has drawn attention to the *technical* sophistication
...perhaps rightly critiqued the tendency amongst film critics
...in Expressionist horror-fantasy films as allegories of
...history which speak of the national character, the 'German
...on (Elsaesser, 1989, 25). Fantasy is never, totally, that trans-
pa... *Nosferatu* clearly attempts to create a 'typical' German town,
and juxtapose it against a foreign threat – and it is not difficult to place this in
the context of attitudes prevalent in Weimar Germany in the 1920s. We can
turn, in particular, to those aspects of the film which – in relation to Stoker's
Dracula – had undergone the most 'remodelling'. The most surprising
character shift in the film involves Renfield, who – as I noted above – is now
Hutter's employer, a real estate agent. Like Nosferatu, he is a bald,
hunched, obsessed figure – as the English intertitle notes, 'subject of many
an evil humour'. The clarity of the various intertitles contrasts with the
correspondence shared by Nosferatu and Renfield: they are both shown
poring over a sheet of paper covered in hieroglyphics. They are, in other
words, engaged in a private transaction – and the hieroglyphics underscore
its foreignness (to 'us'). Renfield encourages Hutter to carry out the deal
with the vampire, promising him money and advancement. It is Renfield,
clearly, who brings the plague of Nosferatu to Bremen; later in the film (even
though the connection between Renfield and Nosferatu is never made
public) he is chased across the town by a crowd of angry townspeople in a
scene that anticipates, for example, the 'folk's' attack on Frankenstein's
monster in James Whale's 1932 film.

The film thus supplements its dominant vampire narrative with a second,
connected sequence of events. That is, Nosferatu's destruction, involving
the willing sacrifice of a woman 'of pure heart', unfolds alongside Renfield's
persecution by 'the people'. Drawing the Nosferatu/Renfield narratives
together helps us to situate the film's evocation of a foreign threat to an
otherwise 'innocent' German town – a threat dealt with in a simultaneously
fantastic and 'real' way. Given the appearance of Nosferatu and the connec-
tion to Renfield – who helps him to purchase German property (the film
emphasises that Nosferatu will be Hutter's neighbour) – it is, in fact, difficult
not to see this German film as anti-Semitic. Elsaesser notes that the narrative
of *Nosferatu* depends upon 'the enactment of a deal, a bargain, an ex-
change', showing the dark side of trade – it brings the plague – but (not least
because the appearance of the principal actor does not concern him) he
never connects this to anti-Semitic representation. M. Bouvier and J-L.
Leutrat, however, describe Schreck's Nosferatu as 'a Shylock of the Car-
pathians' (cited in Skal, 1990, 52), which seems accurate enough. Perhaps
Ellen *does* come to represent the 'German soul' here, at the mercy of the
property-acquiring Jew-vampire; the famous scene which shows the shadow

of his arm and hand moving up along Ellen's body, and the fist clenching over her heart, would suggest that, for the moment anyway, that soul is possessed. Incidentally, Nosferatu's destruction, caught in Ellen's bedroom by the sun's rays, amounts to a kind of overexposure: the film itself helps to destroy the creature it has created.

Nosferatu repeats the point that the vampire preys upon the *young*: they are shown, finally, to be strong enough (committed enough to the emergent nation?) to repel this particular foreign threat – although sacrifices have to be made. In the meantime, the 'folk' are also mobilised, to chase the 'real' version of this fantastic creature, Renfield, out of town – to evict those who would negotiate with foreigners, sell them German property, speak their peculiar language. As I noted above, there is no Crew of Light in the film, and Van Helsing/Bulwer is a minor character who arrives too late to intervene. He is a parody of the insulated academic type, oblivious to the 'real' events taking place around him – for this particular Van Helsing, vampires inhabit only the plant and animal kingdoms. In Stoker's novel, of course, Van Helsing had been able authoritatively to diagnose the vampire and implement remedies; in *Nosferatu*, however, the film acts as its own authority, making events unfold *without* diagnosis. There is no debate about belief and disbelief, for example: the vampire, and the remedy, just *are*. Thus, when *The Book of Vampires* tells us, apocalyptically, that a woman 'of pure heart' is needed to end the plague, it becomes clear that the point must be borne out to the letter. The decision is focussed onto Ellen: killing the vampire becomes her responsibility alone – but it is also, by implication, a civic duty. Nosferatu now occupies the neighbouring building and stares longingly into her bedroom. Sending Jonathan away, Ellen allows him to come *into* her bedroom, so that her civic function is now clearly channelled through her sexuality. To keep German property 'pure' – free of vampires – she must allow her body to become impure.

If the film has any ambiguity at the narrative level, it is in this closing scene – since Ellen's moment with the vampire both finalises this national allegory, and is, in its literal evocation, tangential to it. That is, the climax to the film (which is supposed to bring it to closure) is also the point at which the national allegory is most unsettled – precisely through the transference of it into this sexualised space. It severs, rather than draws together, the private and the public, inside and outside, the fantastic and the 'real'. Ellen's role as a wife and a woman seems, at this crucial point, utterly remote from her civic responsibilities, breaking rather than reaffirming her connections to the 'folk' outside. Moreover, by focussing on her sexuality, the film introduces a new complication. By making Ellen's decision to let the vampire into her bedroom central to the narrative, *Nosferatu* inevitably invokes the conventional presentation of woman as virgin and whore – she *is* 'pure' (and is therefore appalled by what she has to do) but she is also not *really* 'pure' (because she makes her bed available to the vampire). The film works hard

to suggest that this scene is not a seduction – Gregory A. Waller reads it as a rape (Waller, 1986, 193) – but, to carry itself through, it must also show that Ellen is complicit in the act (sending her husband away, making herself 'available'). The tension between Ellen's private and civic (or, national) roles is, then, 'stretched' in this scene: the most horrific moment in the film is also, ideologically, the most fissured. It is worth noting that the ambiguity of this scene is emphasised in Werner Herzog's 1979 remake of *Nosferatu*, not least through the change of Ellen/Mina's name to Lucy – who, as Paul Monette's fine book of the screenplay makes clear, comes to 'love' the vampire she lures into her bedroom (Monette, 1979, 137) – and he loves her in return. This remake in fact provides a good example of ideological 'remodelling': Herzog, in a move more appropriate to his times, perhaps, used the vampire 'positively' to critique the bourgeois characteristics of the German people.

TERENCE FISHER'S *THE BRIDES OF DRACULA*

Hammer Films reputedly saved the British film industry: they made hundreds of profitable films between the mid-1950s and the late 1970s, most of them variations on nineteenth-century horror narratives already 'worked over' by Universal Pictures in the 1930s – *Frankenstein*, *Dracula*, the Mummy, the Werewolf, *Dr Jekyll and Mr Hyde* – as well as films about zombies, witches and witch-hunters and a number of psychological thrillers. David Pirie has drawn attention to the shift in trade across the Atlantic, helped by Universal relinquishing the copyright over their horror classics – which led to Hammer Films establishing their dominance in the horror genre by the late 1950s, creating a specifically 'English Gothic' look to their films (Pirie, 1977, 77). Hammer pioneered the use of 'lurid' colour, red and blue especially, and began to present violent and sexual events in an increasingly explicit and 'shocking' way – developing their special effects accordingly (for example, the creation of 'real' blood). Their vampire films apparently provoked the greatest audience 'distaste' (78), with their graphic staking scenes and images of burning flesh. Pirie comments on their 'overriding physicality' (78): they drew increasing attention to the body as a site for potential mutilation, and (as far as its female actors were concerned) titillation. Hammer's screenplay for Richard Matheson's classic vampire novel *I Am Legend* (1954) – which would have been their second vampire film – was banned by the British film censors before filming had even begun (86–7). By the mid-1960s, however, Hammer's vampire films were openly flaunting the connection between biting and the (female) orgasm, pointing its stakes in between heaving bosoms. In the early 1970s, with their 'female sex vampire' series (Roy Ward Baker's *The Vampire Lovers* (1971), Jimmy Sangster's *Lust for a Vampire* (1971), Peter Sady's *Countess Dracula* (1972), and John Hough's *Twins of Evil* (1971)), Hammer Films presented full-

frontal nudity and scenes of overt lesbianism, and firmly associated vampirism with 'perverse', although highly eroticised, sexual behaviour. Describing a scene from *Lust for a Vampire*, which shows blood dripping from the mouth of the lead female vampire and running down over her bared breasts, Pirie wonders how Hammer's Gothic horror films were able to get past the British – and American – censors at this time, 'especially in the suggestion of sadistic pleasure' (100).

For S.S. Prawer, Pirie – whose book emphasises the connections between the vampire and sexuality in vampire films – is an 'eloquent apologist' for the Hammer material, in particular the early work of Terence Fisher (Prawer, 1980, 256; another 'apologist' is T. Liam McDonald, who claims, against the odds, that the later lesbian vampire films of Roy Ward Baker are handled 'with elegant restraint': 'his camera never leers', McDonald, 1992, 158). Prawer actually incorporates a reading of Fisher's *Dracula, Prince of Darkness* (1965) into his study – but he disapproves of it on the whole, regarding it as having 'the interest and significance of a symptom rather than that of a successful work of art' and contrasting it unfavourably with Werner Herzog's remake of *Nosferatu* which, for Prawer, 'uses the language of European painting' (Prawer, 1980, 263–4). The privileging of high art horror films over 'exploitative' films – and the Hammer Films producers often flaunted this image of themselves (241–2) – has already been remarked upon as a feature of Prawer's study. Nevertheless, he stays with Fisher's film long enough to raise some useful points. In particular, he notes the intention by Hammer Films to appeal to 'a Britain newly orientated towards "youth"' (246), with 'youth' becoming an increasingly marketable phenomenon (already spoken to and for by film, in the American 'teen flicks' of the 1950s). Prawer sees Fisher's films as conservative as far as representations of class are concerned – but he notes, returning us to Neale's example of a dominant discourse in the horror genre outlined above, that the staking scene in *Dracula, Prince of Darkness* put into the foreground questions of 'law and order', a preoccupation of the times. That is, the ferocity of the staking called the righteousness of the authority-figures in the film into question: the film seems to say, for Prawer, 'that if this is what law and order look like, we had better rethink our values' (263).

I want to elaborate on these points by turning to an earlier film directed by Fisher, *The Brides of Dracula* (1960). This was an unusual vampire film in some respects. It did not star Christopher Lee as Dracula – although the equally well-known Peter Cushing played Dr Van Helsing. Rather, the film featured a new, young actor in the role of Baron Meinster, a vampire with a 'baby face'. The film opens with a voice-over: 'Dracula . . . is dead, but his disciples live on to spread the cult and corrupt the world.' The notion of a 'cult' – growing, potentially out of control – is emphasised during the film and associated with the youthful Baron Meinster. In this respect, the film clearly has something to say about 'youth'. It begins with Marianne (or

Danielle: her name seems to change during the film) travelling in a coach – driven at top speed – to a Ladies' Academy for her first posting as a teacher. She has become, in other words, recently independent. The coach stops at an inn; soon afterwards, an elderly woman, Baroness Meinster, arrives at the inn and – since the coach has unexpectedly departed (these early events seem to be arranged by a mysterious, dark man who, inexplicably, is never seen again in the film) – she offers to take Marianne back to her castle for the night. In a room below, Marianne glimpses a young man. The Baroness admits that he is her son – and her prisoner. She explains that, once, she had 'spoiled' him and encouraged his friends and 'laughed at their wicked games'; but he brought ruin into the castle with his cruelty and madness, and the Baroness, despairing, had secured him with a golden chain. Marianne is horrified: when the Baroness is otherwise occupied, she frees the son – and Dracula/Baron Meinster's rampage begins, directed firstly at his mother (who becomes his first victim, turning into a vampire) and, later, at the Ladies' Academy.

The discourse of 'law and (dis)order' is already available in these opening scenes; but clearly, it is modulated through the more immediately recognisable topic of parental responsibility. The young Baron has no father, just an overindulgent mother – the extra table-setting at supper reminds us that the family is in this sense incomplete. The only restraint she provides is, ultimately, no restraint at all. This mother-and-son parable is set alongside an incident in the village involving a father and his daughter – the Baron's first *willing* victim and, hence, part of the growing 'cult' of young vampires. Marianne is presented as simply naive, easily duped by the aristocratic Baron; so is Gina, another young teacher at the Academy who likens the handsome vampire to 'Prince Charming', and soon becomes his second willing victim. The Ladies' Academy is another kind of family, managed by an elderly husband and his wife – with the teachers and girls as their daughters. The father, Herr Lang, is an 'ogre'; but in this film, strict fathers are as ineffectual with the young as overindulgent mothers. Indeed, Hammer Films had little time for strict fathers, who were often represented (as in *Twins of Evil*) as obsessed and demented – the cause of youthful waywardness, rather than the solution. No doubt this 'critique' was also directed at the censors: to penalise the kind of excesses defined as appealing to youth, it implied, would only drive them underground – where, as a 'cult', they would be even less desirable.

The film solves its family crises through the figure of Dr Van Helsing. He shows both concern about the growing 'cult' and understanding for those who would be drawn to it; that is, his role in the film is paternal, rather than patriarchal. Through him, the film rehabilitates the figure of the doctor who carefully and correctly diagnoses what is wrong – contrast this with *Nosferatu*, which refuses the space for diagnosis or understanding (Ellen must do what she must do . . .), and thus renders its Van Helsing character

(who is *supposed* to diagnose) completely ineffectual. In *Nosferatu*, the illusion of the vampire is kept up until the end; in *The Brides of Dracula*, Van Helsing's role is to *disillusion* the young about vampires – their 'cult' is not as appealing as it might at first seem. He mediates between the strictness of parents (which doesn't work) and the loose morals of youth (which get them into trouble); his role, symptomatic perhaps of Hammer vampire films' on-going recovery of the 'Victorian values' of vampire narratives, is one of *management*. (The film introduces another doctor, Dr Tobler, as a point of contrast. A comic figure – unusual for Hammer horror films – he is literally unhealthy, and cares only about his fees, not about the well-being of his youthful patients. As a doctor, he is a bad parent.) The final scenes show a prolonged battle between Van Helsing and the young Baron over Marianne – in an old, burning windmill. As the cross of the windmill catches fire, the Baron is caught in its shadow and expires. Religious iconography was used freely by Hammer Films; the priest in the film, however, is shown to be as ineffectual as Van Helsing was in *Nosferatu*. The closing scene may certainly suggest that Meinster has somehow been recovered by the church; but, more likely, it is meant to echo, and depart from, the famous ending to James Whale's *Frankenstein* (1931), which had the monster trapped in a burning windmill, under siege from an angry 'lynch' mob. Whale had focussed on the burning cross of the mill, which one commentator has taken as a deliberate suggestion of the Ku-Klux Klan (O'Flinn, 1986, 212), active in America at the time. In Fisher's film, however, there is no angry mob – the situation calls for diagnosis at the 'personal' level, rather than the recruitment of righteous-ness at the 'mass' level. Moreover, the burning cross is in shadow: the ending is calmer, with Meinster dying peacefully. Whale had also shown Baron Frankenstein reunited in the arms of his fiancée, Elizabeth; in Fisher's film, this is echoed with Van Helsing embracing Marianne, likewise signalling the return to order. But the embrace is paternal, not erotic: it shows the return of a prematurely independent girl into the parental/paternal fold.

It would be fair to say that little theoretical attention has been devoted to Hammer horror films over the years. For the Freudian horror film critic Robin Wood, they show an 'unremitting crudeness of sensibility' (1973; cited in Prawer, 1980, 268) – there would seem to be little there to analyse. Roger Dadoun's 'Fetishism in the Horror Film' (1989) is an exception, however, and – in the light of the above remarks about youthful excess and parental concern – it is worth commenting on it briefly here. Like Žižek, Dolar and Copjec, the Lacanians whose work was discussed in Chapter 3, Dadoun brings 'high theory' to bear upon 'low culture'. His thesis, in fact, is similar to theirs. It begins with a discussion of the Freudian fetish – noting that fetishism arises out of an identification with that which is no longer there, namely, the pre-Oedipal mother (the breast). One was engulfed in this formless 'time before'; but afterwards (in the Oedipal phase) one experi-ences the anxieties of separation, abandonment, disintegration – and the

101

unsettling knowledge that what was taken as a totality is now seen to be lacking: the mother does not have a penis. One's sexuality functions primarily as a defence against these anxieties, as a means of ritualistically replacing what is no longer there. For Dadoun's Oedipalised (male) subject, this involves the erection of the phallus-fetish, 'all the more rigid and impressive for being fragile and threatened' (Dadoun, 1989, 41). The phallus-fetish may certainly make its presence felt (54) – but this 'substitute' for the missing penis 'can only be, in the last resort, an illusion' (55). It is, in effect, both there and not there (55–6).

For Dadoun, this 'phallus-fetish' is represented nowhere more effectively than in vampire films – through the figure of Dracula. Murnau's Nosferatu is, for Dadoun, 'a walking phallus', an 'agglomeration of points' (54–5). Christopher Lee's Dracula is similarly 'erect', with his long teeth, 'penetrating look' and 'piercing' eyes (55). Yet this phallicness is remarkably unstable – it is liable at a number of moments to dissolve (back) into formlessness, as the Hammer films show so well with their perfected 'time-lapse' special effects (where Dracula eventually, in a number of films, turns to dust and is blown away by the wind). He is powerful by night, but helpless – as an infant – by day. He seems engorged, but his body is empty. He is shown to be in the room – but he casts no reflection in the mirror. (Actually, Murnau's Nosferatu *does* cast a reflection in Ellen's bedroom mirror.) And all the while, the archaic mother is there – and not there. Dadoun points out that in the Hammer vampire films especially, there are in fact no *actual* 'mother figures' attached to the vampire. The mother appears, instead, 'as a very archaic mode of presence', symbolised through an ever-decreasing series of enclosures, more and more confining and 'uterine' by nature. This kind of representation leads us finally 'to the purest, most original sign of archaic motherhood, a *pinch of earth*' (52).

Dadoun cites the one exception to this 'rule' – *The Brides of Dracula* – where the young vampire is the son of 'an old lady of harmless demeanour' (52). That is, the vampire *does* have an actual mother in this film. The elaboration of this exception might seem, of course, to undo Dadoun's thesis. In fact, on the whole in these Hammer vampire films, Dracula has no parents at all – mother or father. But *The Brides of Dracula* is an exception to this rule in the opposite sense to Dadoun's thesis, since, in this case, the vampire has no *father*. The film does enact a certain pre-Oedipal scenario, but with different consequences. By going down to a room at the back of the castle and unlocking the golden chain which holds the son prisoner, Marianne symbolically 'delivers' a boy-child, the vampire with the 'baby face' – that is, she cuts the umbilical cord and enables 'birth' to take place. The Baron's function after this moment is both to identify himself sexually, and to identify himself through the family structure (the slippage from one to the other in this film characterises his 'perversity'). Thus, he 'claims' his mother almost immediately; he claims two 'brides' or sisters; and finally, by biting

Van Helsing, he attempts to claim a father. But Van Helsing repudiates this claim – and rejects the son's identity as a son. In effect, the otherwise promiscuous Baron is emasculated: the Oedipal stage, through which the Baron must go in order properly to establish his phallic identity (by identifying with the father), never gets off the ground. Of course, the father's refusal is also necessary as far as the 'cult' is concerned – which must similarly be emasculated before it can grow (up).

NEAR DARK AND THE LOST BOYS

Most American vampire films, in the 1980s and early 1990s, at any rate, directly addressed 'youth culture' – (upwardly) mobile white youth, on the whole. They introduced a rock'n'roll sound track, developed the connections between special effects, speed and travel, fine-tuned the vampiric puns, and had their vampires getting around in gangs, showing off their leather and their hardware. Young American vampires become highly attractive to others (in terms of their 'look', and as a subculture); this may be the least manageable thing about them. I have chosen to discuss two vampire films produced during the same year, 1987, which are in many ways – visually, especially – quite different from one another. Kathryn Bigelow's *Near Dark* was a low-budget movie which presented its subject seriously; Joel Schumacher's *The Lost Boys* was a glossy, big-budget studio film which combined drama and 'out of control' comedy. Nevertheless, they do share similar anxieties of the kind already noted in relation to *The Brides of Dracula* – anxieties centred around the adolescent's relations to the family and to sexuality, and which have to do with questions of law and lawlessness. In both films these 'spaces' are shown to be incomplete and therefore vulnerable – they become what are often called 'sites of contestation', which draw all the various forces at work in these films together. Moreover, whereas in *The Brides of Dracula* events are managed from above, as it were – that is, by a concerned, paternal figure – these films advocate *self*-management. Youth is now asked to be, or shown to be, capable of managing its own problems. Indeed, in *The Lost Boys*, muddled adolescence is helped from *below* – by younger kids who know their own minds (precisely because they are *not* adolescent).

Both *Near Dark* and *The Lost Boys* feature handsome young male protagonists who, as they become involved with vampires, experience at some length the trauma of the transformation. The vampires are in both cases gangs with a certain cool glamour. What is emphasised here is the 'pull' of lawlessness – figured through these films' connections with the 'road movie' genre and, in the case of *Near Dark*, with the western. In both cases, however, this 'pull' goes hand-in-hand with the 'pull' of heterosexual romance, where each protagonist is attracted to a particular vampire girl. In *Near Dark*, Caleb lives on a farm outside a small town in Oklahoma where

nothing much happens. He has a father and a younger sister, Sarah – but no mother. Caleb's early throwaway taunt to a friend, that he has slept with his (the friend's) mother – to which the latter replies, 'You wish. . .' – thus takes on a certain significance: the film could well be read as the recovery of a mother-figure and the enactment of Oedipal desire. A strange girl – May – appears and Caleb picks her up, secure in his sexual power. But, as they kiss in his truck, *she* takes control and, after she bites him, he is thoroughly weakened. The gang of vampires to which she belongs then kidnaps Caleb in front of his (now even more incomplete) family and drive off. They are a raunchy, whooping group with a Southerner feel – in fact, the leader, Jessie, claims to have fought for the South during the Civil War. The film juxtaposes the lawlessness of the vampire gang – they can do 'anything we want' – with the law-abiding world of the father and his family.

Caught up in the world of this vampire gang, Caleb is locked into the two conflicting dominant representations of youth culture analysed by Dick Hebdige: 'fun' and 'trouble' (Hebdige, 1988, 17–36) – although in the choreographed, pun-laden 'slasher' killings in the roadhouse, acted out to The Cramps' version of the song 'Fever', there would seem to be no conflict at all here. One policeman tells Caleb, 'Get home, and be a good boy'; another tells his father, 'your boy's fallen in with some trouble'. Caleb is 'on the turn', as the vampires call it – although they repeatedly note that he 'don't belong' with *them* (until later, when he literally 'earns his spurs'). Caleb has remained in his weakened condition for most of the film, unable to kill for himself and dependent for blood on May, which makes her maternal, nurturing role in relation to him clear. He is re-empowered, however, when he sees his father and sister at a motel – the more so when, later on, the vampires kidnap Sarah. After Caleb has fought with a rival vampire, another youth, May helps Sarah to escape. The rest of the vampires are burnt up by the sun. Caleb's father is a vet: he performs blood transfusions on Caleb and May to return them to the human fold. May helps to 'complete' the family: her maternal instincts are also demonstrated when she saves Sarah.

The film's complication lies in the way it 'mirrors' the good family through the vampire gang. The leader, Jessie, has a female companion who also reveals her maternal instincts: in this film, all women, even vampire women, are potential mothers. May is a generation down, and there is a male youth of around the same age – Caleb's rival – although it is important to note that he and May have no sexual interest in one another. As well, there is a young boy, named Homer – significantly enough for this nomadic outfit – who 'mirrors' Caleb's sister Sarah and who has the role of May's 'kid brother'. As families go, this one is, then, more 'complete' than Caleb's. Certainly the film juxtaposes the two, positively and negatively: while Caleb's family is orderly and 'clean', the vampires are dirty and raunchy; and there is some suggestion that Caleb's family stands for a 'good' kind of America, while the vampires stand for a 'bad' America (connected through Jessie to the South in

the Civil War). But the differences between each kind of family are also broken down. Jessie and his female companion reminisce fondly about when they first met, and as they drive towards their own death, they touchingly hold hands – a scene that recalls a similar double suicide in the James Cameron film *Aliens*, which shares several cast members with *Near Dark*. That is, the vampire couple (the only adult couple in the film) present the values of loyalty and fidelity: good family values. Conversely, it seems that Caleb's family is just as liberal about freedom as the vampires: when she goes out late at night to get a Coke and meets Homer, Sarah defiantly tells him, 'I do what I wanna do when I wanna do it' – a declaration which puts her 'on side' with the vampires.

It would be wrong, then, to see the vampire family/gang as 'liberatory' and Caleb's family as 'repressive'. From one perspective, the vampires want to 'colonise' Caleb's family. But in the opening scenes Caleb is just as disturbing to them as they are to him: they were, as I have suggested, a 'complete' family unit until he came along. We could argue that both families are equally disturbed by the irruption of male adolescent heterosexuality: the vampires are ultimately destroyed by it, while Caleb's family reaps its benefits by recovering the mother-figure, or at least, the mother-function. But Caleb's sexuality is also Oedipally directed, a regressive drive which weakens him or renders him infantile – until the end when he is able to break away from the vampires and destroy them. The vampires themselves, however, are, for all their association with the 'fun'/'trouble' mode of representing youth, already much more 'grown up'.

The Lost Boys introduces a family which, in contrast to Caleb's, has no *father*. Michael and his younger brother Sam move with their divorced mother, Lucy, from Phoenix to Santa Carla (Santa Cruz) on the west coast. Here, they stay with their grandfather, an 'eccentric' figure who remains marginal to their lives and – since he seems always to understand the children – has no patriarchal/paternal role to play. The film opens with a panoramic view of the Santa Carla beach scene, full of 'Gothic' types, hippies, 'surf Nazis' and various other subcultures (with the music of Echo and the Bunnymen's version of the Doors' song, 'People Are Strange'). This panoramic view is interspersed with posters of missing children: Santa Carla is not a good place for family coherence; it is 'abnormal'. Just like Caleb with May in *Near Dark*, Michael is almost immediately attracted to a mysterious girl, Star. But she 'belongs' to David, who leads a gang of glamour-punk bikies (by far the most attractive subculture in town) who have been flaunting their 'lawlessness' in the local fairground – already killing a security guard. These are the vampires, the 'lost boys', a double-edged title that refers not just to missing children in Santa Carla but also to J.M. Barrie's *Peter Pan* (1911) and the children who never grow up – who remain, as this novel puts it, 'gay and innocent and heartless', and who, like the vampires in the film, can fly (Barrie, 1974, 213).

An erotic triangle is established which runs in two different directions: Michael competes with David for Star, while David competes with Star for Michael. David's own interests in Star, who is not yet an actual vampire, seem non-sexual: she sleeps alone in a bed, while he sleeps with the other boys in a nearby cave. His interest in Michael is more unsettling – for Michael. Following *Peter Pan*, it is not difficult to read the vampires in the film as likewise gay and heartless, if not innocent; as Elaine Showalter has noted in her brief account of the film, the lure of vampirism is connected to the lure of homosexuality – and it gives rise, in Michael, to 'homosexual panic' (Showalter, 1990, 183), a topic discussed already in relation to vampire fiction in Chapter 3. David's question, 'How far are you willing to go, Michael?' carries this homosexual subtext. He calls for Michael to 'be one of us' far more insistently than the family of vampires do for Caleb in *Near Dark* – although *The Lost Boys* is equally concerned with the 'turn' into vampirism. Like Caleb, Michael accordingly moves away from his family: his younger brother Sam, who reads vampire comics which show male vampires always biting *women*, barely recognises him; and Michael cannot raise his (sexual) identity crisis with his mother, even though it is more important to him than 'girls and school'. But Star is there to tip the balance: she literally guides him 'back' to heterosexuality while the boys are away – and back to the family home. Interestingly, like May with Homer in *Near Dark*, she is similarly connected to a young child, the boy Laddie; that is, she has a maternal function. By offering them both the protection of his home – as well as his masculinity in the ensuing battle with David and the vampires – Michael fills the hitherto missing role of father himself, and thus recovers the 'complete' family.

More so than the vampires in *Near Dark*, the 'lost boys' constitute a family which is diametrically opposed to Michael's: whereas he has no father, they do; whereas he has a mother, Lucy, they do not. Max, the King Vampire in this film, owns the local home video store. He begins to court Michael's mother, with the intention of marriage – but he is clearly marked out as a vampire for those who know the codes. When he visits Michael's house, for example, he asks to be invited in: informed audience members might already have 'recognised' him at this point. Unlike *Near Dark*, this film in fact trades on the extent of one's knowledge about vampire lore – folding it in to a wider network of references to popular cultural iconography, rock music especially (but also other films), which *aficionados* would in fact recognise without too much difficulty (the only obscured references in this film are to homosexuality).

Recognition actually becomes important to the film's resolution. Early in the film, Sam meets two brothers, the peculiarly-named Edgar and Allan Frog. Sam's extensive knowledge of comic books makes him receptive to the Frog brothers' warnings about real vampires: they take their comics literally, and seriously. Indeed, for these boys there is none of the kind of critical

distance attributed to cinema audiences earlier in this chapter by Tom Ganning; as serious fans, they resemble rather than differ from the myth of the panicking audience he had tried to dispel. Their total immersion in popular culture means that knowledge and belief are connected ('I know everything about vampires . . . therefore I can believe in them'), enabling vampire lore to be mobilised as an empowering illusion with 'real' effects. But the Frog brothers are also juvenile versions of the right-wing vigilante, with their army gear and their manic paranoia (or homophobia). In many respects, they are themselves harder to believe than the vampires. As they come increasingly to occupy the closing scenes, the homosexual/ heterosexual subtext is replaced by the sheer visibility of spectacle; the crisis is parodically redeemed by a 'boy's own' knowledge of and belief in the more lurid aspects of popular culture; and the film allows itself to indulge in over-the-top pyrotechnics – flaunting its own unbelievability at last – as it disposes of the vampires one by one.

Two narrativised relations with vampires are thus constructed: the 'private', primarily sexual relations involving Michael (which he keeps to himself), and the 'public' relations involving Sam and the Frog brothers, with their shared knowledge of vampire lore. In *Nosferatu*, we had seen that one narrative – the 'public' narrative concerning Renfield – had *stood* for the other, private, sexual narrative concerning the vampire, and vice versa. In *The Lost Boys*, however, the public narrative involving Sam and the Frog brothers *overrides* the private, sexual narrative involving the 'lost boys' and Sam's older brother. There is no clear connection, finally, between the vampire lore flaunted by the younger children, and the sexual crisis which is associated with vampirism for the older adolescent. And does it 'mean' anything to have the King Vampire, Max, as the manager of a video outlet? Actually, this might be an equation which reflected cinema's anxieties about its future at this time, seeing itself in the mid-1980s as under threat from videoed movies and the kind of democratising of viewer habits they promised – where less people were actually going *to* the movies – where more and more people, wittingly or otherwise, were instead inviting them into their homes. In other words, the association of videos and vampires seems specific to cinema, as a demonisation directed against an apparently unmanageable flow of movies through the community.

6

VAMPIRES IN THE (OLD) NEW WORLD: ANNE RICE'S VAMPIRE CHRONICLES

The 'vampire chronicle' – where the life and fortunes of a vampire are mapped out through a number of novels – is a recent development in popular horror fiction. Chelsea Quinn Yarbro's *Hotel Transylvania* (1978) was the first of a sequence of novels about le Comte de Saint-Germain, an aristocratic (and, as it happens, ambidextrous) vampire who effortlessly glides through history. She has also written a trilogy about a female vampire, Olivia, Saint-Germain's one and only true love. Patricia Nead Elrod's 'vampire files' series, which began with *Bloodlist* (1990), traces the fortunes of a vampire detective, Jack Fleming, in his search for the woman he loves – who, again, is another vampire. Yarbro in particular has sold well, marketed at one point as the 'Queen of Horror' – although *Hotel Transylvania* has been out of print now for some time. But the best-known contemporary chronicler of vampires is without question Anne Rice.

Her first novel in the 'Vampire Chronicles', *Interview with the Vampire* (1976), was not an immediate best-seller because Rice at this time was unknown – she had not been published before. Her biographer, Katherine Ramsland, reports that Ballantine made the book into an 'event' the following year, however (with an extensive tour, coffin-shaped book displays, T-shirts, and so on), ensuring its success through heavy promotion (Ramsland, 1991, 170). The second novel in the sequence, *The Vampire Lestat* (1985), was published almost ten years later; but Rice's reputation as a horror novelist was secure by this time, and it became a best-seller the first week it was released. *The Queen of the Damned* (1988) went to the top of *The New York Times* best-seller lists during its first week of publication, and stayed in the lists for seventeen weeks, far outselling (at 400,000 copies) the previous novels in the series. None of these novels has since been out of print. Hollywood has at last been successful in negotiating with Rice for the film rights of *Interview* (she was reportedly unhappy at the decision to cast Tom Cruise as Louis, however); there was talk of producing a Broadway musical (the pop singer Sting had apparently been involved in discussions); the Vampire Lestat Fan Club launched itself in 1988; in 1990 Innovation, an art production outfit, had begun to serialise *The Vampire Lestat* in comic

book form; and – to give an idea of her reach into other kinds of markets – the hip New York music magazine *Reflex* took Anne Rice as the topic of its first non-music cover story. The fourth novel in the chronicles, *The Tale of the Body Thief*, was published at the end of 1992.

We should note that Yarbro, Elrod and Rice are women writers, although for the most part their vampire heroes are male. Their chronicles share a number of characteristics usually associated with women's romance – notably, the tracing out of the vampire's search for fulfilment, for a 'complete' love relationship. But, under the umbrella of the vampire genre, romance themes may be dispersed or channelled through other topics or interests – an involvement with criminality, for instance (Elrod's 'vampire files' are a variation on the hardboiled detective fiction genre), or a detailed recreation of historical events (Yarbro and Rice's novels are well researched, historically speaking), or a kind of macro-presentation of occult or mythological activity which is shown to control the narrative in certain ways (as in Rice's later novels). That is, these novels are not *just* romances. Some differences can be noted between Elrod and Yarbro on the one hand, and Rice on the other, by way of introduction. The former novelists' vampires are solitary figures, rarely coming into contact with their own kind. Rice's vampire chronicles, however, have something in common with the family saga genre. Her vampires often cohabit with one another in familial relationships; and in *The Queen of the Damned*, this is opened up to an extended 'great family' with an original set of vampire parents from which all the others are descended. Consequently, her novels are more genealogical than the others. This may seem to characterise Rice's fiction as conservative, essentially grounded in a coherent family structure. But that claim is complicated by the fact that her male vampire protagonists – Louis, Lestat and Armand – are decidedly 'queer'. Rice flaunts the gayness of her male vampires; they cohabit together as 'queer' parents, with vampire children; at other times, they may be bisexual or sexually 'polymorphous'. We would need to think about what it means for Rice, a reputedly heterosexual wife and mother, to write 'as' a queer male vampire. And here is another reason for Rice's importance as a vampire novelist: she was possibly the first writer to narrate her stories in the first person from the vampire's point of view.

INTERVIEW WITH THE VAMPIRE

Rice's first vampire novel took an unorthodox approach to the genre by having its vampire protagonist, Louis, interviewed by a boy (presumably in late adolescence) with a tape-recorder. This narrative strategy emphasises disclosure (through confession or revelation) and publicity, topics which become increasingly important in Rice's vampire chronicles. The reader hears the 'other' speaking first-hand; the vampire comes out of the closet and makes himself known; he gives us 'the real story' (at last) about vampires

like
Audience

(Rice, 1988, 4). Moreover, the boy is the perfect listener, hooked by the narrative to such an extent that, at the end, he wants to be *like* Louis, a vampire. That is, the novel builds its own ideal reception – where the interviewer is thoroughly passified, standing as an image for the converted reader, the fan – into its structure. Yet even as the 'truth' of Louis-as-a-vampire is taken for granted – to be believed – the novel sets into motion a complicated version of the dialectic between belief and disbelief, illusion and disillusion, that, as we have seen, has preoccupied so many of the vampire narratives so far discussed. *Interview with the Vampire* maintains the illusion of vampires at one level, since Louis 'exists'; at another level, it disillusions its own investment in 'real' vampires almost entirely, turning vampirism into something akin to a posture or style, a *simulation* of the real. This novel seeks the 'truth' about vampires, and comes back empty-handed; it does, however, make a significant conversion (namely, the interviewer/reader) along the way.

The novel opens in 1791, with Louis – actually, Louis de Pointe du Lac – as the son of a plantation owner in New Orleans, Louisiana, the setting for much of Rice's horror fiction. This Southern American city becomes a powerful, occult site for events – a place in the New World which is nevertheless somehow older and more decadent than Europe, simultaneously 'primitive' and sophisticated, a 'mixture' of all kinds of peoples:

> There was no city in America like New Orleans. It was filled not only with the French and Spanish of all classes who had formed in part its peculiar aristocracy, but later with migrants of all kinds, the Irish and the German in particular. Then there were not only the black slaves, yet unhomogenised and fantastical in their garb and manners, but the great growing class of free people of colour, those marvellous people of our mixed blood and that of the islands, who produced a magnificent and unique caste of craftsmen, artists, poets, and renowned feminine beauty. Then there were the Indians, who covered the levee on summer days selling herbs and crafted wares. And drifting through all, through this medley of languages and colours, were the people of the port, the sailors of ships, who came in great waves to spend their money in the cabarets, to buy for the night the beautiful women both dark and light, to dine on the best of Spanish and French cooking and drink the imported wines of the world.
>
> (Rice, 1988, 39)

We can easily note how this passage naturalises pre-Civil War New Orleans as – somewhat against the odds – a place where different ethnicities interact 'freely' with one another, where class differences are dissolved (everyone is suitably 'aristocratic') and so on. But this utopian image of what might be termed the 'global exotic' is important as a background to Rice's vampire fiction – and perhaps to vampire fiction in general. This genre tends to

110

override class and ethnic differences at one level by emphasising mobility and movement. As I have already noted in previous chapters, the vampire was consciously constructed as a 'citizen of the world', a figure to whom boundaries (national boundaries in particular) meant very little. To recall Wolfgang Schivelbusch's phrase, utilised in Chapter 1, this fiction tends to offer a 'panoramic perception' of the world – a perception which is intimately related to travel in its broader manifestations. Indeed, as we shall see in the next chapter especially, contemporary vampire fiction is 'panoramic' in both space and *time*. It visits as many moments in history as it does countries, and each moment is as freely interactive in terms of class and ethnicity as the next one.

Louis is a lapsed Catholic, a *disillusioned* Catholic – perhaps he has seen too much of the 'world' which circulates through New Orleans. His brother, by contrast, is a religious zealot who has visions; that is, he believes wholeheartedly in the illusions of the Catholic Church. This juxtaposition of illusion and disillusion – belief and disbelief – is important in Rice's novel. Louis does not 'believe' (in) his saintly brother (8); yet precisely because of this traumatic disillusion, he is allowed to see the 'reality' of vampires. His subsequent belief in vampires, in other words, is a kind of modern, secular replacement for his lost Catholic faith. Because Louis has 'no illusions' (142), he is, then, both less than Catholic – and more than Catholic. That is, he both believes in nothing, and is (therefore) able to believe in *anything*, including the unbelievable – vampires. As he says to Armand much later in the novel,

> you ask me how I could believe I would find a meaning in the supernatural! I tell you, after seeing what I have become, I could damn well believe anything! Couldn't you? And believing thus, being thus confounded, I can now accept the most fantastical truth of all: that there is no meaning to any of this!
>
> (241)

Rice's novel plays with this folding together of illusion and disillusion in a number of ways. It takes the form of a quest, primarily to find out the 'truth' about vampires. Louis, a 'Creole' American vampire with a French accent, feels 'shaped by Europe more deeply and keenly than the rest of Americans' (149). The girl-vampire Claudia encourages Louis to return there, to 'see where it had all begun' (149): 'It was her idea most definitely that we must go to central Europe, where the vampire seemed most prevalent. She was certain we could find something there that would instruct us, explain our origins' (150). But in Transylvania, the vampires are simply 'mindless, animated corpse[s]' (192), offering no answers to Louis and Claudia. The novel rejects Eastern Europe as a source: it is too 'primitive' (not 'aristocratic' enough? not glamorous enough?) to be of any use; it only disillusions. Louis and Claudia travel instead to Paris, 'the mother of New Orleans' (204) – the city which 'had given New Orleans its life' (204). They are led to the

Théâtre des Vampires, a theatre in which real vampires *act* as vampires for a mesmerised audience. The troupe presents the audience with an illusion (theatricality) of an illusion ('real' vampires); far from leading Louis and Claudia to the 'origins' of vampirism, they show it to have been (always?) a mode of representation, a *sign* of vampirism, a style or a posture. To be a vampire is, in other words, to *act* like a vampire. This is vampirism at its most *disillusioned*, a rejection of all the European traditions and superstitions. In the same spirit, Louis tells the boy interviewer that vampire lore – crosses, garlic, stakes through the heart and so on – is 'bullshit' (22).

Yet the novel allows the illusion of vampirism to flourish at the level of representation itself. There is no reality or meaning behind vampirism, as Louis realises – and this is 'the most fantastical truth of all'. But one can still 'be' a vampire because – since there is no reality behind it – acting and being collapse into each other. The reality of vampirism lies precisely in this point. And for Rice, a new kind of faith is subsequently produced, one that is aligned with popular fiction rather than with the Catholic religion. Her audience at the Théâtre des Vampires is mesmerised by the performance. They are a 'titillated crowd', under the 'spell' of theatre (227). A highly erotic, somewhat disturbing scene unfolds on the stage – where a young woman is stripped naked and killed by the troupe of vampires. Louis, who is watching, can actually 'taste' her (226); his involvement with the perfor-mance is entirely sensual. That is, he is 'carried away' with what he sees. The scene anticipates Rice's later sketches of mesmerised audiences at Lestat's rock concerts in *The Vampire Lestat*; the erotics of the event (illusory as it may be) produce real effects (excitement, arousal) at the mass level. I have noted that being and acting are collapsed into each other to make vampires 'real' in this novel. But Rice also attempts to collapse the boundaries – we might say, the 'critical distance' – between audience and performance, reader and text, outside and inside. In this context, the boy interviewer's desire to become a vampire at the end of the novel (he reappears, in fact, as the vampire Daniel in *The Queen of the Damned*) is not entirely surprising. It is, as he expresses it, a way of rejecting 'despair' (342) – where one's faith, having lapsed in the modern world, is recuperated through a closing conversion (in)to the fiction itself. It is hard to imagine a more effective way of accounting for fandom, in this closing image of the converted reader/ listener.

Louis himself is given the 'Dark Gift' – that is, converted into a vampire – by Lestat, in the first of a number of 'queer' scenes. Lestat is like a 'lover', and Louis is 'taken' (18), in a drawn-out ecstatic moment which has them mingling their fluids together. Rice emphasises the differences between these two male vampires, with Louis as delicate and sensitive (i.e. feminised) and Lestat as aggressive and impetuous (i.e. masculinised). It is worth noting, given my use of Bennett and Woollacott in the previous chapter, that in both *The Queen of the Damned* and *The Tale of the Body Thief* Lestat in

fact refers to himself as 'the James Bond of vampires' (Rice, 1989, 10; 1992, 6), emphasising his recklessness and his lack of concern about killing. He also emphasises his loner identity; in spite of this, however, he helps Louis to pass the Dark Gift on to a 5-year-old girl, Claudia, and the three of them coexist for a while as a family. But this is a 'queer' family: Claudia's persistent questioning of how she was 'created' by two men – 'How was it done?' (110) – resonates in this context. Louis and Lestat are a kind of demonic (but not demonised) gay couple, queer male parents competing with each other for 'our daughter' Claudia (94). At the same time, they are Claudia's 'lovers' (102, 118): the queerness of their relationship lies partly in the folding together of gay love with heterosexual incest/paedophilia.

This way of representing parent-child relations is certainly unconventional, to say the least. But it is 'normalised' through Louis's search for what is missing in the relationship: the mother. Claudia's actual mother had died of the plague shortly before Claudia was 'taken' by Louis and Lestat. The journey to Paris – 'the mother of New Orleans' – is, then, also a kind of Oedipal return, an attempt to recover a lost maternity. Indeed, it is triggered by Claudia's two attempts to kill Lestat, the most fatherly (i.e., patriarchal) of the two male vampire parents. But, as already indicated, Paris ultimately offers no 'meaning' to Claudia – and she expresses her 'inevitable disillusion- ment' (210) to a distraught Louis. He responds by trying to create a surrogate mother for her, turning the doll-maker Madeleine into a vampire. In the meantime, he is drawn to Armand, an older male vampire; and, to complicate matters, Lestat has also journeyed to Paris to look for them.

The result is a variation on Eve Kosofsky Sedgwick's 'erotic triangle', where a struggle 'between men' ensues over a woman. In this case, the struggle 'between men' (Lestat and Armand) takes place over another *man*, Louis. Claudia and Madeleine, far from being crucial to this arrangement, are apparently its most disposable features – soon afterwards, they are both burnt to death. But they become all the more important after they have gone; Claudia in fact comes to haunt the later novels in the chronicles, as a kind of absent presence.[1] Louis – an immortal vampire – now realises that everything, even great art, is transient: 'The magnificent paintings of the Louvre were not for me intimately connected with the hands that had painted them. They were cut loose and dead like children turned to stone. Like Claudia, severed from her mother' (321). He joins Armand, his 'companion' (324), on a trip around the world. Returning to New Orleans at last, he finds Lestat set up in a 'domestic' scene with another 'smart, gay' (334) male vampire – and a baby. The scene is, in part, a parody of the moment in Stoker's novel when Dracula throws a baby to the hungry vampire women. Rice's vampires are hungry, too – they may feed on the child – but they are also maternalised. Louis rocks the baby and finally returns it safely to its crib – but in his despair he leaves New Orleans soon

afterwards, wishing to be somewhere 'where there was nothing familiar to me. And nothing mattered' (341).

Thus the novel moves back and forth between the recuperation of a mother-and-child relationship (the familiar relationship: home) and the unfamiliarity of one's separation from the mother (away from home). In this sense it is nostalgic; but it recognises that the return to the mother (like the return to Paris) is ultimately an illusion – that such a pre-Oedipal moment can never be completely recovered. It recognises, too, that to be disillusioned – separated – is nevertheless to require that such illusions exist – the illusion that vampires are real, the illusion of a return to the pre-Oedipal mother. Since the novel puts this dialectic between illusion and disillusion into play, Rice's authorial relations to her imagined audience might be figured in exactly these terms. In its most disillusioned moments – like the magnificent paintings of the Louvre, and like Claudia – Rice's novel is a kind of orphan, 'cut loose' from the mother and set adrift in an unfamiliar, even hostile, world. At the same time, the illusory metaphor of author-as-mother is maintained: Rice's audience (like the boy interviewer at the end) is eventually converted through a pre-Oedipal relation to the novel, working at the level of sense and arousal and desire.

In an interview with Rice, Greg Fasolino asked, 'You now have a rather large cult of fans – people obsessed with your work. Does that excite you?' (Fasolino, 1992, 46). Rice admitted that it is 'a little frightening', but emphasised her commitment to *them*: 'The thing they really want from me is the most extreme and true and personal stuff I have to give, and I'm gonna keep doing it, as long as I have breath in my body' (46). It is difficult to avoid reading this as an image of the author-as-mother, feeding her fans – her children. The image of author-as-vampire might also be invoked, and the two images in this context are not inconsistent with each other. Conversely, the image of fans-as-vampires is also apparent in her comment to Fasolino ('The thing they really want from me'). Rice's own Dark Gift is the novel itself; she writes the exchange between author and fan into the novel in terms of two vampires, parent and child – lovers – mingling their fluids together and sharing the ecstasy, but nevertheless wondering afterwards how it was done.

THE VAMPIRE LESTAT AND QUEEN OF THE DAMNED

Rice's second and third novels in the Vampire Chronicles opened up the vampire's search for his origins on an epic scale. *The Vampire Lestat* is in fact structured as a series of narratives which begin in the present day – the modern age – and then move further and further back through history to an original moment, to a moment of Genesis for vampires. Lestat de Lioncourt is older than Louis, and he gives an account of his own conversion in pre-Revolutionary Paris at the hands (or teeth) of the alchemist-turned-vampire, Magnus. We should note that Lestat in turn converts his own mother,

Gabrielle, in an obviously incestuous scene – she is, he confesses, '[t]he only woman I had ever loved' (Rice, 1986, 186). In the next narrative sequence, Lestat describes his meeting with Armand, an even older vampire who still lives according to 'the Rules of Darkness' (246). He takes these Rules as a means of verifying his own authenticity – whereas Lestat, by contrast, is seen as inauthentic, a modernised, sceptical vampire who does not abide by traditionally sanctioned vampire lore. Armand himself was converted by Marius in Renaissance Venice – in another gay scene which connects Marius to the painter Caravaggio, with Armand as his willing apprentice. Lestat then searches for Marius and the origins of the Dark Gift. Interestingly enough, given the discussion in Chapter 2, he finds Marius in Greece – and learns all about Marius's conversion to vampirism hundreds of years ago in classical Rome. Marius and Lestat identify with each other because, as the novel has it, their respective epochs had undergone the same kind of crisis. That is, religious faith was declining in 'the years of Augustus Caesar' (415), just as it is in decline in the modern age. Both characters thus stand 'on the cusp of the old way of doing things' (415–16), living without faith (without illusions) and yet not entirely 'cynical' (disillusioned) either. As Marius notes, 'We sprang up from a crack between faith and despair' (416) – precisely the crack occupied and empathetically exploited by Rice's fiction.

But there are older vampires than Marius. The novel turns to Egyptian mythology as a source for the oldest kind of magic, imagining two original vampire 'parents', the father Enkil and the mother Akasha – to whom all other vampires are ultimately connected, as a kind of extended family. Marius has the task of minding these parents, 'Those Who Must Be Kept', who are almost inanimate – appearing like statues to Lestat. Given the Oedipal and pre-Oedipal structures in Rice's fiction, it is not surprising to see Lestat attracted to Akasha. (Her name, and her role as the 'original' mother, clearly recalls H. Rider Haggard's 'She', Ayesha.) He feeds from her ('My mother, my lover', 529), and incurs Enkil's rage. But in Rice's fiction, the mother is always more powerful and more *present* than the father, and in fact Enkil is later easily destroyed in *The Queen of the Damned*. The novel closes with Lestat, resurrected in 1984, preparing for his rock concert, his ultimate act of self-disclosure – and aware of Akasha's presence.

In *The Queen of the Damned*, Akasha returns as a vengeful mother, who claims Lestat as her son and her lover – but begins to destroy her other 'children', the vampires she had originally 'animated' (Rice, 1989, 328), in order to create a matriarchy, a world ruled entirely by women. Rice introduces a second narrative alongside this one, however, juxtaposing them against one another. This second narrative involves Jesse, an orphaned girl adopted by a formidable woman, Marahet. Marahet keeps extensive records of her family chronicles on computer files, and Jesse soon realises that she is part of a 'Great Family' (185) which stretches back, matrilineally, into the distant past. Jesse joins the Talamasca, a secret, Masonic organisation which

has been observing and documenting supernatural activity – and which believes, as a matter of course, that vampires are real. This organisation is also matrilineal: it is administered from a 'Motherhouse', and in fact constitutes 'another "Great Family"' (192) through its own extensive records and files. The two 'Great Families' – whose histories are recorded in Marahet's and the Talamasca's chronicles – are in fact one and the same: both provide matrilineal genealogies of vampires. Akasha, on the other hand, wishes to wipe these genealogies clean and start again, like an exterminating angel. The novel traces out the battle between Marahet, who is a productive vampire – she produces genealogies, writes family histories, adopts children – and Akasha, who has none of these interests and sees history as, instead, destructive. Rice polarises the two positions in terms of gender, allowing her two female characters to argue that history is productive when maternalised, and destructive when patriarchal – an argument which makes Akasha herself patriarchal, since she, too, wishes to destroy in order to (re)create a new matrilineal order. In response to this, Marahet empathetically invokes the 'Great Family' once more, demonstrating on a huge electronic map of the world that vampires have been everywhere in place and time, appealing to the others through an image of global multiculturalism:

> No people, no race, no country does not contain some of the Great Family. The Great Family is Arab, Jew, Anglo, African; it is Indian; it is Mongolian; it is Japanese and Chinese. In sum, the Great Family is the human family.
>
> (500)

This image carries the day: Marahet's twin sister Mekare, an earth-Mother figure, arrives soon afterwards and dispatches Akasha, cutting off her head and consuming her brain and heart.

In their article 'Undoing Feminism in Anne Rice's Vampire Chronicles', Devon Hodges and Janice L. Doane offer a powerful criticism of Rice's investment in this kind of narrative structure. They note the shift from Oedipal structures in *Interview with the Vampire*, to pre-Oedipal structures in *The Vampire Lestat* and *The Queen of the Damned* – since the latter novels recover the 'archaic' mother and (in Lestat's case) represent the pleasure of the pre-Oedipal return. Hodges and Doane focus on Claudia in *Interview*, suggesting that – through this 5-year-old girl vampire, the 'daughter' of Louis and Lestat – Rice shows how a woman's attempt to resist 'her position as an infantilised object of desire' is 'eventually contained by being redefined as an object of exchange between men' (Hodges and Doane, 1991, 162). Because this novel is concerned with Oedipal struggles – focussing around Claudia and her 'parents' – it is able, at least, to show how culture 'devalues women' (163). As I had noted above, Claudia – and Madeleine – are in one sense the most disposable characters in this novel; at another level, of course, Claudia

in particular is the most *disturbing* character, unsettling the 'homosocial' and essentially 'patriarchal' bond 'between men', that is, between Louis and Lestat, and later, Louis and Armand (who helps to destroy Claudia in order to make that bond more secure). In the later novels, however, this kind of feminist critique is lost. The shift into pre-Oedipal 'pleasures', usually associated with a conversion to vampirism, certainly places the mother 'in a more privileged position' (163); but it also colonises this otherwise unconscious realm, turning it into an idealised or utopian space which ultimately overrides or 'precedes' sexual difference. Hodges and Doane look at the relationship between Lestat and his mother Gabrielle in these terms. Lestat has a tyrannical father; he identifies instead with his mother, and she helps him to realise his masculinity by turning him into a wolf-hunter. Or rather, she helps him to realise *her* masculinity: 'She spoke in an eerie way of my being a secret part of her anatomy, of my being an organ for her which women do not really have. "You are the man in me," she said' (Rice, 1986, 72–3). Gabrielle is masculinised through her relations with her son (she dresses as a young man after her conversion). Lestat, on the other hand, is feminised – that is, rendered 'effeminate' – through his relations with Gabrielle. Hodges and Doane rightly note the 'regressive' representation of homosexuality here, that is, that it is related to a son's overidentification with his mother (Hodges and Doane, 1991, 164). But this pre-Oedipal, utopian exchange of gender roles has another implication:

> The return to the mother that seems to disrupt gender boundaries by feminising the son who embraces the maternal, and by lending to the mother the son's phallic power, is also the path to postfeminism. Ironically, the return to the mother is what allows Rice to kill off and transcend feminist politics . . . sexual difference is a dead issue.
>
> (168)

This is a persuasive argument; but I would note at least two problems with its direction. The first lies in the way Hodges and Doane smooth over the 'queer' aspects of Rice's vampires. A certain 'normalisation' of parental relationships occurs as a consequence – for example, they are able to speak confidently about 'patriarchy' in *Interview with the Vampire* (159) – which is at odds with the later claims that Rice kills off the issue of 'sexual difference'. More importantly, they never explore the realm of 'queerness' in all its contradictory splendours. Their article is worth contrasting to Sue-Ellen Case's 'Tracking the Vampire', discussed in Chapter 3. While Case celebrates the possibilities inherent in the 'queer' vampiric realm (in Rice's case, this might involve the peculiar folding together of parenthood and paedophilia, or reproduction and gay love), Hodges and Doane see it as a 'postfeminist' form of neutralisation (171). (It would be worth teasing out the connections between this claim and metaphors of sterility in their article – as if 'queer' sexuality is not (re)productive for feminists, as if it doesn't get

them anywhere.) Certainly Rice's fiction is oriented towards the fantasy of maternal origins; but it also occupies the kind of 'in-between' state explored by Case in her article, which sees the vampirish mingling of bodily fluids as something in *excess* of the 'normalised' mother–child relation. Case had described the non-normative pleasures to be derived from 'queer' vampires in positive terms; Hodges and Doane, on the other hand, speak disapprovingly – for example – of Rice's fascination with sado-masochism, of her 'fantasies of power and surrender' (170). We should note, however, that Case focusses primarily on the 'lesbian vampire' – whereas Rice's 'queer' vampires are always male.

The second problem concerns their view of mass or popular cultural forms. Hodges and Doane's (unsuccessful) search for 'an emancipatory maternal rhetoric' leads them to critique the 'conservative, postfeminist narratives of mass culture' so 'greedily ingested by American readers' (158). We can certainly entertain the notion that Rice's fans 'ingest' their vampire narratives. I have developed an image above of Rice herself as Mother Vampire, lovingly 'colonising' her readers; but I have also noted that the image can work the other way, with the fans in turn 'colonising' – or vampirising – the novels. That is – to use the description a second time – a *mingling* of fluids occurs: the relationship between mass or popular cultural narratives and their readers, in other words, is not simply one-way. Rice's novels have at least two kinds of readerships – her 'gay audience' and her 'mainstream readers' – which, by her own account at least, are barely aware of each other (Fasolino, 1992, 45). To regard these readerships as 'colonised' by mass culture is both to collapse them together (to erase their own 'sexual differences') and to disempower them – to refuse the possibility of an active engagement with the narratives, to refuse readers of popular fiction the kind of '*productive* consumption' described in Chapter 4.

Hodges and Doane do away with this dynamic altogether: these readers are nothing more than passive (but insatiable) consumers. Worse, for these critics they must also be *bored* consumers – Rice's readers 'can only be bored' by the fiction, they claim, because of its 'repetitive structure' (Hodges and Doane, 1991, 166). (We could again tease out the metaphor of sterility here: Rice's fiction, like mass culture itself, doesn't get us anywhere; it offers only un(re)productive pleasures.) Hodges and Doane also claim that, through their 'repetitive' returns to an original moment, Rice's novels are thus essentialist, preferring 'truth' over 'lies': 'Not for Rice an avant-garde modernism that would play on the undecidability of representation' (167). This claim returns us to the kind of polarity we have seen before, in which high culture is privileged and popular or mass culture is disparaged. The former, according to this argument, defamiliarises us, while the latter is all *too* familiar. Hodges and Doane want Rice to write avant-garde, modernist novels because it is here that 'representation' becomes problematic; instead, she writes popular fiction where everything is apparently straightforward. It

is not difficult to deconstruct this polarity, however – by attending, in particular, to Rice's play with illusion and disillusion, belief and disbelief, discussed above.[2]

FLANEURIAN VAMPIRES:
THE TALE OF THE BODY THIEF

The kind of polarity just described – which privileges high culture (complex) over popular culture (simple) – divides its readers along similar lines. Most commonly, the high cultural reader is imagined as contemplative; by contrast, the reader of popular fiction, the fan, is distracted – and, for Hodges and Doane, easily bored, experiencing either dubious or unproductive pleasures. (This particular polarity – juxtaposing contemplation and distraction – has already been noted in relation to Polidori's 'The Vampyre', discussed in Chapter 2.) It could well be argued, however, that Rice's vampire fiction enables both reading positions to be occupied, again making this polarity difficult to maintain. The novels may well be distractive, taking readers 'out of themselves'. But, passing over the question of the kinds of pleasures this then enables (productive or otherwise), the novels do in fact also encourage philosophical contemplation. Fasolino calls them 'metaphysical'; Rice is seen as an *intellectual* writer of popular fiction. Her novels unfold as meditations; their moments of ecstasy puncture long passages of inquiry amongst vampires into a range of 'classical' topics – faith, art, humanity, purpose. The vampire is itself, of course, a contemplative creature who is *subject* to distractions – a philosopher and a sensualist, a frequenter of libraries and galleries who must regularly surrender to an uncontrollable appetite. For Lestat, this appetite is also a topic to be contemplated: he ceaselessly wonders about the kinds of distractions (the urges, the pleasures) that make him what he is. In the meantime, he watches the world go past and discourses about it at great length; he collects works of art, wears fine clothes, and refines his sensibilities. In this sense, he is, in effect, an aesthete – a dandy.

Rice's fiction actually flaunts its high cultural orientations, drawing in particular on Italian Renaissance and Baroque iconography – where high culture is also at its most sensual. (Not untypically, for example, the cover of *The Tale of the Body Thief* (1992) shows a fragment from Giovanni da Bologna's *The Rape of the Sabines*.) Her vampires are familiar with the kind of 'magnificent paintings' Louis had described in *Interview with the Vampire*; they have enough time on their hands to contemplate them at length. Indeed, to be a vampire is to *be* 'cultured' – that is, to have 'aristocratic' tastes – and also (these points are related) to be idle. Louis, Lestat and the other vampires do not work, although they do have investments and, with the help of financial advisers, are able to accumulate large amounts of capital. Their 'job' is, instead, to find out who they are and where they came

from. In *Interview with the Vampire*, this is an entirely recreational procedure – making this novel more of a 'distraction' than the others, perhaps. But in *The Vampire Lestat*, *The Queen of the Damned* and *The Tale of the Body Thief*, self-discovery becomes part of a much larger process – involving, as I have noted above, the establishment of extensive computer files and archives. That is, self-discovery is no longer personal (or familial), but organisational. Lestat has to negotiate with the Talamasca to access his archives; he realises, in the meantime, that he has come into contact with an organisation which knows more about him than he knows about it. That is, he realises that he has been all this while under surveillance.

Yet this is also a feature of the vampires themselves, which constantly monitor each other's movements and read each other's thoughts (or, conversely, try to 'cloak' their thoughts from each other). In *The Queen of the Damned* they are likened to radio receivers (Rice, 1989, 494). A tension is worked out in the novels between the vampires' need for anonymity or privacy, and their nagging sense that someone – another vampire, usually – is watching them, that they are part of a larger network of 'airwaves'. Lestat tries to break out of this predicament by making himself as visible as possible, by making his vampirism public – as a rock star playing to a mass audience. This only upsets the other vampires and the Talamasca, however, since no one else believes him (although his human fans may believe *in* him – a distinction Lestat entertains in *The Tale of the Body Thief*). By the beginning of *The Tale of the Body Thief*, Lestat is disillusioned with publicity and has returned to the anonymous world of the city – but he is still being watched.

The Tale of the Body Thief opens in Miami, rather than New Orleans – a city of 'desperation' and 'risk', full of murderers and therefore 'perfect . . . for the vampire' (Rice, 1992, 12). Here, Lestat operates as a kind of solitary vigilante, pursuing serial killers with the help of his own computer and the extensive files he has 'purloined' from the Police Department. Lestat is himself, of course, a serial killer with 'style'; his quarry, on the other hand, is 'filthy' and 'sloppy' (17), a bad dresser, someone of no interest whatsoever at the level of individuality (he is never named by Lestat). The vampire's dandy-like posture distinguishes him from the urban jungle – a place which would seem to do away with individuality altogether. Lestat is essentially *different*; he has 'style'; he breaks the 'rules'; and he has the means to negotiate the otherwise anonymous city through his extensive surveillance systems. With his Parisian background and his refined sensibilities, he might in fact be viewed as a kind of *flâneur* – that is, a city stroller, an urban spectator, someone with leisure enough to watch the world go past and skill enough to read its various 'commonplace' signs. The word has been given a particular currency by Walter Benjamin, who utilised it – in a discussion of Charles Baudelaire as a nineteenth-century urban lyric poet – to speak about crime fiction, taking the *flâneur* as a kind of prototype of the detective. The

flâneur – a Parisian dandy, in this case – puts his idleness to good use: 'He only seems to be indolent for behind this indolence there is the watchfulness of an observer who does not take his eyes off a miscreant' (Benjamin, 1973, 41). Benjamin noted a contradiction at work in the figure of the *flâneur*, however – that, while he subjected the urban world to an 'individualising' gaze (i.e., his own), he simultaneously assisted in the erasure of individuality by reducing what he saw to a series of statistical points.

Taking up Benjamin's thesis in the context of a discussion of the crime fiction of Edgar Allan Poe, Dana Brand has noted that in effect the *flâneur* 'domesticates' the world, rendering it manageable and thus reassuring himself of his mastery over it (Brand, 1990, 225). But reassurance at one level produces anxiety at another – knowing that there is 'deep crime' out there which is beyond the flâneurian gaze and therefore cannot be managed or domesticated. Brand suggests that Poe's detective, Dupin, is an attempt to engage this deeper level of activity, to move beyond the flâneurian level. He is, in other words, 'capable of mastering the urban environment *without* inhibiting its capacity to produce anxiety and terror' (229). He 'focusses, rather than denies, the city's power to produce shock and dislocation' (237). We can note in passing that Brand's description of Dupin, Poe's aristocratic and cynical detective, makes him sound very much like a vampire: 'Secluding himself by day in a mansion with closed shutters, Dupin explores the Paris streets by night . . . distanced from and invisible to the inhabitants of the city through which he moves' (230). When Dupin solves his crimes, however, this 'distance' is collapsed and, vampire-like again, he actually *inhabits* those inhabitants – that is, he occupies their consciousness (in order to get at the truth they are concealing). Brand quotes a passage from Baudelaire himself, which expresses the vampiric aspect of the detective's inhabitation of others as he goes about solving their crimes: 'like those wandering souls who go looking for a body, he enters as he likes into each man's personality' (cited on 232). This kind of detective fiction, then, both focusses on the production of 'shock and dislocation' in the city – and indulges in panoptic 'fantasies of control' over the city's radical 'otherness' (233).

Rice's *The Tale of the Body Thief* is precisely about the inhabitation of someone else's body – an inhabitation which causes (rather than does away with) 'shock and dislocation'. While he monitors his serial killers, Lestat is aware that he, too, is being watched. The Talamasca have a benign interest in Lestat and follow his movements carefully in order to protect him from unnecessary publicity. Their motto is, 'We watch and we are always there' (Rice, 1992, 76) – a version, perhaps, of the famous Pinkerton's detective agency motto, 'we never sleep'. But Lestat is also monitored by someone less benign (and once associated with the Talamasca), the mysterious Raglan James – the 'body thief' – who spies on Lestat through computer surveillance networks and, more archaically, through out-of-body travel. James finally

convinces Lestat to exchange bodies, to give Lestat his longed-for experience of being human again. The homoeroticism of the exchange is emphasised. James, a young man, 'wants' Lestat's body – and Lestat in turn confesses, 'I couldn't take my eyes off him, off this body which might soon become mine' (156). But the exchange, for Lestat, is profoundly disillusioning – and to reflect this disillusion, the novel shifts out of the fantastic mode and into a kind of 'dirty realism'. That is, the kind of 'shock and dislocation' Brand had described above also operates at a generic level; the novel literally 'dislocates' *itself*. The vampire's flâneurian distance from the inhabitants of Miami is now entirely collapsed; but the inhabitation of one of those inhabitants by no means supports the panoptic 'fantasy of control'. Lestat's engagement with the real world makes him *more* anxious, not less – as if to be a vampire is to keep anxiety at bay. He becomes sickly and downtrodden, and all his money is stolen. However, a particular kind of 'fantasy of control' *does* become available to him. Losing his vampire's body, Lestat is 'no longer one of them' (273) – that is, no longer 'queer'. The mingling of fluids associated with vampirism – which emphasises mutual attraction and consent, and produces sublime pleasures – is replaced, for Lestat, by heterosexist power. In fairly graphically described scenes, he rapes a young woman, and later deflowers a somewhat masochistic nun. To be human (that is, male), he thus considers at one point, is 'monstrous' (220); it triggers off an overwhelming desire to escape from this particular radical 'otherness' and return to the 'queer' flâneurian realm of the vampire.

The novel thus inverts the conventional perception of realism-as-real and horror-as-fantasy – since, here, realism takes Lestat 'out of himself' and the experience is unexpectedly disturbing. He returns, instead, to a conception of *fantasy*-as-real, noting sardonically that the desire to be 'human' (to be 'real') is in fact based on an 'illusion' (401). Lestat, with the help of David Talbot, an ageing ex-leader of the Talamasca, tracks Raglan James to – of all places – the *Queen Elizabeth II*, as it cruises around the Caribbean. Here, he regains his vampire's body in a rebirthing scene that represents the *QEII* as a kind of womb, a 'sad and tawdry' mother (343). The exchange enables Lestat to leave the realist mode behind and re-enter the 'queer' realm of horror fantasy. David, it turns out, has also exchanged his body for the one vacated by Lestat – becoming a young man again. Lestat is ambivalent about this exchange, however, and decides to leave. He travels to Asia and then to Europe, reasserting his vampirish role as a 'citizen of the world': 'the old cliché was true – *the world was mine*' (398). In Barbados, he sees David again – who tells Lestat that he, too, would like to be a part of the grand tour: 'There are places I want to go – lands and cities I always dreamt I would visit' (410–11). For Lestat, this amounts to saying that he would like to become a vampire – not least because travel is viewed by David precisely as he views it, that is, as a means of contemplation: 'There has to be a period of traveling, of learning, of evaluation. . . . And as I engage in my studies, I write. I write

everything down. Sometimes the record itself seems the goal' (411). Lestat then 'takes' David in a passionately homoerotic scene and, with Louis, they begin the first part of their travels, to the Rio carnival.

The novel thus returns to the connection between the vampire and what I had called earlier in this chapter the 'global exotic' – where the vampire functions as a kind of internationalised, cosmopolitan tourist, mobile (and leisured) enough to make the world 'my own' – and channelling that world through the kind of 'panoramic perception' discussed elsewhere in this book. The point is taken up by Dana Brand in relation to the *flâneur* and the detective: 'The viewpoint of the detective is, like that of the *flâneur*, panoramic. . . . Like the *flâneur*, he distances himself from what he observes in order to achieve his panoramic perspective' (Brand, 1990, 237). In Stoker's *Dracula*, Jonathan Harker had travelled by train to Transylvania, reproducing the panoramic perspectives of late nineteenth-century travelogues. In Rice's *The Tale of the Body Thief*, Lestat and David cruise around the Caribbean on a luxury ocean liner and then make their way to South America – elevating tourism to the global level, and so turning the entire world into a place without borders – a place without 'otherness', a place with which one is, then, already *familiar*. This is certainly a 'fantasy of control' – but it is also a fragile fantasy which, in *The Tale of the Body Thief*, at least, is 'dislocated' through Lestat's disturbing encounter with the unfamiliarity of the 'real'.

7

VAMPIRE BLOCKBUSTERS: STEPHEN KING, DAN SIMMONS, BRIAN ALDISS AND S.P. SOMTOW

This final chapter will examine what I have perhaps inexpertly called 'vampire blockbusters'. Over the last twenty years, vampire fiction has opened itself up, as it were, to operate on a grand scale. In the case of Somtow, Simmons and Aldiss, that scale is international – or rather, American/international, since the movement of this fiction is always essentially focussed on (and always returns to) the USA. S.P. Somtow – whose real name is Somtow Sucharitkul – is particularly flamboyant in this regard, flaunting his internationalism at the end of *Vampire Junction* (1984) with the signature (*pace* James Joyce), 'Alexandria, New York, Rome, Geneva, 1980–83' (Somtow, 1984, 362), and repeating the gesture at the end of his sequel, *Valentine* (1992), 'Los Angeles, Bangkok, 1990–1991' (Somtow, 1992, 383). But not all of the vampire novels to be discussed in this chapter move so fluidly across the globe and through America. Stephen King's novels are usually set in and around small American communities – the Southern Maine town of Jerusalem's Lot, in the case of his vampire novel – although they may also present a character who is travelling through, an 'outsider' from elsewhere (such as Ben, one of the heroes in *'Salem's Lot* – as well as the vampires themselves). It is worth noting that Somtow and Simmons also turn to small communities for some of their action (Junction in Idaho for Somtow; Germantown in Pennsylvania for Simmons), to produce a local/global juxtaposition of events. King's *'Salem's Lot*, however, is highly localised and so in this sense it is the exception amongst the novels to be discussed here.

But each of the vampire novels under discussion do share another kind of 'blockbuster' mobility, moving rapidly from event to event, driven along by a series of increasingly climactic confrontations between heroes and vampires. They are dense, volatile and exciting – and often quite massive: Dan Simmons's *Carrion Comfort* (1989) runs to almost a thousand pages. Structurally, they usually plot two (sometimes three) narratives alongside each other, hopping from one narrative to the next in a series of short, 'cinematic' sequences. As the novels develop momentum, each sequence works up to a cliff-hanging description of a horror just about to happen –

then shifts to another narrative to work up to a similar kind of cliff-hanger. Their suspense derives from this continual shifting from narrative to narrative, where explanations of a horror-about-to-happen are always being momentarily deferred. In this sense – and because of the grandness of their scale – some of these vampire novels have much in common with the modern international thriller (Simmons's novel in particular works as a thriller at one remove). Their principle concern is with revealing an underlying horror which is governing or manipulating events at the surface level. This horror is barely visible but nevertheless omnipresent; only a few characters, however, can actually see it 'for what it is'. These novels dig up – quite literally, in Aldiss's case – something which operates below the surface but which helps to give that surface its reality. They work, in other words, as thrillers do, by formulating a paranoid consciousness which is then used positively. The heroes possess that paranoid consciousness – or, at least, they can be persuaded to possess it. They are then measured against other characters who, by contrast, are not paranoid *enough*. To put this in the terms used earlier in this book, the heroes, like Van Helsing in *Dracula*, have a certain kind of 'open mind' which allows them to believe what might otherwise be unbelievable, and to act accordingly. Charleston's Sheriff Bobby Joe Gentry in *Carrion Comfort* makes the point clear in this passage:

> I always hate in those vampire movies where they got corpses stacked up all around 'em, with two little holes in their necks 'n' all, and some of them corpses are comin' back to life 'n' all, and it always takes the good guy ninety minutes of the two hour movie just to convince the other good guys that the vampires are real.
>
> (Simmons, 1990, 218)

What complicates this picture in *Carrion Comfort* is that 'the good guys' may themselves be vampires – like the FBI agent Haines. The paranoid consciousness works at a conventional level in this novel, which presents its most frightening vampire as a Nazi war criminal, pursued by a Jewish psychiatrist who – assisted by the famous Nazi hunter, Simon Wiesenthal – does not doubt the identity of his quarry when he sees him at last. To recall the discussion of Slavoj Žižek in Chapter 3, these novels demonstrate the gulf between 'I think' and 'the Thing that thinks' – a gulf that only the paranoiac can bridge, where the one is able (and in fact was always able) to recognise the Other. Accordingly, to appropriate Žižek's Lacanian terminology, these novels are by nature 'catastrophic' – they actually map out the apocalypse that Žižek imagines would happen if this gulf actually *was* done away with. But the paranoid consciousness can also work against the confidence of recognition: identities can be changed; people are never quite what they seem, nor are they ever where they 'belong'. The very notion of identity in the internationalised American context of these novels is, at least at a certain level, thrown into question. The Israeli Mossad agent Jack Cohen thus

expresses his frustration at how difficult it is to locate their Nazi quarry with this remark: 'There is no place in the world where ID means less than in America' (371). Paranoia here, as elsewhere, begins with *this* recognition. That is, it is precisely the mobility of identity in the modern world that enables the paranoid consciousness – and these vampire novels – to flourish.

STEPHEN KING'S *'SALEM'S LOT*

King has written extensively on horror fiction, usually threading his commentaries through with autobiographical recollections. His account of his own generation's susceptibility to horror is worth quoting at length:

> We were fertile ground for the seeds of terror, we war babies; we had been raised in a strange circus atmosphere of paranoia, patriotism, and national *hubris*. We were told that we were the greatest nation on earth and that any Iron Curtain outlaw who tried to draw down on us in that great saloon of international politics would discover who that fastest gun in the West was . . . but we were also told exactly what to keep in our fallout shelters and how long we would have to stay in there after we won the war. We had more to eat than any nation in the history of the world, but there were traces of Strontium-90 in our milk from nuclear testing.
>
> (King, 1982, 23)

Here, horror is culturally (and generationally) specific: it exists in the slippage between knowing who you are and knowing too much, where to know who you are is also in fact to be deluded. That is, it exists in the tension between illusion (Americans possess a powerful international identity) and disillusion (this comes at a certain cost; Americans are at the same time disempowered at the local level – as Americans). Moreover, a knowledge of horror is made to appear original to these 'war babies' – ingested into them at infancy through the mother's breast ('our milk'). This is one of King's most lucid statements on horror. Elsewhere, however, he runs a series of more conventional positions: that horror expresses what 'we would be afraid to say right out straight' (47); that horror is accordingly 'primal', associated with 'anti-civilised emotions' (204); that horror 'says it's okay to join the mob, to become the total tribal being, to destroy the outsider' (47); and that horror thus serves a *cathartic* function (27), purging us of those 'anti-civilised emotions' and presumably enabling us to function as socially normalised people once more. None of these positions speaks for the kind of disturbance King locates in the quote above – a disturbance which, far from being unable to be said, is known only too well; a disturbance which is original to the 'war babies' generation, but not 'primal'; a disturbance which derives precisely from *being* 'civilised', from already *belonging* to 'the mob'; and a disturbance which refuses to be cathartic, which cannot be purged in order

for normalisation to be restored. It is a disturbance which, like the vampires at the end of some of the novels under discussion here, stubbornly lingers on.

King presents himself as exemplary in his 'war babies' statement: he stands for a generation which has grown up with horror, which knows all about it – which knows *too much* about it, perhaps. But King's relations to horror may also be specific to his function as a particular kind of writer – and reader – of horror fiction. King has written on the three best-known nineteenth-century horror classics, Mary Shelley's *Frankenstein*, Stoker's *Dracula* and R.L. Stevenson's *The Strange Case of Dr Jekyll and Mr Hyde* – and has, indeed, assisted in their on-going canonisation.[1] These three novels, he suggests, draw upon the 'myth-pool' of horror archetypes – the 'myth-pool' in which 'all of us . . . have communally bathed' (66) – to give us three images of evil: the Thing-with-no-name, the Vampire and the Werewolf (Stevenson's novel is understood as a version of the werewolf myth). These novels may well express the unsayable, and to read them may well be a cathartic exercise. The problem for King, however – as I have suggested – is that we ('all of us') have not merely 'bathed' in the images these novels offer us. As readers, we have *saturated* ourselves in them. Again, King presents himself as exemplary here: his own familiarity with horror *fiction* becomes generational, also typical of the 'war babies'. But his point is worth pursuing. As with reality itself, we know these images of horror fiction only too well – we now know too much about them. Horror fiction would seem to be the literature of exhaustion: how can it ever be *unfamiliar* to us again? It cannot, of course, especially if it is read in terms of 'archetypes' which it is condemned always to repeat. But King's own vampire novel, *'Salem's Lot* (1975), does at least provide one kind of alternative strategy. It turns familiarity with the vampire genre into a virtue; to know too much about vampires is disturbing, certainly, but it is also ultimately salvational.

King shows his small town of 'Salem's Lot to be vulnerable to vampires because of its isolation from 'reality', especially the reality of American political activity: 'the Lot's knowledge of the country's torment was academic. Time went on a different schedule there. Nothing too nasty could happen in such a nice little town. Not there' (King, 1977, 33). The passage enables at least two positions *on* the 'real' which have been important to much horror fiction. The 'real' is emptied out in order to return (more intensely, more disturbingly) as the 'repressed' of 'Salem's Lot. The town's isolation enables it to maintain the illusions it does; it is ready, therefore, to be disillusioned. In this context, however, the town is not so much unusual as *typical* – 'typically American'. The claim that the town's knowledge of the real is 'academic' opens up this ambiguity: perhaps it knows *more* than other towns, rather than less. Later passages in the novel make this clear: 'The town knew about darkness' (219) – although it has been reluctant 'to look the Gorgon in the face' (385). *'Salem's Lot* is thus able to juggle two conceptions of its small American town: that it is unusual in that it is isolated from the

'real' (which can therefore 'return' to it); and that it is typical in that even in its isolation it knows about the real which is about to inhabit it and which, perhaps, has always already inhabited it (not least, through the history of the Marston house). Thus, it can work as a contemporary allegory, responding in particular to the 'typical' disillusions of America's post-Vietnam involvement (to which it refers a number of times), and at the same time it can disavow its allegorical status, since the town's – and the vampire's – atypicality is also preserved.

The notion of an 'academic' knowledge of 'reality' is in fact important to the novel. Its three heroes are each conceived in these terms. Matt, an unmarried, 'nonpractising Methodist' (176), teaches English literature at the local high school. At one level, Matt's literary background enables him to distinguish between fantasy and reality; at another level, it constitutes his only remaining source of belief, as he recognises when he sees one of the vampire's victims:

> *What you're thinking is madness.*
> But step by step he had been forced backward toward belief. Of course, being a literary man, it had been the first thing that had come to mind. . . .
> *Scratches? Those marks weren't scratches. They were punctures.*
> One was taught that such things could not be; that things like Coleridge's 'Cristabel' or Bram Stoker's evil fairy tale were only the warp and woof of fantasy. Of course, monsters existed; they were the men with their fingers on the thermonuclear triggers in six countries, the hijackers, the mass murderers, the child molesters. But not this. One knows better. The mark of the devil on a woman's breast is only a mole, the man who came back from the dead and stood at his wife's door dressed in the cerements of the grave was only suffering from locomotor ataxia, the bogeyman who gibbers and capers in the corner of a child's bedroom is only a heap of blankets. Some clergymen had proclaimed that even God, that venerable white warlock, was dead.
> *He was bled almost white.*
>
> (177)

Indeed, Matt and vampires appear to be made for each other, precisely because the vampire is itself such a literary creature:

> it was fitting that when trouble finally came to him – great trouble – it should come in this dreamlike, darkly fantastical form. A lifetime's existence had prepared him to deal in symbolic forms that sprang to light under the reading lamp and disappeared at dawn.
>
> (375)

The second hero, Ben, also has a literary background. Like a number of King's protagonists, he writes popular novels. As an outsider, however, he is

under suspicion in 'Salem's Lot. His friendship with Matt is exceptional in this context, and is premised on their mutual ability to believe in the unbelievable – because they are already familiar with it:

'According to folklore, the marks disappear,' Matt said suddenly. 'When the victim dies, the marks disappear.'

'I know that,' Ben said. He remembered it both from Stoker's *Dracula* and from the Hammer films starring Christopher Lee.

(186)

Ben's readiness to believe contrasts with his girlfriend, Susan, whose 'unbelief' (217) leads to her death. Belief in this novel draws only the men together – and the boys. The third hero is Mark, an adolescent who – like the Frog brothers in *The Lost Boys* – is thoroughly immersed in the genres of popular horror. He is distinguished from the two men because he is interested not so much in literature as in magazines and film – 'low culture'. His knowledge is, however, even more 'academic' than theirs: as a fan, he knows his material both intimately and scientifically; he knows it only too well. Each character, then, is shown to be – to recall the point above – saturated in literary and popular/low cultural knowledges. These knowledges are brought to bear upon the vampire, and together the three heroes succeed in destroying it. In the process, they create what one character calls 'a paranoid's dream' (267): given the sources of its various 'academic' knowledges, this novel is not surprisingly highly self-conscious about the paranoid fantasy it creates.

It would be possible to locate a certain homophobia in the novel, which shows its German-born vampire to be 'almost effeminate' (363) and presents Matt and Ben's amusement at the thought that the townspeople might regard them as 'a couple of queers' (188). King kills his vampire; Matt also dies before the intimacy with Ben ('between men') becomes troubling. The novel ends by turning instead to the developing relationship between Ben and Mark, the adolescent boy. This relationship is depicted in terms of father and son – but it also works as a projection of the relationship between writer and reader. Matt was older than Ben; as a teacher of the 'Liberal Arts', he was tied to the kinds of literatures no longer in circulation but which are influential for all that. Mark, on the other hand, barely reads novels at all. He does, however, have models of Frankenstein's monster, Mr Hyde and Dracula in his bedroom and is thus (for all his contemporary low cultural interests) located in a tradition of 'classical' or canonised popular horror. Ben – the writer – mediates between these two characters, indebted to Matt and his middlebrow (even highbrow) literary culture, but ensuring that Ben *remains* within the frame of popular fiction. 'Salem's Lot, in other words, demonstrates the 'paternal' influence of popular fiction over a low cultural realm which might otherwise slip beyond it – and to which adolescents are supposedly turning. All the knowledges in the novel are located in and

through a 'classical' tradition of popular fiction and older, influential litera-tures, which, it suggests, the young can inherit. These traditions are shown to be 'living', organic – and capable of producing redeemable knowledges. The novel, in short, monumentalises itself by turning popular fiction into a mobilised, recuperative, *literary* discourse – through which everything is directed and to which everything, ultimately, returns. Even the vampire, when he dies, has a 'mouldy library smell' and bones which flake away 'like pencils' (423).

DAN SIMMONS'S *CARRION COMFORT*

Dan Simmons's first vampire novel – which takes its title from a poem by Gerard Manley Hopkins – won the 1990 Horror Writers of America Bram Stoker Award. It also won the 1989 British Fantasy Society Award and the 1990 Locus Award for Best Horror Novel; Simmons is, in fact, a frequently awarded and highly respected horror and science fiction novelist. To recall Dana Brand's phrase in the previous chapter, *Carrion Comfort* is essentially a 'fantasy of control' – or rather, it is an *analysis* of a fantasy of control. It introduces a coterie of aristocratic 'mind vampires', people who are able to control others by inhabiting their minds. Two mind vampires are central to the story: Melanie, who is sometimes a narrator, and Willi Borden. Al-though they have been intimate with each other, their narratives are on the whole mutually exclusive, coming together only briefly at the end. Melanie's narrative, involving her battle against a former rival mind vampire, Nina, is generally localised – focussed in and around Charleston and then in her 'house of horrors' (Simmons, 1990, 843) in Germantown, Pennsylvania (America's Transylvania?). Melanie kills a negro in the struggle; soon afterwards, the man's outraged daughter, Natalie Preston, joins forces with Sherrif Bobby Joe Gentry against her. This localised narrative operates at street-level: Natalie and Gentry work with a gang of black youths against Melanie – for whom blacks 'didn't even count' (119) – and the people she ruthlessly controls. They meet Saul Laski, a Jewish psychiatrist living in New York who is, as it happens, involved in a much more extensive programme of revenge against Willi Borden. Borden is also Herr Von Borchert, a Nazi without a conscience – for whom Jews don't count – who Saul had met during his time in the concentration camps. Now, Borden is associated with the Island Club, a group of powerful right-wing American mind vampires, directors of massive corporations who enjoy playing 'blood sports' with human victims. The Island Club is capable of secretly controlling events at the global level, manipulating American foreign policy; they are also shown to be responsible for real crimes, such as the murder of John Lennon. Saul, Natalie and Gentry are this novel's version of the Crew of Light, often working together against these mind vampires. Indeed, Saul is the novel's Van Helsing figure, a psychiatrist who practises hypnosis and who readily

believes in the unbelievable – that is, in otherwise invisible deep structures of activity. His most sympathetic hearers are Mossad, the Israeli intelligence agency which, precisely because of its 'long history of paranoia' (987), is easily persuaded about the reality of the mind vampires. But although these characters do work together, the two narratives remain fairly distinct, especially along the lines of gender: Natalie is the focus of the localised struggle with Melanie (Gentry is killed during this struggle), while Saul literally comes to grips with Willi Borden in a more internationalised arena. Interestingly, Melanie survives, but Willi does not; she remains at the end of the novel as a possible threat, whereas the narrative involving the two men is triumphantly closed down.

These highly-paced struggles drive *Carrion Comfort* along, turning it into perhaps 'the best page-turner ever to come into the hands of horror fans' (Morris, 1990–1, 16). It is full of graphically described events, moving close in its descriptions of dismemberment and death to what is currently called 'splatterpunk'. But it is also a contemplative novel, offering a number of spaces through which characters – Saul especially – can meditate on topics which bear directly upon the action, and upon the novel's function as a work of popular fiction. Saul has written a book called *The Pathology of Violence*, a study of the way people can be 'programmed' to commit violent acts (76). The 'programme' is seen to operate at an individual rather than a social level – whereby one person can be directly influenced by another. The study essentially examines the power of 'charisma':

> What was the root source of human violence? What role did violence and the threat of violence play in our everyday interactions? By answering these questions, I naively hoped someday to explain how a brilliant but deluded psychopath like Adolf Hitler could turn one of the great cultures of the world into a mindless, immoral killing machine. . . . As I spent years compiling data and developing premises, I secretly harboured a theory so bizarre and unscientific that it would have ruined my professional standing if I had so much as whispered it to colleagues. What if mankind had evolved until the establishment of dominance was a psychic – what some of my less rational friends would have called a *parapsychological* – phenomenon? Certainly the pale appeal of some politicians, the thing the media calls charisma for want of a better term, was not based upon size, breeding ability, or threat display. What, I surmised, if in some lobe or hemisphere of the brain there were an area devoted to nothing else but projecting this sense of personal domination?
>
> (187)

Saul's thesis is borne out through the existence of 'real' mind vampires; the fiction, in other words, makes it true. Indeed, the thesis is appropriate to popular fiction in particular, which itself occupies a 'less rational' position

than, say, science – so that scientists like Saul (and Van Helsing, for that matter) must also necessarily be shown to be *unscientific*. Saul's thesis may be 'bizarre' in scientific circles, but in the realms of popular fiction it is absolutely credible. The thesis is evolutionist in that it imagines that some people – the 'charismatic' ones, the 'alpha personalities' (440) – rise to the top of the scale, while others – the 'level zero' people – remain at the bottom, underdeveloped, morally empty, throw-backs to a prehistorical moment (692). The mind vampires are seen in this way – yet they are also 'charismatic', able to dominate others. The top and the bottom of the evolutionary scale thus fold into each other: was Hitler an 'alpha personality' or a 'level zero' person – or both? Saul, Natalie and Gentry, however, provide an alternative to these extremes that compares them with Stephen King's liberal heroes. Saul is a university teacher in New York; Natalie also has a university education and teaches; and Gentry, although a sherrif, is a Duke University graduate in the Arts. In other words, they all share a particular pedagogical 'tradition': middlebrow rather than elitist, responsible rather than amoral, enlightened rather than obsessed. Even so, they are drawn into the realm of those extremes – becoming close in some senses, as they occasionally recognise, to the mind vampires they are struggling against. That is, they, too, are capable of becoming obsessed, violent – and charismatic.

The novel, of course, requires both the extreme, amoral position of its mind vampires and the responsible position of its heroes in order to function. It wants to *be* violent – and speak *against* violence, as Saul does in his lectures on modern horror films (783). The violence in *Carrion Comfort* is therefore self-consciously enacted: one is encouraged both to experience it spontaneously, as it occurs, and establish a critical (or moral) distance from it – but not such a critical distance that one would not want to experience it again. The novel maintains that violence is like 'rape' – a rape of the mind – but it is also 'addictive' (788). This 'addictive' and mind-oriented aspect of violence makes it an appropriate topic for popular fiction. Indeed, the 'fantasy of control' in which the mind vampires indulge – where one mind occupies another, like a 'virus' (495) – is associated with the way popular fiction influences its readers. The novel introduces, almost in passing, a writer of popular fiction who had planned a book called *The Mind Vampires* – which, as a fictional idea, stands at the very source of events which the novel often claims as 'real' (such as the murder of John Lennon, mentioned above). For the novel, in fact, fiction is a means of *revealing* the 'real', which otherwise passes unnoticed. Melanie describes the book's project just before she makes the writer kill himself:

His idea for a book – he told Nina that he had been working on it for some time – was that many of the murders then being committed were actually the result of a small group of psychic killers, he called them mind vampires, who used others to carry out their grisly deeds. He said that a paperback publisher had already shown interest in his outline

and would offer him a contract tomorrow if he would change the title to *The Zombie Factor* and put in more sex.

(21–2)

The last remark draws a distinction between popular fiction and exploitative trash – a distinction Simmons returns to in his account of the B-grade Hollywood producer Tony Harrod. *Carrion Comfort* maintains a sense of popular fiction as a responsible form (related to its engagement with the Holocaust and the Jewish experience). But it sees that the slide into exploitation may not always be preventable – and may even be desirable (since it can produce arousal, excitement). Horror fiction in particular can thus also be an *irresponsible*, 'level zero' form, producing the kinds of effects (terror, pleasure, addiction) associated, in fact, with the mind vampires. That is, horror fiction must itself have a 'charismatic' function. To read it in the terms laid out by Simmons, it must successfully interpellate its readers (that is, exert its control over them, drawing them into a narrative which *is* violent and to which they will become 'addicted') and yet – to maintain a certain intellectual credibility, to allow moments of contemplation in the midst of an otherwise 'distracted' mode of reading – it must also be seen to speak out *against* interpellation.

BRIAN ALDISS'S *DRACULA UNBOUND*

Aldiss's novel follows his earlier *Frankenstein Unbound*, as an attempt to return to an 'original' moment in the history of horror. More so than Stephen King, perhaps, Aldiss – a prolific British SF novelist – thus participates in the on-going process of the canonisation of a select tradition of British horror classics. But the task is also to reorient those classics, even to 'rewrite' them – to occupy their terrain and pull them in various unforeseen directions. In particular, these nineteenth-century novels are now inserted into a globalised realm of activity, where characters move freely from one place to another. Of course, in one sense, nothing has changed: *Dracula* was itself a novel about mobility and movement, across nations. But *Dracula Unbound* also moves across *time*, beginning in Utah in 1999. Moreover, it moves freely back and forth between fiction and 'reality' – in a world where Bram Stoker becomes a character, just like Dracula. All this would seem to be liberatory: the novel 'unbinds' *Dracula* by working through it and across it in this way. Yet, in an important sense, the project is also constraining; Stoker's novel is not so much 'unbound', as refitted.

Joe Bodenland – his name is at one point mistaken for 'Borderland' – is a scientist and the director of a large corporation in Dallas, Texas. His associate Clift, an archaeologist, has discovered the preserved corpses of two vampires, a man and a woman, which are dated as 65.6 million years old. In the meantime, Joe has developed a 'time machine' which can send toxic waste back into the past. Joe is married to Mina Legrand; their son, Larry, is

engaged to Kylie, to whom Joe is sexually attracted. Clift and Joe encounter a peculiar 'ghost train' which, it turns out, travels through time – and carries vampires, or 'Fleet Ones'. This 'train of the Undead' (Aldiss, 1992, 84) offers the two characters a particularly extensive 'panoramic perception', as they journey back to prehistoric times at one moment, to late nineteenth-century England (to visit Bram Stoker) at another, and to Tripoli, Libya, AD 2599, at yet another. It turns out that Joe's 'time machine' has provided the technology for the vampire's train, enabling them to do battle with humans to re-establish their rightful position as masters. After meeting Bram Stoker, Joe goes into the future to find a powerful super-fusion bomb which he then takes back into prehistory. His closing decision – which he puts before his family, Stoker and another character – involves whether or not to detonate the bomb, which would destroy the vampires before they can travel in time, but would also destroy almost every other living thing and send the world into an ice age. The novel is thus a 'fantasy of control' on a grand scale. Joe is able to see what might have happened to the planet, and is also able to prevent it happening. He has a thoroughly 'panoptic', flâneurian – and paranoid – view of things: his 'panoramic perception' makes him capable, to modify Dana Brand's words slightly, of mastering the *global* environment.

Joe is another scientist with an unscientifically 'open mind', suitable for fiction; as he tells Stoker, 'I come from an age where anything can be believed' (110). By contrast, Van Helsing – who appears in this novel as a character, alongside Stoker and Dracula – does *not* believe in vampires: Aldiss introduces him only to make him redundant. Joe is also contrasted to Kylie, who is 'crazy about religion' (23). In this novel, men are technical and women are spiritual – and sexual. Thus, when he dreams that he is approached by three vampire women, as Harker was in Stoker's novel, Joe recognises one of them as Kylie. The novel also introduces a female vampire, Bella, who corresponds to Stoker's Lucy. Moreover, Mina becomes a vampire – and her son, Larry, has erotic dreams about her. Stoker's wife Florence, on the other hand, is in the background, only alluding enigmatically to her husband's fondness for young girls – and to his syphilis. Stoker sees vampires in precisely this way, as a syphilitic virus, as a heterosexually-transmitted disease – as parasites/women to whom men are fatally attracted. The novel seems to take a different line. Count Dracula has two horns on his head, like the god Pan; vampires are Nature in its 'original' form, much older than humanity. This prehuman stage also means that vampires have '[n]o real individuality' (160); they are underdeveloped in this sense, much like Simmons's 'level zero' people – functioning as a kind of unified, organic community with a 'one-track mind' (155), communistic rather than democratic. According to the novel, individualism came with Christianity, which is why vampires so despise the cross. To believe in vampires, Joe has to recognise this point – and believe in Christianity, too. That is, he must become (if only for a moment) 'religious', like Kylie. Belief

is feminised here; but it is also conceived of as a 'throw-back' on the evolutionary scale, as pre-Enlightenment, as irrational. It is associated, in short, with the vampires themselves.

Joe's scientifically-grounded scepticism is challenged by vampires – which he must believe in, so that he can destroy them – and by women, which he has to learn to live with. This is the irrational 'pull' which turns this somewhat machismo adventure novel into science *fiction*; this is what remains scientifically inexplicable in a novel which likes to explain as much science as it can to its readers. The 'pull' is to be resisted, but it is also irresistible. It works against the 'progressive' ideologies which this science fictional work (like much SF) depends upon – but it is nonetheless attractive. The topic of incest is raised in this context. Dracula calls Bella his 'bride and daughter' (154): he is 'naturally' incestuous. Joe's attraction to Kylie – who is a vampire in his nocturnal dreams – is also incestuous. Science can locate the source of this attraction, but it is *too* 'primitive' to be 'explained':

> He saw . . . the pale and loving woman who had so recently become his daughter-in-law. For those beautiful features, those soft limbs, that sensuous body with its delectable secrets, lust filled Joe's body. . . .
>
> Suppose there was a type of creature which was subject to different processes. A creature like a vampire, without intellect. . . .
>
> And they preyed on humankind by activating one of the strongest instincts below the neocortical level, the great archetype of sex.
>
> As a flower attracts by its scent.
>
> His dream. . . . The incestuous dream of union with Kylie, dead or alive. Repugnant to his consciousness, evidently delightful to some more primitive layer of sensation.
>
> (129, 131–2)

This view of woman-as/and-vampire is certainly heterosexist; the novel goes on to take them both as a kind of original 'symptom', producing anxiety, in a sense not far removed from that used by Joan Copjec, described in Chapter 3. The prehistorical world of vampires is also a pre-Oedipal world, where everything is in a mutual, ecological 'balance' with everything else. Humans ('mankind') have 'disturbed' that world, bringing imbalance (211). But this imbalance is associated with what distinguishes humans from vampires, or, in this related context, men from women: individualism. The point is complicated, however, in the discussion surrounding Joe's decision to detonate the super-fusion bomb. The characters take a vote on the decision in order to be 'democratic' (237). The four men support the detonation; Mina wavers, finally agreeing with the men; but Kylie steadfastly opposes the decision. Her opposition is initially on 'religious' grounds: she 'believes' it is wrong. Later, however, it is given a more cynical expression: 'Well, look, if I said okay, wouldn't it be kind of sick for a family to all agree, yes, fine, let's kill off thousands?' (237). She recognises that her objection is of value

135

only insofar as it enables the group to *appear* 'democratic'. For the group to think alike would be 'kind of sick', that is, communistic; they would then resemble the vampires they are trying to destroy. Democracy, on the other hand, can not only tolerate objections, it *needs* them. Paradoxically, Kylie herself becomes the 'individual' here – the necessary factor which brings a democracy into being. The novel comes up against the gendered structure of its own ideology at this point; what is imagined as a moment 'before' individualism – the most 'primitive' thing – turns out to be predicated on the fact that individualism already exists, and is thus the *least* 'primitive' thing. At this point, for all her archaic 'religious' beliefs, Kylie is a particularly modern and articulate character. *Dracula Unbound* ends by trying to cancel this out, by reducing Kylie back to something inarticulate – as if a woman's sexuality really (and merely) speaks for itself: 'Let Kylie chatter. Any girl who looked that good in a bikini did not have to make too much sense' (243). This closing and surprisingly chauvinist erasure of Kylie is not unconnected to the destruction of the vampires in the novel – the very motivation which drives *Dracula Unbound* along. The novel's 'fantasy of control' is tied to Joe's panoptic vision, his mastery of the global environment; it also involves a certain blindness to what he otherwise cannot seem to take his eyes away from.

S.P. SOMTOW'S *VAMPIRE JUNCTION* AND *VALENTINE*

Of the four novelists under discussion here, S.P. Somtow is by far the raunchiest. His vampire novels evoke an entire spectrum of crimes – incest, paedophilia, rape, patricide and matricide, murder, necrophilia, pyromania and, of course, vampirism – often spectacularising them through the 'splatterpunk' mode which Simmons had only touched in his novel (preferring instead to simulate 'real' violence, as in the account of the murder of Aaron's family). Bodies break up and and fly about in Somtow's novels ('Oh my God, she's splitting in two down the middle!') in ways that forestall Simmons's earnest meditations on violence and responsibility. Indeed, they are in certain respects flamboyantly *irresponsible* – sliding much more willingly into the 'trashier' fictional realms from which Simmons had distanced himself. Philip Brophy's term 'horrality', used to describe contemporary horror films, might well be applied here: Somtow's fiction certainly throws together the various encodings of this word, 'horror, textuality, morality, hilarity' (Brophy, 1983, 85). This is contemporary vampire fiction at its most ambitious and its most *excessive*. It is as if all the characteristics of the subgenre described so far – which the novels under discussion in this chapter (and in Chapter 6) know only too well – have here been pushed to the limit, including the vampire itself.

Somtow's young vampire protagonist, Timmy Valentine, is thus also a 'saturated' creature – not just in the sense that he is continually feeding, but

in the sense that I have used in relation to Stephen King. That is, he is overburdened with meaning (especially 'archetypal' meanings) and, more importantly, he is highly *conscious* of being so overburdened. Accordingly, it is the vampire himself who now suffers from 'anxiety'. The role of Somtow's first vampire novel, *Vampire Junction* (1984), is certainly to diagnose that anxiety – so that it includes a Jungian psychiatrist, Carla, amongst its central characters, who (rather than destroy the vampire) puts Timmy under analysis. But it is also to *release* it. Rather than simply being contained or managed by the analysis, in other words, that anxiety diffuses through the text to inhabit everything it touches – producing many more vampires, Carla included, in the process. Each vampire picks up meanings along the way, pulling against the containing structures – the Jungian 'archetypes', especially – used by the novel to anchor meaning, to ground it. Lisa and Kitty, who also become vampires because of Timmy, are good examples. Lisa becomes a 'sea-vampire' who makes Timmy and Rudy, Timmy's assistant, more anxious than usual: 'Containment. That's what we must have. When she comes back, cover her corpse with garlic. Stick crucifixes on all the exits. She won't die, but she'll have to stay put. . . . For how long?' (Somtow, 1984, 141). Timmy worries about Kitty in the same way: 'We have to put Kitty under restraint, but she still grows bolder and bolder. She won't listen to reason' (149). Somtow's novels, then, are not only 'fantasies of control' – they do, after all, subordinate much of their narrative to Jungian paradigms – they are also fantasies about being *out* of control. Even a group of vampire-killers, who might have restored order in another novel, only contribute to the spread of anxiety – they are appropriately named the 'Gods of Chaos' (in contrast to Stoker's Crew of Light).

This pull against 'containment' makes Somtow's vampire fiction even more mobile than the novels discussed above. His vampire, Timmy, is certainly a 'citizen of the world', moving freely from place to place – and arriving, finally, at a small town called Junction, in Idaho. Moreover, like Aldiss's vampires, he also moves freely through *time* – or rather, through history, going back as far as Pompeii (which is his point of origin). The novels are arranged around the various moments in Timmy's many lives, some of which are listed in sequence at one point: '[h]e remembers Pompeii. Alexandria. Carthage. Castile. Rome. Tiffauges. Cathay. Thauberg. Oswiecim. Junction' (Somtow, 1992, 108). Each moment locates Timmy in relation to a mythologised or canonical figure: the Sybil in Pompeii (who is like a vampire, since she had been condemned to live forever), Gilles de Rais in Tiffauges (where Timmy is disoriented by someone even more evil – and excessive – than he is), Caravaggio in Renaissance Naples and Hadrian in Rome (two sequences which connect gay love between men and boys to the production of great works of art), and, later in *Valentine*, Cortes and Moctezuma in the New World. These moments each represent a 'junction', an important metaphor in Somtow's first vampire novel especially. The town

of Junction is presented as the place upon which all these moments converge – which makes it, too, overburdened: it 'seems to mean a thousand things' (120). Characters arrive at Junction, appropriately, by train: this is the novel's destination, a 'picture postcard' American town (Somtow, 1984, 253). But it is also a labyrinth. The house at the centre of Junction has many rooms and no centre (making it very different to, say, Stephen King's Marston house in *'Salem's Lot* – which, although off-centre, clearly signifies its meaning). That is, even inside the house one continues to travel. *Vampire Junction* in fact ends with Timmy, Carla and Stephen boarding the train once more – consistent with the novel's evocation of continual, 'nomadic' motion. *Valentine* ends similarly, with the characters metaphorically stepping back 'on the train', about to leave 'the last-known station on the railroad' (Somtow, 1992, 382).

Timmy's journey to the New World provides a good example of the 'panoramic perception' which goes along with this kind of travelling: it presents the Americas as if they are being seen for the first time – a presentation which relies upon the fact that one is, of course, already familiar with what is being described. In *Vampire Junction*, the 'Gods of Chaos' are also great travellers. In an interesting variation on Jonathan Harker's journey into Transylvania at the beginning of *Dracula*, they travel into Thailand to visit an old monk who can tell them about vampires. Prince Prathna, one of the 'Gods of Chaos', is an Asian aristocrat – and he acts as their guide:

> For a while, they drove in silence, interrupted only occasionally as Prathna pointed out the sights. Here a park where dirty children knocked about a rattan ball or *takraw*; here a convoy of yellow-robed bald monks crossing a street, bringing traffic to a screeching halt; and now, as they near the city's ancient heart, the baroquely twisted spires and golden pointed eaves of the Temple of the Emerald Buddha. . . .
> Each day brought more spectacle. Prathna had declared, 'If we can't figure the old boy out, we might as well see the sights before we die'. They took canal trips and saw the Temple of Dawn, glittery and bulbous against the setting sun. They saw snake farms and crocodile farms; they visited massage parlours as a change from what Prathna called his 'homely comforts' of the garden of pleasures.
> And at night they went to their separate suites in Prathna's palace. Even the air conditioning could not mask the pervasive scent of jasmine. As they lay in their soft beds, sometimes in the arms of soft young women, the Gods of Chaos dreamed.
>
> (Somtow, 1984, 156, 164–5)

These travellers go into Thailand as much to see the 'sights' as to learn about vampires – they may even prefer the former activity to the latter. The connection between travel and 'dreaming' is important to notice, however.

At the end of *Valentine*, Brian Zottoli – a popular novelist who becomes a vampire-killer, much like Ben in *'Salem's Lot* – considers himself to be 'travel[ling] in a perpetual dreaming' (Somtow, 1992, 382). He is, it seems, yet to wake up: the 'dream', like a sequel, will continue. This is where the sense of *release* described above comes from. That is, the novels appear out of control precisely because travelling and dreaming are so intimately connected. What is being mobilised here, in other words, is the 'unconscious' – and Somtow takes it on a grand tour. This is a protean, malleable world, always difficult to see clearly. Somtow exploits the image of Transylvania in this respect – as a place 'beyond the forest', as Europe's 'unconscious' (to recall Geoffrey Wall's claim, cited in Chapter 1). But this also tends to reduce these 'other' places to the same: they are all, ultimately, versions of the 'dark forest . . . the forest with no end' (Somtow, 1984, 78, 80). Somtow's Transylvanian-induced 'unconscious' now stretches across the world, suitably internationalised, with spectacular effects. In the process, however, it reduces that world to a set of archaic images. The Jungian paradigms at work in both novels do not help matters. Certainly these novels are highly mobile, moving rapidly from site to site – as Timmy mutates from character to character. But the Jungian paradigms only collapse the differences (and the distances) *between* each site. This is especially true of *Valentine*, which has its crazy TV evangelist speak against 'so-called experts like Joseph Campbell' who claim 'that all mythologies are saying the same thing' (Somtow, 1992, 287) – a claim which the novel, distancing itself from the evangelist (who later realises his delusions anyway), clearly tends to support. In *Valentine*, East meets West precisely at the level of 'mythology': they literally come together as P.J., a Shoshone mystic, and Lady Chit, a Thai princess, make love. Timmy essentially mutates into various versions of the resurrected Christ ('Tammuz and Adonis and Osiris', 286ff.); accordingly, he is seen by others always in the same way – they adore him, they worship him, they want to be like him. The novels certainly travel, but they always return to the same 'junction': one 'dark forest' is like any other.

In *Valentine*, the Jungian image of the 'archaic' unconscious is placed alongside a more contemporary conception of cinematic illusion. Or rather, these conceptions (dreaming, and the 'dream-industry') are two sides of the same coin. Much of *Valentine* takes place in and around Los Angeles – 'Universal City' (78) – inside television studios and on movie sets. The Jungian paradigm had spread across the globe to reduce it to an archaic sameness. Cinema is seen in a similar way, as a globalising medium which also spreads its illusions across nations. *Valentine* characterises this as decadent, but it also celebrates the freedoms it brings. An academic appears on a talk-show to make this point, and – with a 'philosophy [that] is a conflation of Carl Jung's and Joseph Campbell's' (301) – his position would seem to be endorsed by the novel:

as we enter the final decade of the millennium, the amount of apoc-
alyptic imagery in popular culture – and televangelism, distasteful
though it may be to some, must be considered a manifestation of
popular culture – must steadily increase, just as it did when we were
moving toward the year AD 1000. . . . The interesting thing about
today's version of millennial madness is the way it can reach into so
many people's homes without the lifting of a madman's finger, you see.
A word which the Reverend Peters dropped during yesterday's ravings
is *very* significant – he called his ministry a *virtual cathedral*. In other
words, it is the illusion of reality transformed into hyper-reality. Do
you see what I mean? As we near the millennium, realities shift and
blend and we could emerge with a wholly different reality – a magical
transformation. I don't necessarily see the end result as a bad thing at
all. That's where I differ from the Armageddon doomsayers.

<div align="right">(300)</div>

The novel mobilises the illusion of cinema at a 'universal' level, as if nothing
now, in the years following Reagan's America, is 'real'. The vampire helps to
bring this into being – with Timmy's participation in the discovery of the New
World leading inexorably towards the making of a grand illusion, *Valentine:
The Motion Picture*. But the vampire is also, by this time, a *disillusioned*
creature. I had noted earlier that Somtow's novels enact a 'pull' between the
containment of diagnosis and a narrative which encourages *release* – which
celebrates what is *excessive* to diagnosis. Timmy labours under the burden of
this excess; he is, as I have suggested, a 'saturated' character, anxious about
his well-being and the 'special effects' he has on others. A problem of belief
is, as always, involved. Here, however, the problem is that *too many* people
believe in him – and want to believe in him. It was once difficult to find
believers; now, it is difficult to find people who do *not* believe. As Brian
Zottoli – a figure for the popular novelist himself – remarks, 'We're all
paranoid' (114): in a world 'saturated' with illusions, paranoia is a natural
condition. Timmy consequently enacts a withdrawal from the novel – and
from the 'saturated' world the novel evokes, where those illusions (the
illusion of cinema, of 'hyper-reality', of vampires) have spread relentlessly
across the globe. In short, he becomes 'human', trading his vampiric nature
away to an all-too-willing wannabe, a look-alike fan. The strategy might
recall events in Anne Rice's *The Tale of the Body Thief* – but the 'real' is now
comforting rather than dislocating. At one level, this ex-vampire still needs
his illusions (there is always the cinema . . .); at another, he has had quite
enough.

CONCLUSION

It seems appropriate to end a book on vampires with an image of exhaustion; but it is also worth restating the fact that vampire fiction and film are far from exhausted as far as contemporary cultural production is concerned. The vampire's *nature* is fundamentally conservative – it never stops doing what it does; but *culturally*, this creature may be highly adaptable. Thus it can be made to appeal to or generate fundamental urges located somehow 'beyond' culture (desire, anxiety, fear), while simultaneously, it can stand for a range of meanings and positions *in* culture. The simultaneity at work here, it seems to me, explains why the vampire has lived so long.

This book has attempted to map out the vampire in these terms. Thus, in Chapter 1, I examined the representation of the vampire as 'foreign' or 'unassimilated' – located 'beyond' culture in this sense – but I also wished to show that this representation was grounded *in* culture as one means by which it achieves self-definition. In Chapter 2, the vampire was shown to enable mediation between what is 'beyond' culture (Nature, the folk, rustic super-stitions) and what is culturally definitive (the nation, society, science) – where the former 'animates' the latter. In Chapter 3, Freud's concept of the 'uncanny' was worked over (some might say, overworked) to the same ends: the vampire is figured as simultaneously unfamiliar ('beyond' culture) and familiar (culturally located). Chapters 3 and 4 looked at the structures of management which Victorian vampire narratives developed precisely in order to deal with the vampire's 'difference'. This 'difference' was conceived in sexual terms, amongst other things: the vampire's 'queerness' seemed to place this creature 'beyond' culture even as culture found itself drawn towards it (erotically, diagnostically). In Chapter 5, youth becomes a 'site of contestation', vulnerable to vampirism from outside (which is also to say: from inside). This is represented in some of the films under discussion as a sexually-inflected struggle between youth subcultures or 'cults' (located 'beyond' culture) and the family (which is *in* culture). The last two chapters follow the fortunes of the vampire in contemporary popular fiction – which continues to show the vampire as an 'unassimilated' figure ('queer', alien-ated), while suggesting at the same time that this creature now inhabits

141

culture to the point of saturation. The fantasies of paranoia these fictions entertain often work, in fact, by shifting from a conventional view of the vampire as culturally marginal (of little social significance, confined to low cultural forms) to a recognition that the vampire is not only central to culture but may even be (re)constructing it in its own image – or vice versa.

I have also wanted, in this book, to create another map of the vampire – which we could lay over the one outlined above – which figures what is imagined and what is real in much the same way, that is, as 'beyond' culture and *in* culture respectively. In vampire fiction, this figuring again occurs simultaneously: I have represented it as a kind of dialectic between illusion and disillusion – as a problem of *belief* – which is mobilised in the fiction for ideological reasons but also to produce a certain kind of force or affect. This mobilisation brings the splitting of what is *in* culture and what is 'beyond' culture back together again, since ideology is intimately tied up with affect: they require each other in order to function. And it is not possible somehow to opt out of this arrangement by declaring simply that one does not believe in vampires (and that therefore one is not affected by them). Even disbelief – or disillusion – can be mobilised in vampire fiction: there is no innocent position here. Of course, characters who do not believe in vampires because that would be irrational are generally the first to fall victim to them; more importantly, however, as I had suggested in my discussion of 'Carmilla', the actual irrationality of narrative itself may well be what brings belief into being at the end of the day.

It might be useful to close this book with a comparison of two recent vampire narratives, taking up in particular the way this subgenre is somehow already 'exhausted' – but is nonetheless able to mobilise (or energise) involvement, even belief, in what it does. Francis Ford Coppola's film *Bram Stoker's 'Dracula'* has already been briefly discussed; what is important to note here, however, is that on the whole this expensive blockbuster was received cynically by critics. One argument suggested that the film traded on a narrative with which audiences were generally familiar – so familiar, in fact, that the force of the film (its ability to frighten, for example) was necessarily reduced in favour of enlarging the film's range or scope.[1] The film was certainly a 'remake' of Stoker's novel, but it also incorporated a range of other textual (cinematic) images from elsewhere in order to 'thicken' its narrative: it worked horizontally, in other words, as much as it worked vertically. Geoffrey O'Brien, in his article 'Horror for Pleasure', summarises the film in this way:

> the narrative possibilities of vampire lore are so intimately familiar that Coppola can get away with casting a commercial blockbuster as a self-consciously postmodernist palimpsest. He does not so much reinvent the horror movie as reinventory it. . . . *Dracula* functions concurrently as a faithful adaption and a caricatural pastiche, while lining its

interstices with portentous contemporary tie-ins (AIDS, drug addiction).

<div align="right">(O'Brien, 1993, 63)</div>

This last point especially is worth taking up: vampire narratives may be mobile enough to touch a range of contemporary issues, but *too* mobile, perhaps, to develop them in an engaged way. References to AIDS in contemporary vampire films, for example, are relatively commonplace, but engagements with the politics of AIDS simply do not happen. Coppola's *Bram Stoker's 'Dracula'* is full of such references; it may be all the more 'exhausted' because of it.

Fran Rubel Kuzui's *Buffy, the Vampire Slayer* was released during the same year as Coppola's 'remake', but the two films have little in common. A teen movie, *Buffy* fits into the kind of trajectory mapped out in Chapter 5 – where youth becomes a 'site of contestation', able to slide into the vicinity of vampires a little too easily. It begins by introducing a Californian community which in a sense is already in a state of 'exhaustion'. Buffy is a high-school cheerleader who, with her friends, lives out the maxim 'I shop, therefore I am', moving freely but idly through a society in abundance. The film comically underscores their disengagement from the world around them, from 'relevant' issues (Buffy pouts at one point, 'Excuse me for not knowing about El Salvador!'). In the manner of the General in 'Carmilla', however, a 'patriarchal figure' (played by Donald Sutherland) comes out of the past to tell Buffy that the community – and her friends in particular – are being threatened by vampires. The film goes on to show how Buffy, who once was disengaged and doubting, now becomes an avenging believer, dispatching the vampires one by one.

This kind of transformation is, as I have shown, typical of vampire narratives – it happens to the vampire hunters in Coppola's film, too. One difference here, however, is that Buffy is female. In Coppola's film the vampire hunters use belief as a means of recovering their masculinity; for Buffy, however, to believe in vampires is to believe in the possibility of her own empowerment as a woman. She thus not only dispatches vampires by herself but puts the sexist boys at school in their place (both the vampires and the boys call her a 'bitch') and refuses the usual subordinated position her girlfriends happily occupy. Buffy's empowerment makes her a very different character from the swooning Mina in Coppola's film: the point here is precisely *not* to be carried away by vampires. A second difference is that the scenario for Buffy's empowerment is now resolutely local. We have seen other vampire narratives use local scenarios for their action – Stephen King's *'Salem's Lot*, for example. But *Buffy* refuses to enlarge itself in the ways already noted in relation to King: to mythologise its community as 'American', for example, or to monumentalise itself as part of a 'classical' literary tradition (as Coppola's film monumentalises itself in relation to a tradition of cinema) – or to push itself towards the status of a blockbuster. Nor does

Buffy laden its 'interstices' with contemporary references to AIDS and so on. This is a film which places clear limits on its scope in order to underline the force of its relatively modest project, namely, the mobilisation of a Californian suburban adolescent girl. And in doing so, the film uses vampires precisely in order to *prevent* exhaustion: what is usually 'beyond' culture is called upon to produce a certain level of empowerment *in* culture for those who might otherwise have surrendered themselves up to it. This kind of intervention at the local level may be one means by which vampire narratives – for all their ambition to travel across the globe – can recover their energies.

NOTES

1 ETHNIC VAMPIRES: TRANSYLVANIA AND BEYOND

1 The map is reproduced in Rae-Ellis (1981, 47). I am grateful to Bill Perrett for drawing my attention to it.

2 For a discussion of 'the politics of backwardness' in Hungary – and Transylvania – see Janos (1982).

3 For a good account of these influences, see Frayling (1991, 317–47).

4 Mircea Iorgulescu's review of these biographical histories takes Sweeney to task for treating Ceausescu as 'the most recent embodiment of a supernatural evil haunting Europe, and especially Roumania' – whereas for Iorgulescu, Roumania and 'the Dracula myth' are separated by claiming the latter as an invention of Stoker's. Interestingly, although it is admired, Behr's book is also taken to task for its (lack of) 'truth': Iorgulescu notes 'the credit he gives to dubious documentary sources, such as romantic biographies . . . and superficial literature for popular consumption', as well as his reliance on information from communist officials (Iorgulescu, 1991, 13). Roumanians may not always wish to distance themselves (and Roumania) from 'the Dracula myth', however: playwright Martin Sorescu found it 'impossible not to think of Dracula' under Ceausescu's regime, and wrote a number of thinly-veiled allegories which connected Ceausescu with the legendary tyrant and 'source' for Dracula, Vlad Tepes the Impaler (Sorescu, 1991, 12).

It is worth noting, incidentally – in a footnote to a footnote – that Ceausescu was not the first Roumanian tyrant since Vlad the Impaler to be vampirised. General Baron Ludwig Haynau, Austrian commander-in-chief during the uprisings in Hungary in 1848 and 1849, was popularly known as the 'cold vampire'. Istvan Deak describes him as 'mean, suspicious, hysterical, and probably a sadist', adding that 'Today no historian is ready to apologise for Haynau's behaviour; and, truly, there is no excuse for his extraordinary brutality' (Deak, 1979, 302, 336).

5 One of Kittler's sources would seem to be Leatherdale (1985). The account of Vambery here is anxious about, precisely, the *influence* of sources:

> This has led to the unwarranted presumption that fact mirrored fiction: that the *real* Armenius Vambery supplied information on the *real* Dracula. Such a presumption is dangerous because Stoker's use of nomenclature was, on occasions, inconsequential. . . . What seems more curious about Vambery, *vis-à-vis* Stoker's researches, is that in most of the encyclopaedias Stoker would have consulted, the entries 'Vambery' and 'vampire' are juxtaposed [Leatherdale's own source here is Dukes (1982)]. Unfortunately, nothing is known of the content of Stoker's and Vambery's conversations or later correspondence,

145

and if Vambery ever wrote on the subject of vampires, or a so-called Dracula, no record has survived. What is, finally, the most persuasive argument against the primacy of the Vambery connection is that all the important information in the novel on Dracula or vampires in general, and which is attributed in *Dracula* to Armenius, can be found in the books and articles listed in Stoker's notes. These notes do not mention Armenius Vambery. In other words he may or may not have featured in Stoker's enquiries, but either way it would appear that *Dracula* could have taken its final form without him.

(89)

Leatherdale's conclusion is the exact opposite to Kittler's.

6 As Arata later points out, Gerard conceived the Roumanians as possessing a 'Roman' heritage, in contrast to other 'degenerate' nations. Her account might then be read as an allegory of the West's triumph over the East.

7 In Wolf (1975) the description reads, 'of rather the Adelphi Theatre type' (306) – a well-known theatre in London which produced melodrama and farce. As Wolf notes, Harker renders the Jew as a comic caricature.

8 Johnson's account of the gypsies in Hungary was no doubt also important for Stoker – the gypsies being Dracula's only allies. Like the Jew, they are 'dispersed amongst all nations' but 'still retain their unmistakable type' (Johnson, 1885,150). Johnson describes their 'wild and nomadic habits': they are 'dangerous' and difficult to 'domesticate' (150). At one point, Johnson is chased by gypsies 'howling like wolves or jackals' (149); in Stoker's novel, the gypsies are clearly identified with wolves, who also follow Dracula (see Stoker, 1988, 374).

9 For further remarks on the connections between Morris and Dracula, see Leatherdale (1985, 131).

10 Marx may also have been familiar with Vlad the Impaler: see Frayling (1991, 84).

11 For an account of the authorship of this novel, see Frayling (1991, 145). Frayling also draws attention to Rymer's essay on 'Popular Writing' (1842) which, by noting that popular fiction depends upon the arousal of 'fear' in its readers (of whom Rymer is contemptuous), sounds very much like Moretti's account of *Dracula*.

2 VAMPIRES IN GREECE: BYRON AND POLIDORI

1 These two characters are interestingly brought together in Elaine Bergstrom's historical vampire novel, *Daughter of the Night* (1992), which draws heavily on McNally's account of Bathory, *Dracula Was a Woman* (1984).

2 For an account of Stoker's interest in Slavic folklore, and for information about Vlad the Impaler and his reputation, see Kirtley (1988, 10–17).

3 Shelley was later to claim, in the Preface to *Hellas* (1822), that 'We are all Greeks': Greece becomes the point of origin for the Romantic sensibility. For a discussion of the politics of this kind of utopianism, see Kipperman (1991).

4 The Giaour's Albanian identity may be part of this self-projection. Byron had been impressed by Albanians or 'Arnaouts', comparing them 'to the Highlanders of Scotland' and admiring their 'magnificent . . . kilts' (Marchand, 1971, 71).

5 For an account of the Paris 'craze' over Polidori's 'The Vampyre', and the various melodramas based on that story, see Frayling (1991, 131–44).

6 Douglas contrasts Robertson Smith's work with that of the neo-Darwinian E.B. Tylor (she wrongly lists his first name as Henry), whose *Primitive Culture* was published in 1871. Douglas comments, 'Whereas Tylor was interested in what quaint relics can tell us of the past, Robertson Smith was interested in the common elements in modern and primitive experience. Tylor founded folk-lore:

Robertson Smith founded social anthropology' (Douglas, 1991, 14). As indicated, folklore as a designated field of study in Britain preceded Tylor; also, the formation of folklore studies in Greece has more in common with Robertson Smith than with Tylor. Folklore – yoked as it is to an organic conception of national identity – *animates* the past, rather than shuts it down.

3 VAMPIRES AND THE UNCANNY: LE FANU'S 'CARMILLA'

1 For a discussion of the convergence of the terms 'host' and 'guest' – which is heavily influenced by Freud's 'The "Uncanny"' – see Miller (1979).
2 Manuel Aguirre has noted that the Enlightenment brought into being the first genealogies of the vampire in Europe – Augustine Calmet's *The Phantom World* (1850, first published in 1740), for example – devoting itself to identifying and classifying this unreasonable thing (Aguirre, 1990, 79–80).
3 As David Punter notes, although with a different emphasis, rather than see Lord Ruthven as Byron, we should see him as 'the representation . . . of a mythological *class*' (Punter, 1980, 119).
4 For an account of these tropes in late nineteenth-century literature and art – as well as a short discussion of 'Carmilla', which emphasises the bestial representation of aggressive sexuality – see Dijkstra (1986).
5 For an interesting discussion of 'vampiric identification' in fashion advertising – where female spectators 'are constrained to assume the position of lesbian vampires' – see Fuss (1992). Fuss notes that fashion advertising licenses homoerotic identification, but manages it too: the female spectator wants to be like the woman in the advertisement, but she must not desire that woman. Thus, heterosexuality activates homoeroticism, and then disavows it: 'Homosexuality is "repressed" to the degree that the structure it provides for the formation of the heterosexual subject is so apparent that it becomes transparent' (732).

4 READING *DRACULA*

1 Christopher Frayling argues persuasively that 'Dracula's Guest' is a 'freestanding story', rather than a discarded earlier chapter from the novel. Certainly there is little connection between events in the story and events in the novel. See Frayling (1991, 351–3), for an account of 'Dracula's Guest', which was not published until 1914.
2 See Leatherdale (1985, 59, 88), for an account of the influence of Le Fanu's 'Carmilla' on Stoker – who had originally set *Dracula* in Styria.
3 Van Helsing may have ejaculated prematurely, in Jennifer Wicke's reading of an earlier scene (Wicke, 1992, 483). The novel describes him leaning over Lucy's coffin, holding his candle 'so. . . that the sperm dropped in white patches which congealed as they touched the metal' (Stoker, 1988, 197). The reference is to sperm whale oil – but the sexual aspects of the description cannot go unnoticed.
4 I am grateful to Ken Ruthven for drawing my attention to this article.
5 Jim Collins gives a different reading, arguing that 'the act of writing and compiling a manuscript' is privileged in *Dracula* over and above any other kind of testimony: see Collins (1989, 87–9). For Collins, those other testimonies each 'fall miserably short' of the truth; writing, by contrast, not only accounts for the strange events, but enables the authors to survive them. The novel thus legitimates itself as a novel, while other modes of reportage are discredited. Collins's argument, however, does not notice the problem of authenticity in the novel – which is bound up with the very means by which writing in the 'new age' is

produced. The point is that 'writing' is no longer what it was; even when the novel closes, there is still the remaining anxiety that nothing in the text can be verified.

6 For a good account of hypnosis and Freudian psychoanalysis, see Borch-Jacobsen (1989, 92–110).

5 VAMPIRES AND CINEMA: FROM *NOSFERATU* TO *BRAM STOKER'S 'DRACULA'*

1 Grounded in the heterosexist romance genre, Coppola's film, as Richard Dyer has noted, is definitely not 'queer'. It may, however, express 'the profound contradictoriness of the cultural construction of heterosexual masculinity, at once dominant and disgusting' (Dyer, 1993, 12).

2 Skal notes that '[t]here was, apparently, almost no kind of consumer product or novelty that could not be enhanced by Lugosi's presence as a vampire' (Skal, 1990, 191). Universal Pictures, who freely licensed a whole range of items which featured Lugosi's screen image, were taken to court by Lugosi's son. Skal gives an account of the long-running *Lugosi vs Universal Pictures* case, and characterises it as 'a kind of postmodernist gothic text' which – by constantly resurrecting an image in the marketplace, which is then fought over as if it is alive – draws vampirism and consumerism together (195).

3 Kim Newman has drawn Lugosi and Lee together in a way which perhaps furthers the association between these screen vampires and the figure of Bond: 'There is no suggestion that Lugosi or Lee feels anything for those they vampirise: their quarrels are with Van Helsing and his acolytes, and the struggles of these films are vigorously masculine' (Newman, 1993, 13).

4 To return to Neale's association of horror, westerns and detective fiction: it is worth noting that vampire narratives have occasionally merged with westerns – as in William Beaudine's film *Billy the Kid Versus Dracula* (1966), or in the 'enormous John Ford shootout' (Saberhagen, 1992, 300) at the end of Coppola's *Bram Stoker's 'Dracula'* – and with detective fiction, as in Loren D. Estleman's *Sherlock Holmes Vs. Dracula* (1979) or P.N. Elrod's ongoing *The Vampire Files* series (1990-), with its vampire detective Jack Fleming. David J. Skal notes that Stoker had introduced a detective, Cotford, into an earlier version of *Dracula* (Skal, 1990, 10).

5 Interestingly, the name of the evil capitalist in the 'Gothic' blockbuster film *Batman Returns* (1992) was given as Max Schrek. This character's vampirish motivations – he literally sucks power out of Gotham City – are fairly clear; but the nominal connection to a German art film seems somewhat idiosyncratic.

6 VAMPIRES IN THE (OLD) NEW WORLD: ANNE RICE'S VAMPIRE CHRONICLES

1 Ramsland (1991) writes at length about the impact on Rice of the death of her 5-year-old daughter Michelle, from leukemia – and how it led, among other things, to the writing of *Interview with a Vampire*.

2 For Hodges and Doane, Rice's novels are nostalgic for a kind of pre-semiological 'real' – 'for the lost pleasures of realism' (Hodges and Doane, 1991, 167), a moment *before* representation. Thus, they note, 'her novels are set up to be talked. Speech is privileged over writing' (167). The dubious equation of 'speech' with 'realism' should be noted; we can add that popular fiction generally (crime fiction, science fiction and so on) privileges dialogue over description – and that while this lends a kind of immediacy to the narrative, it need not be seen as a

strategy to evade representational problematics. We can also note that Rice's shift into 'realism' in *The Tale of the Body Thief* is – as the discussion below will suggest – by no means as comforting as these critics would suggest.

7 VAMPIRE BLOCKBUSTERS: STEPHEN KING, DAN SIMMONS, BRIAN ALDISS AND S. P. SOMTOW

1 A shorter version of King's essay 'Tales of the Tarot' in *Danse Macabre* – which discusses *Frankenstein*, *Dracula* and *Jekyll and Hyde* – was used to introduce a collection which brought these three novels together (King, 1978).

CONCLUSION

1 I am drawing loosely here on Clifford Geertz's distinction between 'force' and 'scope', outlined in his book *Islam Observed* (1968).

BIBLIOGRAPHY

Aguirre, Manuel (1990), *The Closed Space: Horror Literature and Western Symbolism*, Manchester and New York: Manchester University Press.

Aldiss, Brian (1992), *Dracula Unbound*, London: Grafton.

Arata, Stephen D. (1990), 'The Occidental Tourist: *Dracula* and the Anxiety of Reverse Colonisation', *Victorian Studies*, 33: 621–45.

Astle, Richard (1980), 'Dracula as Totemic Monster: Lacan, Freud, Oedipus and History', *Sub-stance*, 25: 98–105.

Auerbach, Nina (1982), *Women and the Demon: The Life of a Victorian Myth*, Cambridge, Massachusetts: Harvard University Press.

Baldick, Chris (1987), *In Frankenstein's Shadow: Myth, Monstrosity, and Nineteenth-Century Writing*, Oxford: Clarendon Press.

Barber, Paul (1988), *Vampires, Burial and Death: Folklore and Reality*, New Haven and London, Yale University Press.

Barbour, Judith (1992), 'Dr. John William Polidori, Author of *The Vampyre*', in Deirdre Coleman and Peter Otto (eds), *Imagining Romanticism: Essays on English and Australian Romanticism*, West Cornwall, Connecticutt: Locust Hill Press.

Barrie, J.M. (1974), *Peter Pan*, Harmondsworth: Penguin.

Behr, Edward (1991), *'Kiss the Hand that Cannot Bite': The Rise and Fall of the Ceausescus*, London: Hamish Hamilton.

Benjamin, Walter (1973), *Charles Baudelaire: A Lyric Poet in the Era of High Capitalism*, London: New Left Books.

Bennett, Tony and Woollacott, Janet (1987), *Bond and Beyond: The Political Career of a Popular Hero*, Houndsmills and London: Macmillan.

Bentley, Christopher (1988), 'The Monster in the Bedroom: Sexual Symbolism in Bram Stoker's *Dracula*', in Margaret L. Carter (ed.), *Dracula: The Vampire and the Critics*, Ann Arbor: UMI Research Press.

Bergstrom, Elaine (1992), *Daughter of the Night*, New York: Jove.

Borch-Jacobsen, Mikkel (1989), 'Hypnosis in Psychoanalysis', *Representations*, 27: 92–110.

Brand, Dana (1990), 'From the *Flâneur* to the Detective', in Tony Bennett (ed.), *Popular Fiction: Technology, Ideology, Production, Reading*, London and New York: Routledge.

Brantlinger, Patrick (1988), *Rule of Darkness: British Literature and Imperialism, 1830–1914*, Ithaca, New York: Cornell University Press.

Brontë, Charlotte (1984), *Jane Eyre*, Harmondsworth: Penguin.

Brophy, Philip (1983), 'Horrality - The Textuality of Contemporary Horror Films', *Art & Text*, 11: 85–95.

150

Brown, Marshall (1987), 'A Philosophical View of the Gothic Novel', *Studies in Romanticism*, 26: 275–301.

Buzard, James (1991), 'The Uses of Romanticism: Byron and the Victorian Continental Tour', *Victorian Studies*, 35: 29–49.

Byers, Thomas B. (1988), 'Good Men and Monsters: The Defenses of *Dracula*', in Margaret L. Carter (ed.), *Dracula: The Vampire and the Critics*, Ann Arbor: UMI Research Press.

Byron, Lord George Gordon (1970), 'The Giaour: A Fragment of a Turkish Tale', in Frederick Page (ed.), *Byron: Poetical Works*, London: Oxford University Press.

Byron, Lord George Gordon (1988), 'Fragment of a Novel', in Alan Ryan (ed.), *The Penguin Book of Vampire Stories*, Harmondsworth: Penguin.

Cadzow, John F. *et al.* (1983), *Transylvania: The Roots of Ethnic Conflict*, Kent, Ohio: Kent State University Press.

Calmet, Augustine (1850), *The Phantom World; or, the Philosophy of Spirits, Apparitions, & Co.*, trans. Revd Henry Christmas, 2 vols, London: Richard Bentley.

Carroll, Noel (1990), *The Philosophy of Horror, or, Paradoxes of the Heart*, London: Routledge.

Case, Sue-Ellen (1991), 'Tracking the Vampire', *Differences*, 3: 1–20.

Castle, Terry (1988), 'Phantasmagoria: Spectral Technologies and the Metaphorics of Modern Reverie', *Critical Inquiry*, 15: 26–61.

Charnas, Suzy McKee (1992), *The Vampire Tapestry*, London: The Women's Press.

Cixous, Hélène (1976), 'Fiction and Its Phantoms: A Reading of Freud's *Das Unheimliche*', *New Literary History*, 7: 525–48.

Collins, Jim (1989), *Uncommon Cultures: Popular Culture and Post-Modernism*, New York and London: Routledge.

Cooper, Andrew M. (1988), 'Chains, Pains, and Tentative Gains: The Byronic Prometheus in the Summer of 1816', *Studies in Romanticism*, 27: 529–50.

Copjec, Joan (1991), 'Vampires, Breast-Feeding, and Anxiety', *October*, 58: 25–43.

Craft, Christopher (1990), '"Kiss Me with Those Red Lips": Gender and Inversion in Bram Stoker's *Dracula*', in Elaine Showalter (ed.), *Speaking of Gender*, New York and London: Routledge.

Cranny-Francis, Anne (1988), 'Sexual Politics and Political Repression in Bram Stoker's *Dracula*', in Clive Bloom *et al.* (eds), *Nineteenth Century Suspense: From Poe to Conan Doyle*, Houndsmills and London: Macmillan Press.

Crompton, Louis (1985), *Byron and Greek Love: Homophobia in 19th Century England*, Berkeley, California: University of California Press.

Dadoun, Roger (1989), 'Fetishism in the Horror Film', in James Donald (ed.), *Fantasy and the Cinema*, London: BFI Publishing.

Dalby, Richard (ed.), (1989), *Dracula's Brood*, Wellingborough, Northampton: Equation.

Deak, Istvan (1979), *The Lawful Revolution: Louis Kosuth and the Hungarians, 1848–1849*, New York: Columbia University Press.

Dickens, Charles (1985), *Bleak House*, Harmondsworth: Penguin.

Dijkstra, Bram (1986), *Idols of Perversity: Fantasies of Feminine Evil in Fin-de-siècle Culture*, Oxford: Oxford University Press.

Dingley, R.J. (1991), 'Count Dracula and the Martians', in Kath Filmer (ed.), *The Victorian Fantasists*, London: Macmillan.

Dolar, Mladen (1991), '"I Shall Be with You on Your Wedding Night": Lacan and the Uncanny', *October*, 58: 5–23.

Donald, James (1992), 'What's at Stake in Vampire Films?', in *Sentimental Education: Schooling, Popular Culture and the Regulation of Liberty*, London: Verso.

Douglas, Mary (1991), *Purity and Danger: An Analysis of Concepts of Pollution and Taboo*, London: Routledge.

BIBLIOGRAPHY

Dresser, Norine (1990), *American Vampires: Fans, Victims, Practitioners*, New York: Vintage Books.

Dukes, Paul (1982), '*Dracula*: Fact, Legend, Fiction', *History Today*, 32.

Dyer, Richard (1988), 'Children of the Night: Vampirism as Homosexuality, Homosexuality as Vampirism', in Susannah Radstone (ed.), *Sweet Dreams: Sexuality, Gender and Popular Fiction*, London: Lawrence & Wishart.

Dyer, Richard (1993), 'Dracula and Desire', *Sight and Sound*, 3: 8–12.

Elsaesser, Thomas (1989), 'Social Mobility and the Fantastic: German Silent Cinema', in James Donald (ed.), *Fantasy and the Cinema*, London: BFI Publishing.

Englander, David (1989), 'Booth's Jews: The Presentation of Jews and Judaism in Life and Labour of the People in London', *Victorian Studies*, 32: 551–71.

Fasolino, Greg (1992), 'Lestat of the Art - The Dark Gift Discussed', in *Reflex: Alternative Music and Culture*, 29: 42–6.

Florescu, Radu and McNally, Raymond T. (1972), *In Search of Dracula*, Greenwich, Connecticut: New York Graphic Society.

Florescu, Radu and McNally, Raymond T. (1973), *Dracula: A Biography of Vlad the Impaler 1431–1476*, London: Robert Hale & Co.

Florescu, Radu and McNally, Raymond T. (1990), *Dracula: Prince of Many Faces*, Boston: Little, Brown.

Frayling, Christopher (ed.) (1991), *Vampyres*, London: Faber & Faber.

Freud, Sigmund (1987), 'The "Uncanny"', *The Pelican Freud Library: Art and Literature*, vol. 14, Harmondsworth: Penguin.

Frost, Brian J. (1989), *The Monster with a Thousand Faces: Guises of the Vampire in Myth and Literature*, Bowling Green, Ohio: Bowling Green State University Popular Press.

Fuss, Diana (1992), 'Homospectatorial Fashion Photography', *Critical Inquiry*, 18: 728–37.

Ganning, Tom (1989), 'An Aesthetic of Astonishment: Early Film and the (In)Credulous Spectator', *Art & Text*, 34: 31–45.

Garnett, Lucy M.J. (1896), *Greek Folk Poesy*, intro. with essays by J.S. Stuart-Glennie, London: Billing and Sons/David Nutt.

Gilman, Sander L. (1986), *Jewish Self-Hatred: Anti-Semitism and the Hidden Language of the Jews*, Baltimore: John Hopkins University Press.

Glover, David (1992), 'Bram Stoker and the Crisis of the Liberal Subject', *New Literary History*, 23: 983–1002.

Griffin, Gail B. (1988), '"Your Girls That You All Love are Mine": *Dracula* and the Victorian Male Sexual Imagination', in Margaret L. Carter (ed.), *Dracula: The Vampire and the Critics*, Ann Arbor: UMI Research Press.

Grixti, Joseph (1989), *Terrors of Uncertainty: The Cultural Contexts of Horror Fiction*, London: Routledge.

Haining, Peter (1987), *The Dracula Scrapbook*, London: Chancellor Press.

Hatlen, Burton (1988), 'The Return of the Repressed/Oppressed in Bram Stoker's *Dracula*', in Margaret L. Carter (ed.), *Dracula: The Vampire and the Critics*, Ann Arbor: UMI Research Press.

Hebdige, Dick (1988), 'Hiding in the Light: Youth Surveillance and Display', in *Hiding in the Light: On Images and Things*, London and New York: Routledge.

Herzfeld, Michael (1982), *Ours Once More: Folklore, Ideology, and the Making of Modern Greece*, Austin, Texas: University of Texas Press.

Hodges, Devon and Doane, Janice L. (1991), 'Undoing Feminism in Anne Rice's Vampire Chronicles', in James Naremore and Patrick Brantlinger (eds.), *Modernity and Mass Culture*, Bloomington and Indianapolis, Indiana University Press.

Huyssen, Andreas (1986), 'Mass Culture as Woman: Modernism's Other', in Tania Modleski (ed.), *Studies in Entertainment: Critical Approaches to Mass Culture*, Bloomington and Indianapolis: Indiana University Press.

Iorgulescu, Mircea (1991), 'The Dwarf Tyrant of Bucharest', *Times Literary Supplement*, 24 May: 13.

Jackson, Rosemary (1981), *Fantasy: The Literature of Subversion*, London: Methuen.

Jameson, Fredric (1981), 'Magical Narratives', in *The Political Unconscious: Narrative as a Socially Symbolic Act*, Ithaca, New York: Cornell University Press.

Janos, Andrew C. (1982) *The Politics of Backwardness in Hungary, 1825–1945*, Princeton, New Jersey: Princeton University Press.

Johnson, Major E.C. (1885), *On the Track of the Crescent: Erratic Notes from the Piraeus to Pesth*, London: Hurst & Blackett.

Jones, Ernest (1991), 'On the Vampire', in Christopher Frayling (ed.), *Vampyres*, London: Faber & Faber.

Katzburg, Nathaniel (1981), *Hungary and the Jews*, Ramat-Gan, Israel: Bar-Ilan University Press.

King, Stephen (1977), *'Salem's Lot*, London, Hodder & Stoughton (New English Library).

King, Stephen (1982), *Danse Macabre*, London: Futura.

King, Stephen (ed.) (1978), *Frankenstein, Dracula and Jekyll and Hyde*, New York: NAL Penguin.

Kipperman, Mark (1991), 'Macropolitics of Utopia: Shelley's *Hellas* in Context', in Jonathan Arac and Harriet Ritvo (eds), *Macropolitics of Nineteenth-Century Literature: Nationalism, Exoticism, Imperialism*, Philadelphia: University of Pennsylvania Press.

Kirtley, Bacil F. (1988), *'Dracula*, the Monastic Chronicles and Slavic Folklore', in Margaret L. Carter (ed.), *Dracula: The Vampire and the Critics*, Ann Arbor: UMI Research Press.

Kittler, Friedrich (1989), 'Dracula's Legacy', *Stanford Humanities Review*, 1: 143–73.

Lawson, John Cuthbert (1964), *Modern Greek Folklore and Ancient Greek Religion*, intro. Al. N. Oikonomides, New York: University Books.

Leatherdale, Clive (1985), *Dracula: The Novel and the Legend*, Wellingborough, Northamptonshire: Aquarian Press.

Le Fanu, J. Sheridan (1988), 'Carmilla', in Alan Ryan (ed.), *The Penguin Book of Vampire Stories*, Harmondsworth: Penguin.

McDonald, T. Liam (1992), 'The Horrors of Hammer: The House That Blood Built', in Christopher Golden (ed.), *Cut! Horror Writers on Horror Film*, New York: Berkley Books.

McNally, Raymond T. (1984), *Dracula was a Woman*, London: Robert Hale & Co.

McPherson, William (1990), 'In Roumania', *Granta: What Went Wrong?* 33: 9–58.

Marchand, Leslie A. (1971), *Byron: A Portrait*, London: John Murray.

Marchand, Leslie A. (1976), *'So Late Into the Night': Byron's Letters and Journals 1816–1817*, vol. 5, London: John Murray.

Martin, Philip (1988), 'The Vampire in the Looking-Glass: Reflection and Projection in Bram Stoker's *Dracula*', in Clive Bloom *et al.* (eds), *Nineteenth Century Suspense: From Poe to Conan Doyle*, Houndsmills and London: Macmillan Press.

Miller, J. Hillis (1979), 'The Critic as Host', in Harold Bloom *et al.* (eds), *Deconstruction and Criticism*, New York: Seabury.

Monette, Paul (1979), *Nosferatu: The Vampyre*, London: Picador.

Monleon, Jose B. (1990), *A Specter is Haunting Europe: A Sociohistorical Approach to the Fantastic*, Princeton, New Jersey: Princeton University Press.

Moretti, Franco (1988), 'Dialectic of Fear', in *Signs Taken for Wonders: Essays in the Sociology of Literary Form*, London: Verso.

Morris, Bob (1990–1), interview with Dan Simmons, *Midnight Graffiti*, 6: 14–19.

Morris, David B. (1985), 'Gothic Sublimity', *New Literary History*, 16: 299–319.

Neale, Stephen (1984), 'Genre and Cinema', in Tony Bennett *et al.* (eds), *Popular Film and Television*, London: BFI Publishing and Open University Press.

Neale, Stephen (1985), *Cinema and Technology: Image, Sound, Colour*, Bloomington: Indiana University Press.

Newman, Kim (1993), 'Bloodlines', *Sight and Sound*, 3: 12–13.

O'Brien, Geoffrey (1993), 'Horror for Pleasure', *The New York Review of Books*, 22 April.

O'Flinn, Paul (1986), 'Production and Reproduction: The Case of *Frankenstein*', in Peter Humm, Paul Stigant and Peter Widdowson (eds), *Popular Fictions: Essays in Literature and History*, London: Methuen.

Pick, Daniel (1989), *Faces of Degeneration: A European Disorder, c.1848–c.1918*, Cambridge: Cambridge University Press.

Pirie, David (1977), *The Vampire Cinema*, London: Paul Hamlyn.

Polidori, John William (1988), 'The Vampyre', in Alan Ryan (ed.), *The Penguin Book of Vampire Stories*, Harmondsworth: Penguin.

Pope, Rebecca A. (1990), 'Writing and Biting in *Dracula*', *Literature, Interpretation, Theory*, 1: 199–216.

Prawer, S.S. (1980), *Caligari's Children: The Film as Tale of Terror*, New York: Da Capo Press.

Punter, David (1980), *The Literature of Terror: A History of Gothic Fictions from 1765 to the Present Day*, London and New York: Longman.

Rae-Ellis, Vivienne (1981), *Trugganini: Queen or Traitor?* Canberra: Australian Institute of Aboriginal Studies.

Ramsland, Katherine (1991), *Prism of the Night: A Biography of Anne Rice*, New York: Dutton.

Rance, Nicholas (1991), *Wilkie Collins and Other Sensation Novelists*, London: Macmillan.

Rhode, Eric (1976), *A History of the Cinema from its Origins to 1970*, London: Allen Lane.

Rice, Anne (1986), *The Vampire Lestat*, London: Futura.

Rice, Anne (1988), *Interview with the Vampire*, New York: Ballantine Books.

Rice, Anne (1989), *The Queen of the Damned*, London, Futura.

Rice, Anne (1992), *The Tale of the Body Thief*, London, Chatto & Windus.

Richardson, Maurice (1991), 'The Psychoanalysis of Count Dracula', in Christopher Frayling (ed.), *Vampyres*, London: Faber & Faber.

Rodd, Rennell (1968), *The Customs and Lore of Modern Greece*, Chicago: Argonaut.

Ronay, Gabriel (1972), *The Truth About Dracula*, New York: W.H. Allen.

Roth, Phyllis A. (1988), 'Suddenly Sexual Women in Bram Stoker's *Dracula*', in Margaret L. Carter, ed., *Dracula: The Vampire and the Critics*, Ann Arbor: UMI Research Press.

Ryan, Alan (ed.) (1988), *The Penguin Book of Vampire Stories*, Harmondsworth: Penguin.

Rymer, James Malcolm (1970), *Varney the Vampire, or, The Feast of Blood*, ed. Sir Devendra P. Varma, New York: Arno Press.

Saberhagen, Fred and Hart, James V. (1992), *Bram Stoker's 'Dracula'*, London, Sydney and Auckland: Pan Books.

Said, Edward (1978), *Orientalism*, London: Routledge & Kegan Paul.

Schivelbusch, Wolfgang (1979), *The Railway Journey*, trans. Anselm Hollo, Oxford: Basil Blackwell.

Sedgwick, Eve Kosofsky (1985), *Between Men: English Literature and Male Homosocial Desire*, New York: Columbia University Press.

Sedgwick, Eve Kosofsky (1986), *The Coherence of Gothic Conventions*, New York and London: Methuen.

Senf, Carol A. (1988), '*Dracula*: the Unseen Face in the Mirror', in Margaret L. Carter (ed.), *Dracula: The Vampire and the Critics*, Ann Arbor: UMI Research Press.

Showalter, Elaine (1990), *Sexual Anarchy: Gender and Culture at the Fin-de-siècle*, New York: Penguin.

Showalter, Elaine (1993), 'Blood Sell', *Times Literary Supplement*, 8 January: 14.

Simmons, Dan (1990), *Carrion Comfort*, London: Headline Book Publishing.

Simmons, Dan (1992), 'All Dracula's Children', in Byron Preiss (ed.), *The Ultimate Dracula*, London: Headline Book Publishing.

Skal, David J. (1990), *Hollywood Gothic: The Tangled Web of 'Dracula' from Novel to Stage to Screen*, New York: W.W. Norton & Co.

Skarda, Patricia L. (1989), 'Vampirism and Plagiarism: Byron's Influence and Polidori's Practice', *Studies in Romanticism*, 28: 249–69.

Somtow, S.P. (1984), *Vampire Junction*, New York: Tor.

Somtow, S.P. (1992), *Valentine*, London: Victor Gollancz.

Sorescu, Martin (1991), 'Vampires and Vampirology', *Times Literary Supplement*, 11 January.

Stoker, Bram (1988), *Dracula*, Oxford: Oxford University Press.

Stoker, Bram (1990), 'Dracula's Guest', in *Dracula's Guest*, Dingle, Ireland: Brandon.

Summers, Montague (1928), *The Vampire: His Kith and Kin*, London: Kegan Paul, Trench, Trubner & Co.

Summers, Montague (1929), *The Vampire in Europe*, London: Kegan Paul, Trench, Trubner & Co.

Sweeney, John (1991a), *The Life and Evil Times of Nicolae Ceausescu*, London: Hutchinson.

Sweeney, John (1991b), 'Devil Worship', *New Statesman and Society*, 22 March: 17.

Timpone, Anthony (ed.) (1992), *Dracula: The Complete Vampire*, New York: Starlog Communications International.

Todorov, Tzvetan (1973), *The Fantastic: A Structural Approach to a Literary Genre*, Ithaca, New York: Cornell University Press.

Tucker, Robert C. (ed.) (1972), *The Marx–Engels Reader*, New York: W.W. Norton & Co.

Twitchell, James (1988), 'The Vampire Myth', in Margaret L. Carter (ed.), *Dracula: The Vampire and the Critics*, Ann Arbor: UMI Research Press.

Vambery, Armenius (1884), *Armenius Vambery: His Life and Adventures*, London: T. Fisher Unwin.

Vambery, Armenius (1904), *The Story of My Struggles*, London: Thomas Nelson & Sons.

Veeder, William (1988), 'Foreword', in Margaret L. Carter (ed.), *Dracula: The Vampire and the Critics*, Ann Arbor: UMI Research Press.

Wall, Geoffrey (1984), '"Different from Writing": Dracula in 1897', *Literature and History*, 10: 15–23.

Waller, Gregory A. (1986), *The Living and the Undead: From Stoker's 'Dracula' to Romero's 'Dawn of the Dead'*, Urbana and Chicago: University of Illinois Press.

Watkins, Daniel P. (1987), *Social Relations in Byron's Eastern Tales*, Cranbury, New Jersey: Associated University Presses.

Weissman, Judith (1988), 'Women and Vampires: *Dracula* as a Victorian Novel', in Margaret L. Carter (ed.), *Dracula: The Vampire and the Critics*, Ann Arbor: UMI Research Press.

Wicke, Jennifer (1992), 'Vampiric Typewriting: *Dracula* and Its Media', *English Literary History*, 59: 467–93.

BIBLIOGRAPHY

Wolf, Leonard (ed.) (1975) *The Annotated Dracula*, London: New English Library.

Wood, Robin (1985), 'An Introduction to the American Horror Film', in Bill Nichols (ed.), *Movies and Methods: An Anthology*, vol. 2, Berkeley, California: University of California Press.

Zanger, Jules (1991), 'A Sympathetic Vibration: Dracula and the Jews', *English Literature in Transition 1880–1920*, 34: 33–44.

Žižek, Slavoj (1989), *The Sublime Object of Ideology*, London: Verso.

Žižek, Slavoj (1991), *For They Know Not What They Do: Enjoyment as a Political Factor*, London: Verso.

INDEX